Seasoned by Salt

Rodney Barfield

The University of North Carolina Press | Chapel Hill and London

Seasoned by Salt

A Historical Album of the Outer Banks

© 1995 The University of North Carolina Press

Manufactured in the United States of America

The paper in this book meets the guidelines for permanence and durability of the Committee on Production Guidelines for Book Longevity of the Council on Library Resources.

Library of Congress Cataloging-in-Publication Data
Barfield, Rodney.
 Seasoned by salt : a historical album of the Outer Banks / by Rodney Barfield.
 p. cm.
 Includes bibliographical references and index.
 ISBN 0-8078-2231-0 (cloth : alk. paper).
—ISBN 0-8078-4537-X (pbk. : alk. paper)
 1. Outer Banks (N.C.)—History—Pictorial works. I. Title.
F262.096B37 1995
975.6'1—dc20 95-9914
 CIP

99 98 97 96 95 5 4 3 2 1

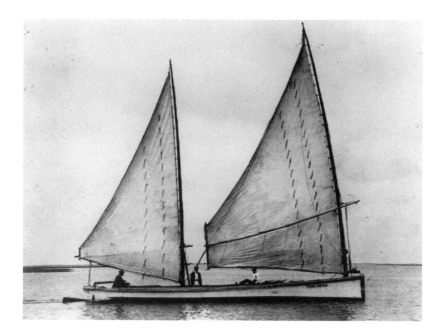

To J.-P.

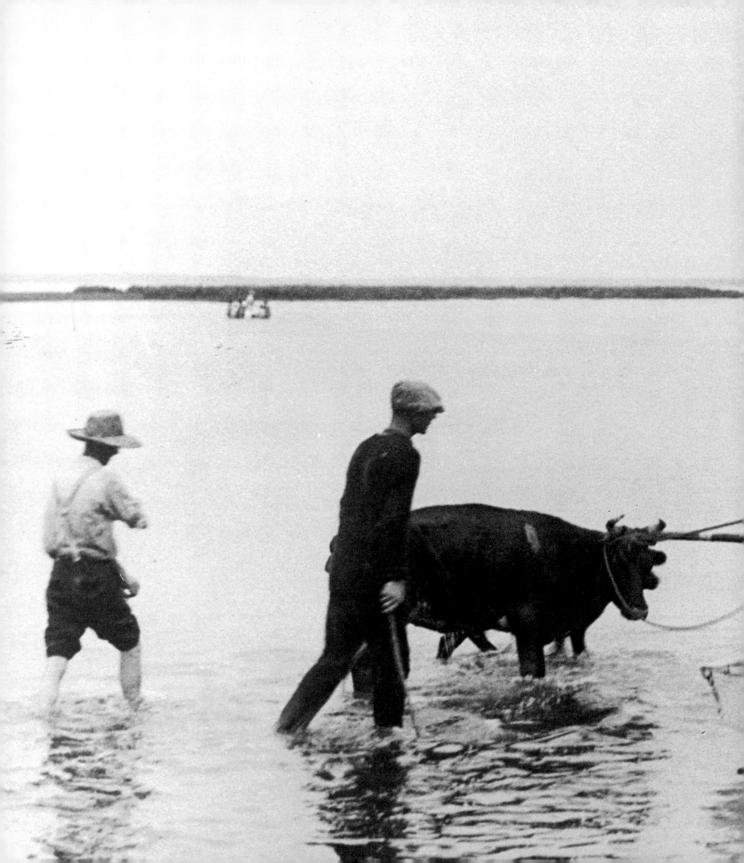

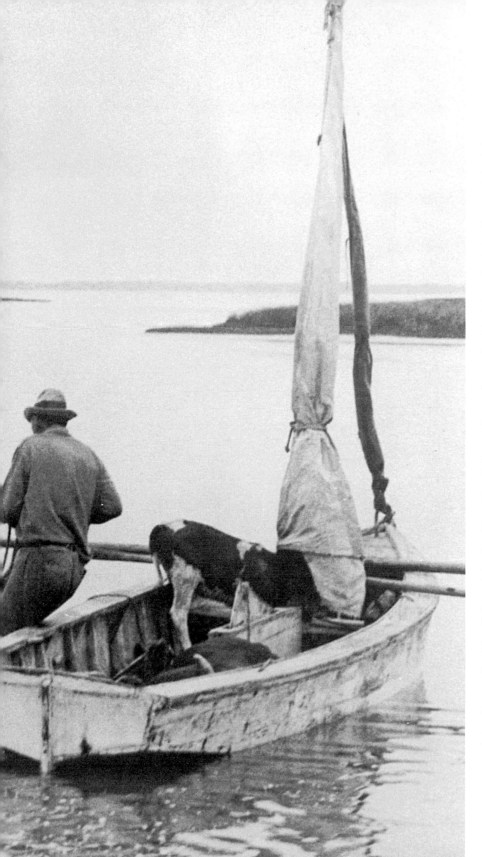

Contents

Map 1.
Northeastern
North Carolina

Wash Woods
Currituck (North) Banks
Corolla
Currituck Peninsula
Elizabeth City
Pasquotank River
Duck
Wright Memorial Bridge
Kitty Hawk
Edenton
Bath
Albemarle Sound
Kill Devil Hills
Colington
Chowan River
Nags Head
Manteo
Roanoke Island
Roanoke River
Plymouth
Oregon Inlet
Pea Island
Bodie Island
Rodanthe
Waves
Salvo
Washington
Pamlico River
Swan Quarter
Pamlico Sound
Avon
Frisco
Buxton
Hatteras
Cape Hatteras
Hatteras Island
Hatteras Inlet
Ocracoke
Portsmouth
Ocracoke Island
Ocracoke Inlet
Neuse River
Core Banks
Harkers Island
Bogue Sound
Shackleford Banks
Cape Lookout

Preface

In my work with museums over the past twenty years, I have often been struck by how quickly and firmly historical photographs arrest a visitor's attention. The lure of a dated image seems to tug at all ages and both genders and is not limited by social, economic, or educational background. There is something inherent in recorded images from the past that touches us at our very centers.

The somewhat daunting notion of this book was the result of watching visitors to the North Carolina Maritime Museum reflect on exhibit photographs of old schooners and faded oyster houses and wizened watermen and -women. One could virtually feel the visitors' urge to reach out and touch the subjects, to ask them about the circumstances of their lives.

On the many occasions when I could not contain my objective perspective and intruded on the viewers' reveries, I found that their interest in the images reached much deeper than an identification label could satisfy. They wanted to understand the subjects' historical context; they wanted to know the names and to hear the sounds and to smell the aromas of the times. Hence the essay format of this book, which tries to inform the photographs with some historical background.

The seemingly whimsical nature of the subjects treated in the book was actually chosen in the same way: by interviews with museum visitors. Three years of hearing and watching patrons react to exhibit subjects convinced me that they knew far better than I what they wanted to see.

I corroborated these sentiments with the natives of coastal North Carolina, those Downeasters who live on the mainland side of the sounds and those residents of the barrier islands known as Bankers. Of course, the interests of those conveyers

of our coastal heritage are not limited to the subjects discussed herein, but these topics are some of the ones most frequently discussed whenever the "old days" are resurrected.

Some of the topics may seem hackneyed to the outsider: for example, how much more can be said about lighthouses? But these issues continue to represent the collective memories and lore of the residents.

I have tried to be faithful to the wishes of the museum visitors and to the sentiments of the Bankers and their ancestors. Where I have succeeded, I credit it to their sharing with me; where I have failed or misinterpreted those sentiments, the fault is entirely my own.

I have introduced the book with a section on the names of the islands and their communities, beginning with Currituck Banks on the northern end and finishing with Shackleford Banks off Cape Lookout.

Island names are so important to the history and lore of the Outer Banks that I have been rather generous in details at times, though the whole actually represents merely an overview of the geographical area. The entries are historical vignettes that should provide the reader with a general background and a sense of location. They are not intended to be conclusive but rather to act as a general guide to locales and common lore.

Following this introduction there are sections on matters common to all of the Outer Banks islands: lighthouses, lifesaving, whaling, the Civil War, storms and shipwrecks, and indigenous boats. The illustrations date primarily from the late nineteenth and early twentieth centuries.

The photographs and narratives in this work reveal a culture shaped by a climate that is frequently harsh and unyielding; by daily preoccupations that are quite different from those of mainland North Carolina; and, in general, by an orientation to the sea that produces a different perspective on and approach to life.

I would like to thank Commissioner James A. Graham for his encouragement of this project; Connie Mason at the North Carolina Maritime Museum for her archival sleuthing and for the book's title; and the Friends of the Museum Board for supporting the initial research efforts on the book.

Superintendent Bill Harris made the photographic archives of the Cape Lookout Na-

tional Seashore available, and Helen Shore did likewise at the Outer Banks History Center. Steve Massengill at the North Carolina Division of Archives and History and Jerry Cotten at the North Carolina Collection, housed in Wilson Library at the University of North Carolina at Chapel Hill, were always helpful and forthcoming, even when I was less than sure what I was looking for. Wynne Dough and David Stick very generously critiqued the original manuscript.

And particular thanks to Michelle Francis for her interest, encouragement, and support.

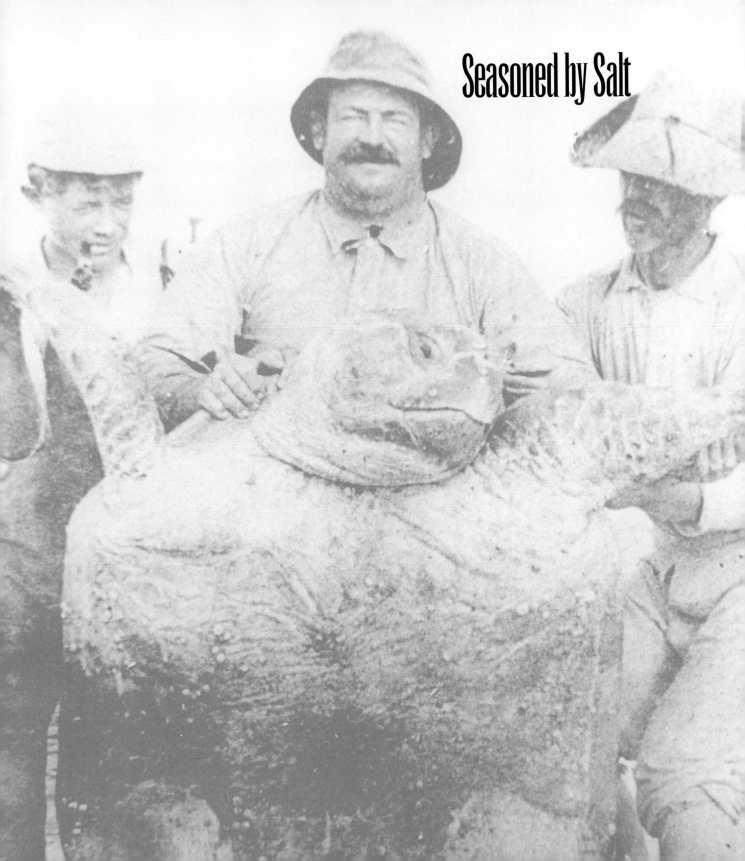

Seasoned by Salt

Map 2. Historic Inlets

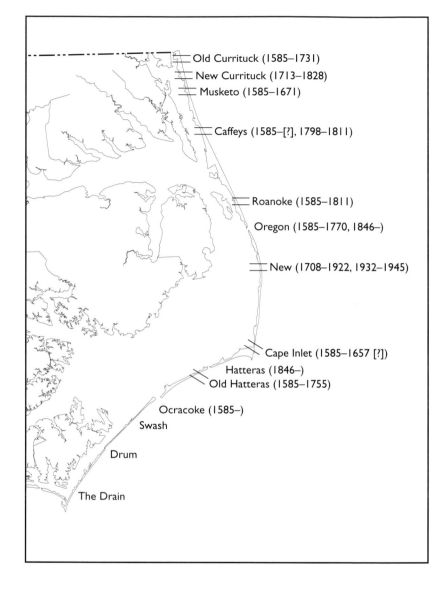

Old Currituck (1585–1731)

New Currituck (1713–1828)

Musketo (1585–1671)

Caffeys (1585–[?], 1798–1811)

Roanoke (1585–1811)

Oregon (1585–1770, 1846–)

New (1708–1922, 1932–1945)

Cape Inlet (1585–1657 [?])

Hatteras (1846–)
Old Hatteras (1585–1755)

Ocracoke (1585–)
Swash

Drum

The Drain

Title: Seasoned by salt :
Author: Barfield, Rodney
Item ID: 34200006944983
Due: **07/03/2017**

Fine Balance for $0.80
This Account

Introduction

The term "Outer Banks" refers to the thin chain of barrier islands and sandbars that parallel the North Carolina mainland from its northern border with Virginia to Cape Lookout, some 175 miles to the south.

Sometimes shortened to the "Banks," the term was used at least as early as 1715, when the North Carolina Council ordered island settlers from Europe to allow Poteskeet Indians to hunt on "any of the said Banks land."

The description became common currency and by the nineteenth century was a kind of shorthand that encompassed the several islands that make up the barrier island chain. A publication in the 1840s by George Throop carried the title *Nags Head, or Two Months among the "Bankers."* Edmund Ruffin, one of the state's prominent nineteenth-century naturalists, described an annual roundup of "Banks ponies" in 1861. The term holds the same meaning today that it did in previous centuries.

The Outer Banks follow a gently sloping southeast orientation from the Virginia border for about seventy-five miles, to the village of Rodanthe, then turn due south for about twenty miles, to Cape Hatteras, very nearly the easternmost point of North Carolina. At Hatteras, the islands veer slightly southwest for fifty-odd miles to Cape Lookout, which most islanders consider the end of the Outer Banks.

Actually, the islands make a dramatic westward turn at Lookout and run for another thirty miles, to Bogue Sound near Swansboro. Bogue and Shackleford Banks do not normally share the Outer Banks designation, but in fact they have the same geographical and cultural features that characterize the Virginia to Lookout chain.

The Outer Banks islands are separated at irregular intervals by narrow channels or inlets that slice through the bars and connect the Atlantic with the sounds that front the mainland. The islands were originally submarine bars formed by the accretion of sand washed up by longshore currents.

The inlets are opened and closed by the tremendous wash of water from ocean storms. Hurricanes whip up a counterclockwise tidal surge that pushes bay waters back up into mainland rivers as sea waves rush through the inlets. As the storm moves northward, eastward-turning winds unleash the pent-up waters, which race back at the islands and tear through the weakened openings to form new inlets.

Some thirty distinct inlets have been recorded along the Banks since the early sixteenth century. The North Carolina coast was well charted during the age of exploration, but it was the navigation demands of Walter Raleigh's effort to colonize the island of Roanoke that made the most significant contributions. Roanoke Colony governor John White's 1584 chart of the area shows nine inlets through the Banks. Theodore DeBry's 1590 engraving of White's charts depicts twelve. Current U.S. Coast Geodetic Survey charts carry seven inlets.

The Bankers' character and lifestyles are due in no small part to the opening and closing of inlets, the meandering paths of hurricanes and nor'easters, and the communities' literal and social insularity. These qualities are often reflected in the names given to the islands and their communities.

The Islands' Names

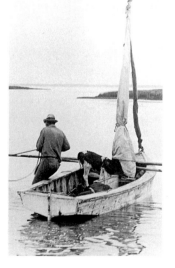

Oral tradition nurtures a colorful and descriptive language, one used not simply to communicate but also to entertain and

amuse. Add to that oral tradition the relative isolation of the Outer Banks, its seaward orientation, and its occasional alienation from the North Carolina mainland, and one begins to understand the complexion of its culture.

The Indian place-names of old, when Captains Amadas and Barlowe chanced upon the barrier islands in 1584, read like a poem: Wococon, Hatterask, Mattamuskeet, Croatoan, Chicamacomico. Over the years, European settlers anglicized the Indian names, but even in their garbled state the names carried the sounds and flavor of an exotic and exciting new land. The English added their own descriptive names and sounds in their attempts to translate or explain the Indian originals.

The English renderings and many of the Indian names survived until the second half of the nineteenth century, when the federal bureaucracy and an influx of outsiders strangled the life out of any word with more than two syllables and replaced them with names like Waves and Avon.

It may add context to the illustrations to explain some of the place-names of the Outer Banks, offering some sense of their origins and lore.

Currituck Banks. Currituck Banks or North Banks is the northernmost island in the Outer Banks chain. The name is of Indian derivation. The island stretches from the Virginia border to Bodie Island below Nags Head and includes the communities of Wash Woods, Corolla, Sanderling, Duck, Southern Shores, Kitty Hawk, Kill Devil Hills, and Nags Head.

In 1728 the Virginia surveyor William Byrd repeated a story he was told about a hermit on Currituck Banks who lived in a thatched hut, dressed in animal skins, and subsisted on raw oysters. Though the tale may be apocryphal, the early inhabitants of Currituck did lead a harsh and elemental existence. As late as 1856, Edmund Ruffin observed that there were only some twenty families on the island, all of whom made part of their livelihood by tending gardens: "They cultivate small patches of Indian corn and sweet potatoes. . . . Upon these products, and with fowling and fishing[,] these inhabitants subsist."

Corolla. The small community of Corolla on Currituck Island is the site of one of the Outer Banks' original lifesaving stations, built in 1874, and of a lighthouse completed in 1875. The village became a popular spot for hunting clubs after the Civil War. One of the

3

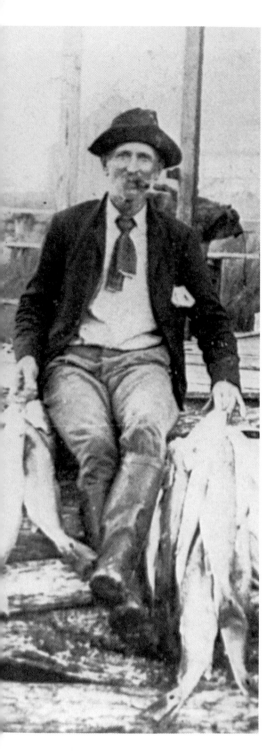

most impressive lodges, the Whalehead Club, is still standing, and Corolla has recently developed into an exclusive vacation resort.

Kitty Hawk. The name "Kitty Hawk" is also of Indian derivation, perhaps from a term used by Indians to refer to goose hunting; this phrase apparently sounded something like "killy honk." Another theory holds that the site was named after the so-called mosquito hawks—dragonflies—that frequented the area. "Mosquito hawk" was shortened to "skeeter hawk," which was further corrupted to "kitty hawk." Whatever its linguistic origins, the name was accepted by the locals as early as the mid-eighteenth century, when it began to appear in land deeds.

In 1874 Kitty Hawk was the site of a lifesaving station, which brought it some local attention. But the village received genuine national fame in December 1903, when Orville and Wilbur Wright made their first sustained airplane flight. It was from Kitty Hawk that the brothers telegraphed news of their historic achievement.

Kill Devil Hills. The Wrights actually made their historic flight at Kill Devil Hills, just south of Kitty Hawk, from one of the highest dunes on the Banks. Theories about the origin of the name abound. One points to a comment by the haughty Virginia surveyor William Byrd that the rum consumed by the Bankers was so "bad and unwholesome, that it is not improperly called 'Kill-Devil.'" Another legend tells about a shipwreck near the site that carried a cargo of spirits called Kill Devil Rum. In 1861, a newspaper editor confused an already muddled issue by writing that sailors found navigation in the seas just off the island bad enough to "kill the devil."

Whatever the point or evolution of the name, Kill Devil Hills appeared on a map in 1808, and so it has remained. The Wright brothers chose the site for its height. In 1932, in recognition of their historic feat, a monument was erected on Kill Devil Hill: a monolith of Mount Airy granite that rises sixty feet above the beach. In a rare display of historic symmetry, the area is popular today with hang-gliding enthusiasts.

Nags Head. Nags Head was on the map of North Carolina by 1738 and has been inhabited ever since. It developed early, in the 1830s, as a vacation resort and remains one of the most popular beach resorts on the Outer Banks. Its name is another of the old place-names that has inspired many legends. Actually, there are several locations in England named Nags Head, and the term may simply have been brought over with the language. But the most popular story, and the one most frequently offered to the tourist trade, is that the natives of the area once lured ships to their doom by walking a horse with a lantern under its neck back and forth on the island. The bobbing lantern looked from afar like a ship's light gently rocking on what one would assume to be deep water. The unsuspecting captain, unfamiliar with the waters, would make for the false signal and beach his vessel on the island, only to be looted by the local population.

Like many other bits of folklore, this Nags Head legend has enough foundation to give it some credibility. Pirates did work out of the Outer Banks notably Edward Teach, a.k.a. Blackbeard, who had nefarious dealings with the colony's officials, including its governor, and met his fate near Ocracoke in 1718. And there is at least one documented case of a looting incident: in 1696, the HMS *Hady* was driven ashore between Roanoke and Currituck Inlets, where "the inhabitants robed [*sic*] her and got some of her guns ashore and shot into her sides and disabled her from getting off."

The fact is, scavenging had a long, if not honored, tradition among seaside communities worldwide. And occasionally the line between scavenging and piracy was so thin that only a lawyer could tell the difference. Though the custom of scavenging may seem harsh and barely inside the law, one should remember that the daily life of the Bankers was equally demanding. The islanders considered the flotsam and jetsam of the sea their good fortune—even a blessing from providence—and tried not to think much about the fellow who lost it. Even today there are still houses on the Banks that were built of material scav-

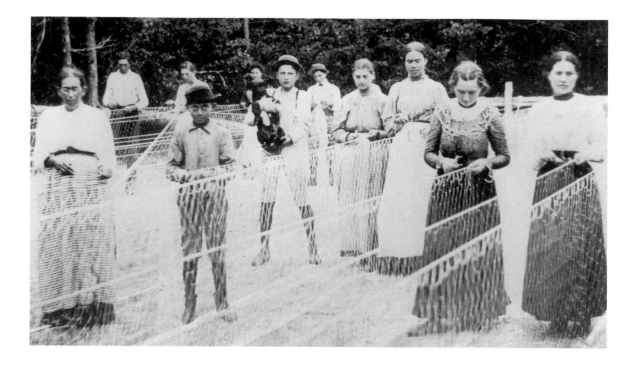

enged from shipwrecks. Elizabeth O'Neal Howard, a local resident of the Banks, told an interviewer in the 1980s that her house was built of lumber taken off the wreck *Nomis,* which broke up in the 1930s.

Whalebone Junction. A native is content to call things as they are: "You know the old gas station down there at the curve that has that whalebone in the yard? Well, you take a left at that junction." And that's how Whalebone Junction got its name. A whale skeleton kept in the gas station owner's yard was the most notable feature of the landscape. The skeleton lives in the name, and the name carries a collective piece of memory for the islanders.

Bodie Island. The next island in the Outer Banks chain, Bodie Island, was granted to Mathew Midgett in the 1720s, and the Midgett name—in one of its many variations—is one

of the most common on the Banks today. The community was part of the lighthouse development in the late nineteenth century. There have been three Bodie lights, the last of which still stands.

Bodie Island also had a U.S. Lifesaving Station; its structure today serves as a facility for the National Park Service. Most of the island is part of the park reserve.

Pea Island. Across Oregon Inlet and running south toward Cape Hatteras is Pea Island, apparently named for its abundance of wild peas, which for generations have attracted Canada geese, snow geese, and ducks. The bounteous waterfowl in turn attracted hunters, who established clubs and harvested the winter resting grounds until about World War II, when the area was declared a National Wildlife Refuge.

Pea Island has the distinction of hosting the state's only lifesaving station that was commanded by a black man. Later it became the only all-black U.S. Coast Guard lifeboat station.

Chicamacomico Banks. Chicamacomico once referred to the northern portion of what is today called Hatteras Island. In the colonial period, Chicamacomico ran from present-day Oregon Inlet to what was designated Kinnakeet Banks. The area was called Hatorask by the Raleigh colonists and on John White's map. Of Indian derivation, this name has been through a dozen different spellings.

In 1861, Chicamacomico was the site of a somewhat humorous engagement between Confederate and Union troops in the Union's first naval invasion of the South. Following the Union capture of Forts Clark and Hatteras, the forts that guarded Hatteras Inlet, the Federals sent an Indiana regiment up the island to hold the Chicamacomico Banks. But Confederates landed on the island and chased the Twentieth Indiana back to their lines at Cape Hatteras Light, whereupon the Federals got reinforcements and then chased the Confederates back up the Banks. The skirmish up and down the Banks was something of a comedic opera in which the weather and accidents played a larger role than military strategy and tactics. The engagement has been dubbed "The Chicamacomico Races."

Chicamacomico was the site of one of the original seven lifesaving stations on the Banks, established in 1874, and its crews were routinely decorated for dramatic rescues. Its most noted save was of the crew of the burning British tanker *Mirlo* during World War I.

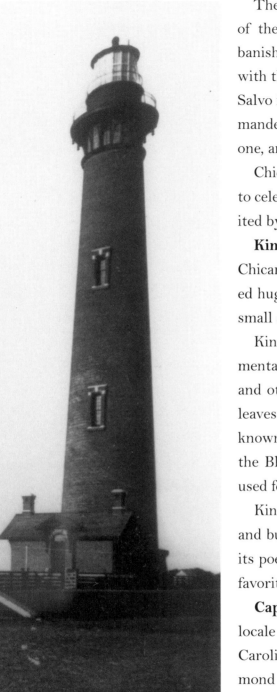

The word "Chicamacomico," apparently beyond the abilities of the postal service personnel to pronounce, was summarily banished in the 1870s, along with "Kinnakeet," and replaced with the less troublesome names Salvo, Rodanthe, and Waves. Salvo is said to have gotten its name from a Union naval commander who asked the village's name, was told it didn't have one, and replied, "Well, give it a salvo anyway."

Chicamacomico may be the last location on the East Coast to celebrate Old Christmas: on January 5, the villagers are visited by Old Buck, an apparition who wears a bull's head.

Kinnakeet Banks. Originally, Kinnakeet Banks ran from Chicamacomico to Cape Hatteras. The stretch of island boasted huge tracts of live oak and red cedar, which gave rise to a small shipbuilding industry.

Kinnakeet was also blessed with an abundance of the ornamental shrub called yaupon holly. The Corees and Poteskeets and other Indian tribes of coastal North Carolina cured the leaves of the plant and boiled them to produce a tealike liquid known as the Black Drink. Much like tea among the English, the Black Drink was used as a social stimulant. It was also used for medicinal and ceremonial purposes.

Kinnakeet had one of the original lifesaving stations in 1874 and built a second station at Big Kinnakeet in 1879. In 1883, its poetic Indian name was changed to Avon. The area was a favorite with hunt clubs in the 1930s.

Cape Hatteras. Cape Hatteras is perhaps the most famous locale on the Outer Banks. The easternmost point of North Carolina, Hatteras is the lookout point over the fearful Diamond Shoals, heart of the Graveyard of the Atlantic. The northward thrust of the warm Gulf Stream and the southward

push of the cold Labrador Current collide just off Cape Hatteras to create one of the most difficult and unpredictable water routes on the East Coast. Unstable weather patterns, shoal waters, and shifting sandbars create a volatile area that has claimed hundreds of ships and lives.

The Gulf Stream meanders northward at about four miles per hour, a serious hindrance to sailing vessels moving south. Unless the vessel has a strong wind behind it, little headway can be made against the current. Before steam engines, maritime traffic moving south on the Gulf Stream route had little choice but to travel into the Atlantic beyond the current or to sail in a narrow corridor between the Stream and the Outer Banks. Hugging the shore was tricky business even in favorable winds and often deadly in contrary winds and seas.

After the Civil War, Major W. S. Stanton made a survey of Ocracoke and Hatteras Inlets for the Army Corps of Engineers. He cautioned against making improvements at Ocracoke Inlet, because maritime traffic using the inlet and turning north would have to round Cape Hatteras and would "incur the dangers of the perilous shoals off the cape, . . . noted as being worse and more dreaded than any other part of the Atlantic Coast."

The major wrote of a lumber freighter from Norfolk bound for Pamlico Sound that was stalled off Hatteras for fifteen days. The captain of the vessel finally gave up, sailed back to Hampton Roads, and reached Pamlico Sound by navigating the Chesapeake and Atlantic canals. After securing his cargo, he sailed through Ocracoke Inlet and rounded Cape Hatteras to find the same ships he had left days earlier still waiting for a favorable wind.

When the naturalist H. H. Brimley visited Cape Hatteras in 1903, he counted twenty-one vessels—three- and four-masted schooners—dead in the waters and unable to round Diamond Shoals due to prevailing southerly winds. The ships had been beating back and forth for days waiting for a favorable wind.

When Brimley asked a local resident about the situation off Hatteras, the man reported that he had counted fifty-three vessels in a similar holding pattern just the previous month. And a surfman with the Lifesaving Service reported that during the previous year he had counted 105 vessels held just north of the Cape for twenty-six days.

Hatteras, then, was a logical location for a lifesaving station and a world-famous light-

house. The U.S. Coast Guard still maintains a station there today.

The town of Hatteras is not to be confused with the Cape, known locally as Cape Point. The town is located some ten miles southwest of the Cape and is one of the largest communities on the Banks.

Hatteras Island was the scene of considerable Union activity during the Civil War. When Forts Clark and Hatteras were captured in the Union's first naval invasion, the island was overrun with Federals; they built a large camp, Fort Wool, just south of the town. After the war, the village relied heavily on its lifesaving station for employment. It also hosted a U.S. Weather Station.

Ocracoke. On the John White map of 1585, Ocracoke Island is designated as "Wokokon." The island begins at Hatteras Inlet and stretches to Ocracoke Inlet, which separates it from the island of Portsmouth. The word "Ocracoke" has also been subjected to various spellings over the centuries.

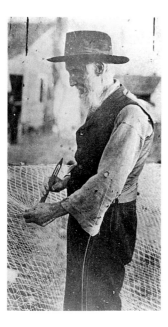

Ocracoke Inlet is one of only three inlets along the Outer Banks that has remained open continuously since before the Roanoke voyages. Raleigh's expeditions sailed through the inlet and charted its waters. Its importance was recognized in 1715 by the North Carolina Assembly, which designated the island as a site for harbor pilots. For that reason, the place was initially called Pilot Town.

Ocracoke was a gaping hole in the British naval blockade during the Revolutionary War. An uninterrupted trade in goods and munitions came over the bar at Ocracoke Inlet, crossed the Pamlico Sound to Washington (N.C.), New Bern, and Edenton, and went up the wagon roads to Valley Forge.

Royal Governor Josiah Martin complained in 1778 that "The contemptible Port of Ocracoke has become a great channel of sympathy to the Rebels while the more considerable ports of the Continent have been watched by the King's ships."

In 1795, Jonathan Price described the village as abounding in live oak and cedar and rich marshes that rendered it suitable for farming. But instead the population, which he numbered at thirty families, chose to make their livelihoods from the sea. The men were mostly ship's pilots.

Ocracoke was a healthy place, according to Price—so healthy that mainlanders used the island as a resort in the fall. He noted that one of the village's ninety-year-old residents "did not appear to feel any of the infirmities of the age."

Ocracoke is also the final resting place of four British sailors who washed ashore in 1942 after their trawler was torpedoed by a German submarine. A British naval attaché visits the small white-fenced cemetery each year to lay a wreath and fire a volley over the graves. A plaque on the fence quotes lines from a poem by Rupert Brooke:

> If I should die, think only this of me:
> That there's some corner of a foreign field
> That is forever England.

Ocracoke has a permanent population of about 650 people, and most of the island belongs to the National Park Service.

Shell Castle Island. Villages along the Outer Banks tended to develop nearest the deepest channels and inlets. As nature opened and closed these water routes, populations moved to take advantage of the changes.

In 1789, John Wallace of Portsmouth Village and John Gray Blount of Washington, N.C., received a state grant for five islands just inside Ocracoke Inlet. Blount was the owner of a large shipping business based in Washington, N.C. Much of his trade, like that of most Carolina shippers, was with the West Indies. The major obstacle for his profitable business was getting his goods in and out of the Pamlico River and across the bar at Ocracoke. A lightering port at the inlet would enable him to collect and store goods from ocean-going ships and transfer them across the sound in smaller boats.

Table 1. Populations of Outer Banks Townships, 1870–1940

	1870	1880	1890	1900	1910	1920	1930	1940
Portsmouth	341	222	204	150	182	143	104	42
Ocracoke	368	400	466	548	565	587	547	525
Hatteras	673	821	906	987	1,041	1,115	1,132	1,201
Kinnakeet	599	631	793	842	644	712	663	806
Nags Head	1,000	1,104	1,296	1,884	2,069	1,881	1,949	2,547

So the partners used the grant money to create a lightering hub on a half-mile stretch of oyster beds called Old Rock, which was only sixty feet wide and lay within sight of Ocracoke. They changed the name of the island to Shell Castle and erected warehouses, docks, a gristmill and windmill, a ship's store and chandlery, and even a lighthouse.

Shell Castle worked as predicted, and the two men built a thriving complex that once housed forty people just to handle the maritime traffic. Other merchants and mariners took advantage of the facilities, and business boomed. Blount supplied the trade, and Wallace, familiar with the waters and the island natives, handled daily operations. Because of his swagger and heavy-handed manner, he was called "Governor" Wallace.

But nature would have its way. Storms and shoaling of the channel accomplished what competitors could not, and the little oyster rock today carries not a vestige of the huge maritime operation that once was Governor Wallace's preserve.

Portsmouth Island. The island of Portsmouth, just south of Ocracoke Inlet, began life in much the same way that other Outer Banks lands did: Virginia renegades, shipwreck victims,

and wayward sailors found a home there. The property first appeared in the records in 1675, and it grew to be the largest seaport between Norfolk and Charleston.

The village of Portsmouth was a lightering port for the transshipment of goods from ships to the mainland. Most of its male inhabitants worked at piloting.

By 1753, trade with the island was so considerable that the village was chartered by the General Assembly and a fifty-acre site was laid out for a town. The Public Health Service established a hospital on the island in 1828, and a U.S. Marine Hospital opened in 1847.

Nature, the dominant force on the barrier islands, dealt Portsmouth and Ocracoke a bad hand in 1846 in the form of a violent hurricane. The storm not only wreaked its usual havoc with houses and boats, the islanders' lifelines; it also changed the natural geography of the area by shoaling Portsmouth Inlet and opening Hatteras and Oregon Inlets.

The Civil War practically evacuated the village, and though residents returned after the war, the population had shrunk to half of its prewar level. In 1867, in further recognition of the town's demise, Portsmouth's customshouse was moved to New Bern. Fishing and whaling remained the major occupations.

The U.S. Army Signal Corps opened a weather bureau station in the village in 1876, but the station brought no prosperity to the town, which had dwindled to forty-five houses and a population of 222. In 1894, a U.S. Lifesaving Service station was opened that employed a dozen men for cash wages, and the town held onto hopes for the future. There were seventy-five children enrolled in school. But the San Ciriaco storm that savaged Shackleford Banks also severely damaged Portsmouth, and many residents joined the general migration to the mainland. By 1903 there were only sixty people left in the village.

Nature continued her indifferent care of the island during the twentieth century. A hurricane in 1933 destroyed oyster beds, a supplemental source of income. Technology conspired to do its part as well. Ships powered with fossil fuel were not as vulnerable to the whims of nature, and the Graveyard of the Atlantic claimed fewer vessels. Consequently, a Coast Guard station at the village was closed in 1937.

By the 1950s, only thirteen people remained at the village, and they would remain there as lifelong residents. The state bought up most of the land on Core Banks from Ports-

Map 3. Shackleford Banks, 1850–1890 (adapted from a map by Connie Mason, 1987)

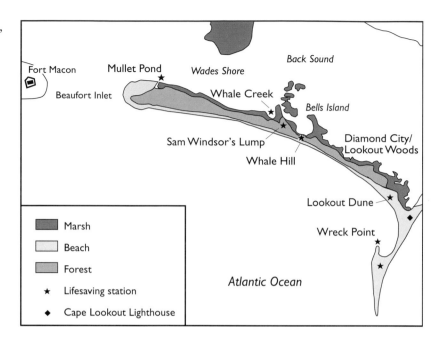

mouth to Cape Lookout and Shackleford Banks in the 1970s and donated it to the National Park Service in 1976.

Cape Lookout. Cape Lookout stands as a lonesome sentinel at the southernmost point of the Banks before they make a dramatic westward turn and develop an east-west orientation. The point was designated "Promontorium tremendum" on DeBry's 1590 engraving of John White's map of the Outer Banks.

The island was used by early setters as a whaling lookout for the on-shore whaling operations there and at Shackleford Banks. A snug bight located just inside the bay at Lookout was used as a haven by mariners of many nations, including Spanish pirates and privateers.

A lighthouse of novel construction—it featured a brick tower inside a frame exterior tower painted with red and white stripes —was erected about the time of the War of 1812. A new tower

was constructed in 1859. With its new, efficient Fresnel lens, this lighthouse became the model for later lighthouses on the Banks.

The island got its lifesaving station in the 1880s, and the station's successor, a U.S. Coast Guard office, remained on the island until the 1970s.

Shackleford Banks

John Shackleford acquired the narrow spit of island known as Shackleford Banks, which runs east to west from the tip of Cape Lookout to Beaufort Inlet, at an opportune moment—about the same time that New England whalers were discovering the lucrative Hatteras whaling grounds.

Settlers dotted the narrow island from Cape Lookout point, with which it once connected, to the western end, which paralleled the Beaufort waterfront. The community of Wade's Shore or Mullet Shore anchored the western end of the island, and Lookout Woods dominated the eastern end. In between, there were clusters of families at Guthrie's Lump and Winsor's Lump.

In 1885, Lookout Woods took the name Diamond City, after the black and white diamond design of the 150-foot Lookout lighthouse, which cast its shadow over the community. Before the terrible storms of 1898 and 1899 drove its residents to higher ground, the island boasted a population of several hundred.

The descendants of Shackleford are found in large numbers today on Harkers Island, on Bogue Banks, and in Morehead City. They are the Guthries, the Roses, the Yeomans, the Salters, and the Hancocks. The Willises, the Nixons, and the Styrons lived there as well.

The islanders fished, gardened and, of course, pursued whales. There were two schools, a church, and a "porpoise factory" on the island.

Today there are no structures left on Shackleford Banks. The islanders had known storms and hurricanes from the beginning, but a monumental hurricane in 1899 (the San Ciriaco) completely washed over the island, flooding gardens, cemeteries, and houses. The entire community surrendered and moved wholesale to Harkers Island, Salter Path, and an area of Morehead City called the Promised Land.

Alida Willis has written that the sight of the Bankers floating their dismantled houses across the sound on sailskiffs to rebuild in Morehead City inspired a local resident to remark, "There go the Israelites on their way to the Promised Land." The characterization stuck, and the neighborhood around Twelfth Street in Morehead City is still called the Promised Land.

The exodus continued for two years, until 1902, when there was not a house or person left on the island. Though the natives visited Shackleford regularly to fish or reminisce—they do so to this day—it would never again know the sense of community that had sustained it for some two hundred years.

The Outer Banks and their people retained a special aura for centuries, in part because their culture always dragged a decade or two behind the state and the nation in the rush to embrace "progress" and "modernization." That is not to say that Bankers have been backward or even provincial. They have always adapted to their environment, to newcomers, and to newfangled ideas. But their acceptance has been grudging. They have not been in such an all-fired rush to get to where the rest of the states seemed to be careening helter-skelter.

Bankers have always understood the impermanence and the vicissitudes of life, a lesson hammered into them daily by the uncertainties of coastal weather and waters. They have incorporated these burdens into their lore and language, have embraced them in the sure recognition that they cannot defeat them.

An Overview of the Outer Banks

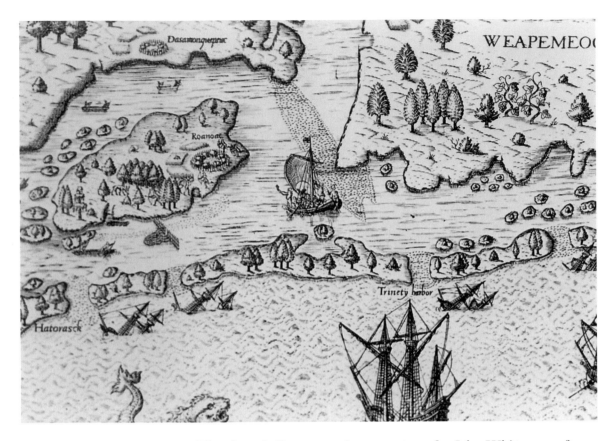

Theodore de Bry engraving, ca. 1590, of a John White map of the northern section of the Outer Banks. White, the second governor of Walter Raleigh's Roanoke Colony, provided the first detailed images of the Banks. This one includes Roanoke Island, several inlets, a palisade fort, and two Indian villages. The drawing also shows a fishing weir, a ship's boat in the sound, and several wrecks. The information gathered by White during his sojourn along the Banks proved invaluable to the company that settled Jamestown two decades later. (North Carolina Collection, University of North Carolina at Chapel Hill)

Above. A grand house at Currituck, ca. 1925. This house, built in 1827 on Currituck Sound, was rather atypical in size and in its elaborate architectural detail. (Photograph by Mary G. Canfield, courtesy of the North Carolina Collection, University of North Carolina at Chapel Hill)

Scenes of Currituck, ca. 1862. Vernacular boats, a windmill, and other placid scenes in Currituck County belie the destruction by Union forces, depicted in the bottom frames of these drawings. (From Charles Johnson's *Long Roll*, courtesy of the North Carolina Collection, University of North Carolina at Chapel Hill)

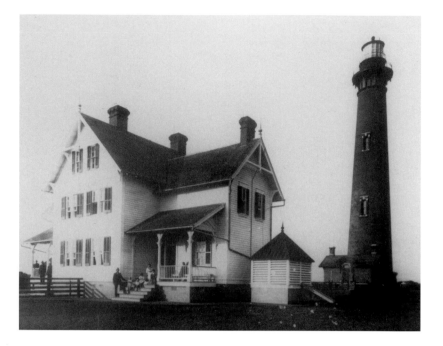

Currituck Lighthouse, ca. 1890. The tower was started in 1872 and completed in 1875. The natural, unpainted brick exterior distinguishes this lighthouse—the state's northernmost—from other lights on the Banks. (North Carolina Maritime Museum)

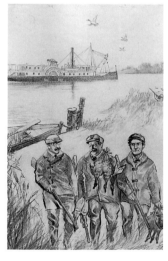

Duck hunting on Currituck Sound. The Outer Banks became a popular recreation area for sport hunters after the Civil War. The sometimes elaborate gun clubs attracted the wealthy and the well-known among industrialists and celebrities. This drawing shows (from left) Pierce Hampton, Grover Cleveland, and Joseph Jefferson returning from the waterfowl hunt. The hunt clubs—which needed cooks, maintenance workers, and guides—created salaried jobs for the local population. (Drawing by Norman E. Jennett in *Editor in Politics*, courtesy of the North Carolina Collection, University of North Carolina at Chapel Hill)

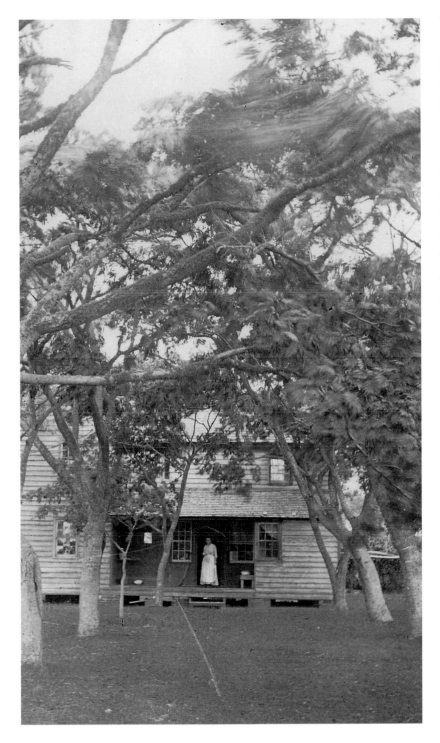

"Meekins Anchorage," ca. 1910. Daniel Meekins's house on the western side of Roanoke Island was built in the 1830s. The two-story clapboard I-house, bereft of stylistic flourishes and adornments, sits in a grove of windswept mimosa. (Victor Meekins Collection, North Carolina Outer Banks History Center)

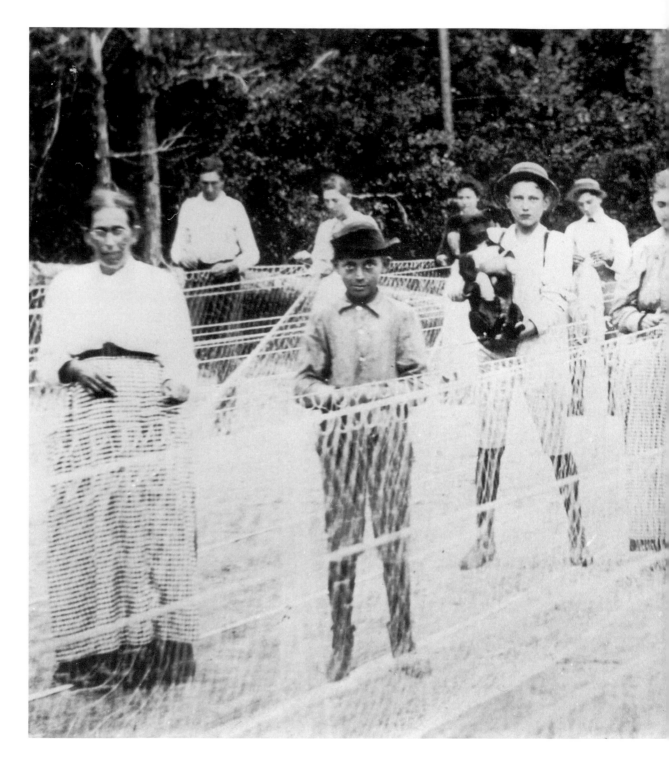

22

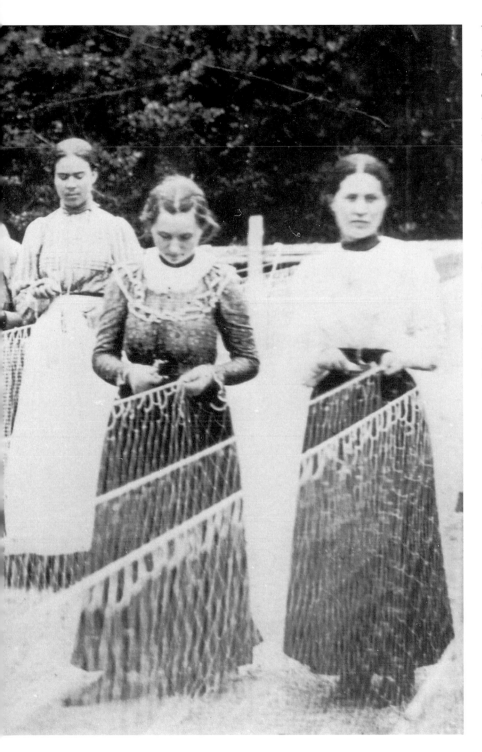

Women and young boys mending nets at Manteo, ca. 1900. The traditional coastal occupations, such as boatbuilding and net making, underwent a dramatic change after the Civil War: cottage industries were harnessed and regimented to meet the demands of large commercial fisheries. (Photograph by W. H. Zoeller, courtesy of the North Carolina Collection, University of North Carolina at Chapel Hill)

23

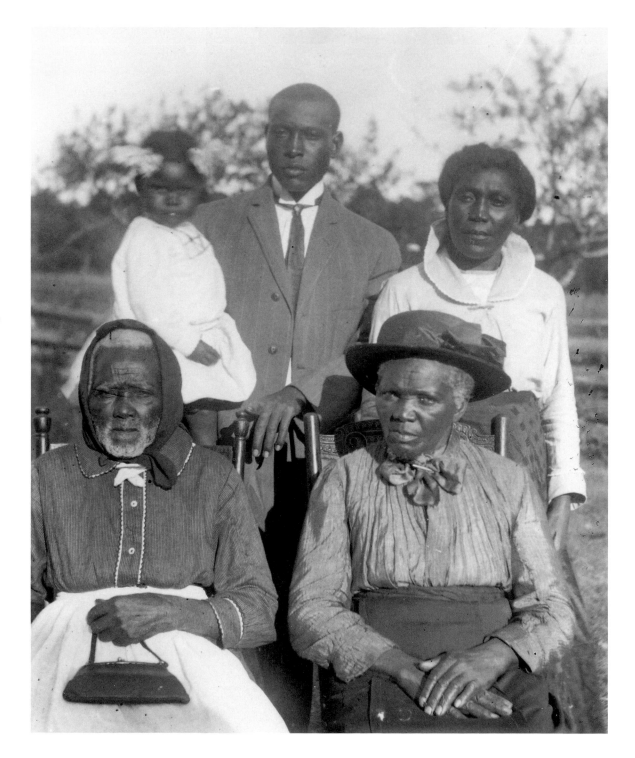

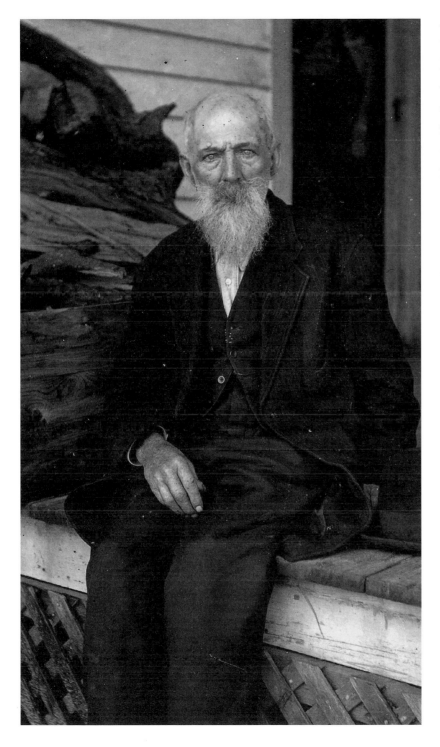

Facing page. Four generations of Barbers from Roanoke Island's ethnic community at North End, ca. 1915. The Barber family may be descendants of the Civil War freedmen's community that General Burnside opened on Roanoke Island in 1862. (Victor Meekins Collection, North Carolina Outer Banks History Center)

Left. Daniel Meekins, a senior citizen of Roanoke Island, ca. 1915. A man who survived the Civil War and may have fought in it, Meekins witnessed some dramatic changes on the Banks in his lifetime. He does not look like one to have accepted them without comment. (Victor Meekins Collection, North Carolina Outer Banks History Center)

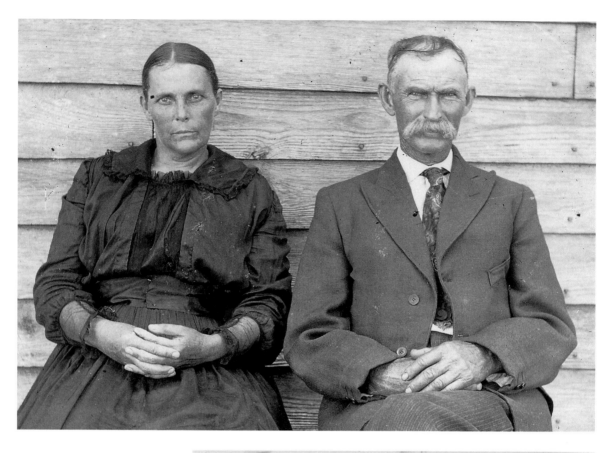

26

Facing page, top. Winnie and Charles Meekins at their homeplace (called the Anchorage), ca. 1915. Bankers were a sturdy and self-sufficient lot. Life could be austere, and frivolity did not curry much favor. (Victor Meekins Collection, North Carolina Outer Banks History Center)

Facing page, bottom. The simple dignity and austere domiciles of the Outer Banks are well represented in this photograph of Mr. and Mrs. James W. Hobbs of Kitty Hawk. The photograph was taken by the Wright brothers, who were friends of the Hobbses. (National Park Service)

Below. Local fishermen were employed as guides for northerners who returned to the Banks after the Civil War to hunt and fish. Paying jobs were scarce on the Banks, and guides earned a respectable supplement to their fishing income. (North Carolina Collection, University of North Carolina at Chapel Hill)

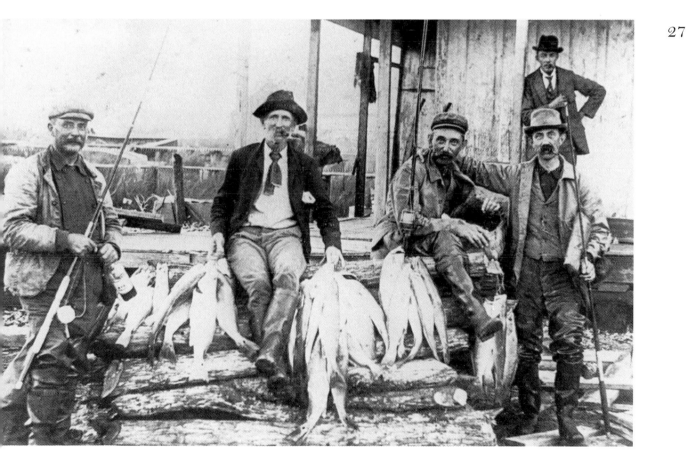

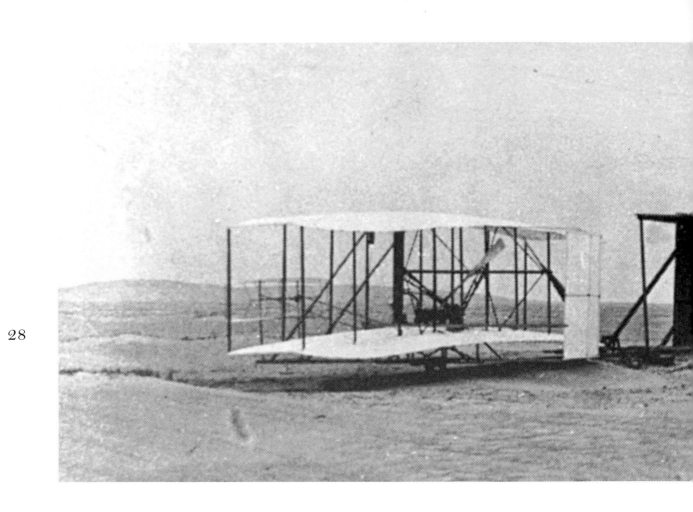

28

The Wright brothers' camp at Kill Devil Hill, 1903. The brothers complained constantly of mosquitoes and sand, but the Banks offered optimum winds for their experimental flights. Several of the local population worked closely with the Wrights on their newfangled gliders. (North Carolina Division of Archives and History)

The Wright brothers, Wilbur and Orville, urbane and learned men, were not prepared for the austerity of the Outer Banks and the area's harsh climate. They are seated here on the porch of their home in Dayton, Ohio, where they worked as bicycle mechanics. (National Park Service)

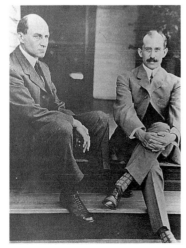

Life on the Outer Banks

The residents of the Outer Banks were products of their age and typically followed the broad social trends of the eastern seaboard, even though they came upon those trends somewhat later than their counterparts on the mainland did. Today, Bankers reflect the American mainstream in their politics, religion, and leisure pursuits.

In the early, unfettered days of the eighteenth century, however, the inhabitants tended to be what Methodist Francis Asbury called "gospel slighters," who favored gaming and drinking regardless of the day of the week. Reverend John Urmston was less kind: he described the region's early settlers as "A nest of the most notorius profligates upon earth." Urmston's harshness reflected his frustration with winning the Banks' residents to the Church of England, a cause that suffered as relations with the mother country worsened and that was finally buried with the American Revolution.

The islanders were equally independent and solitary in their approaches to schooling, work, and social intercourse. They tended to function as individuals, resisted formal organizations, and came together only in times of need or by personal whim.

The Great Awakening that swept through the state after 1800 made inroads along the Banks and found converts in its scattered communities. Protestant religious crusaders, with their fire-and-brimstone sermons, laying on of hands, and speaking in tongues, had a strong emotional appeal for the common folk of the Banks.

The Methodist Society was especially aggressive on the Outer Banks. Two of its representatives were Joseph Pilmore and the Reverend J. Atkinson. Pilmore was working the Currituck region as early as 1772, and Atkinson worked Ocracoke and Portsmouth

in the 1820s. By the 1850s, the Methodist converts on the islands were debating slavery and the other divisive issues that led to the Civil War. As a result of the war, the Methodists separated into northern and southern branches that remained separate into the 1940s.

Schooling on the islands was even less organized. Lessons were offered primarily through private tutors. Parents either pooled their money to hire a teacher or individually paid a set fee for a tutor. School terms were short and irregular, depending on the availability of money and the start of the fishing season.

John Rolinson taught a four-month term at Hatteras Village in 1847. He charged $2.50 per student. The rest of the year he fished with everyone else. During the summers, Tom Arendel traveled from the mainland by boat to Wade's Hammock on Shackleford Banks to teach a two-month semester. His fee was $20 per month.

All school sessions were held in the homes of residents or in simple one-room structures, usually through the sixth or eighth grade. The grades all shared a single teacher. J. W. Mason of Hunting Quarters (now Atlantic) recalled studying his numbers and ABCs with Jim Giles in an abandoned kitchen and then attending a one-room school at Smyrna. Students who aspired to high school had to board at a school on the mainland.

Outer Banks housing reflected the elemental but often harsh and demanding nature of life on the islands; the Bankers built and lived in relative simple but sturdy frame houses without embellishment. The typical one-story coastal cottage that dots the islands has two or four rooms and a high-pitched roof that slopes steeply at the rear. Over the years the residents would add a detached kitchen and perhaps a porch. These houses were inexpensive and easy to construct and could be moved in case of high water. A variation on the cottage was a one-story house with a usable attic, sometimes called a "jump-and-a-half."

Two-story houses were variations of the simple country I-house, with two rooms downstairs, two rooms upstairs, and a center hall. These were altered and added to during the late nineteenth and early twentieth centuries, but their basic features remained unchanged and unadorned.

The houses were usually built of pine, but scavenged timber from shipwrecks occasionally determined the building material. It is not unheard-of to find a house constructed from shipping

crates that washed ashore from a shipwreck. Most of the structures were covered with roof shingles of cypress or juniper.

The dwellings were unpretentious, built with an economy of labor and material. There was no inside plaster or even outside paint until late in the nineteenth century. Furniture was sparse and utilitarian, and decorative pieces such as wall paintings and samplers were scarce. A single fireplace served for both heating and cooking. The houses on the Banks today all date from the nineteenth and twentieth centuries; no eighteenth-century dwellings remain.

Many of the island homes had removable floorboards that allowed high water to wash through during the not-infrequent storms. Otherwise, the houses would (and many did) simply lift from their foundations and float away. "Big Ike" O'Neal of Ocracoke has related that during the Storm of 1899, his father chopped a hole in the floor to relieve the water pressure under their house. The water shot up through the floor, bringing with it a trapped duck.

Most of the houses and other structures were built on the sound side of the islands. It would have been considered the height of foolishness to build on the ocean side, as people do today. The islanders depended on high dunes and vegetation as a break and buffer from ocean storms.

Houses on the barrier islands did not have yards as we know them until the twentieth century. The land on which houses were built simply became part of the general landscape by joining a dune or a sandy path or by fading into a marsh or wooded area. The lots generally held no flowers or yard ornaments, and houses were often nestled under great spreading live oaks for shade.

The Bankers were creative in making the most of their meager resources. Kinnakeet Banks had an abundance of live oak and red cedar, which nurtured a lively boatbuilding industry; in addition, the area had an abundance of yaupon holly, from which it built up a respectable cottage industry of yaupon tea.

The yaupon gave up a tealike liquid that had been used by the islands' Corees and Poteskeets as a sacred drink for rituals and ceremonies. The plant has properties very similar to those of Asian tea and American coffee, including caffeine. When consumed in copious amounts, it acts as an emetic and was thus employed by Indians as an internal cleansing agent.

European settlers quickly learned the art of brewing yaupon and used it as a tea substitute. Kinnakeet became the yaupon-producing region of the Outer Banks and even exported the

product for foreign consumption. Records document that the tea was shipped to Philadelphia as late as 1840.

The yaupon forest could not last forever, and its disappearance coincided with a shift in American tastes toward South American coffee. But the plant was called on again and again when turbulent times disrupted shipping lanes and money was scarce. It was used during the Civil War, World War I, and the Great Depression and was consumed on the islands as late as World War II.

Limited movement to and from the Outer Banks kept family names and place-names intact for generations. It was only after the Civil War, when the area experienced an influx of outsiders, that some of the old Indian names like Chicamacomico and Kinnakeet were replaced with "pronounceable" names.

As in most small and out-of-the-way communities, certain family names dominated the islands. Shackleford and Core Banks contained the Hancocks, Guthries, Willises, Wades, and Gillikins. When those families quit the islands in 1899, the names moved with them to Harkers Island, Morehead City, and Salter Path. On Ocracoke, the Wahabs, Howards, Gaskins, and O'Neals are descended from eighteenth-century island stock. Hatteras had its Styrons, Scarboroughs, Rolinsons, and Stowes, and so on up the Banks. The paucity of new blood on the islands led to a stacking of family names: one may yet encounter an Annie Guthrie Guthrie or an Ethel Gaskill Gillikin.

The people who inhabited the Outer Banks were reared in a no-nonsense environment dominated by unpredictable natural forces. Frivolity did not curry much favor in a land where storms casually claimed lives and houses were routinely swept away.

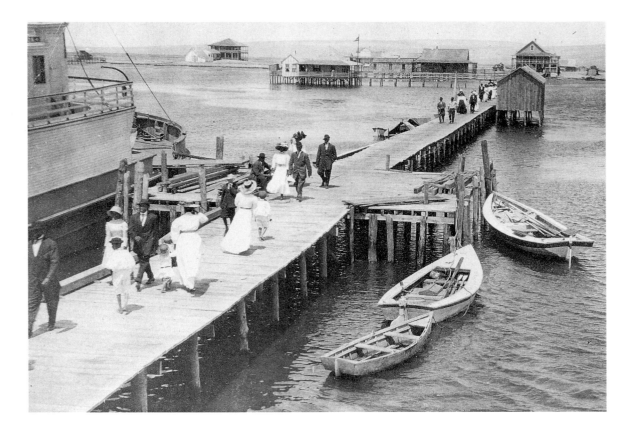

34

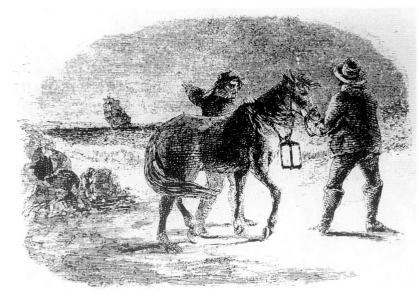

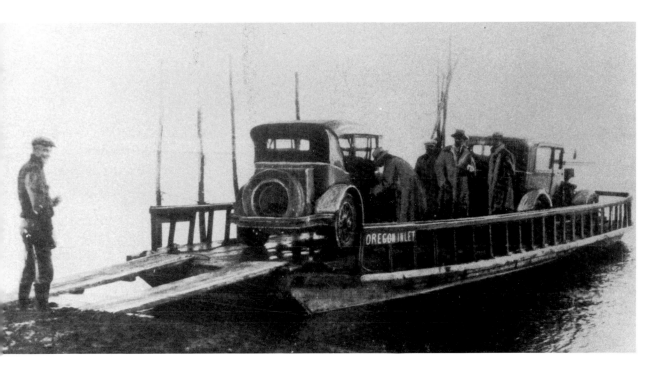

Crossing Oregon Inlet by ferry, ca. 1930. The Outer Banks have been a summer resort for mainlanders since before the Civil War. Others used the outer islands for free grazing land, hunting, and fishing. Hunt and gun clubs were especially popular after the turn of the century, and new transportation systems were created to accommodate the growing traffic. (National Park Service)

Facing page, top. Nags Head tourists promenade along the boardwalk in their summer fashions, ca. 1890s. The community beach resort has hosted mainland vacationers since the 1830s. (North Carolina Collection, University of North Carolina at Chapel Hill)

Facing page, bottom. The legend of Nags Head residents luring ships to their destruction in order to plunder them has endured for generations, despite its dubious origins. So has the name Nags Head, which appeared on maps as early as 1738. The name can also be found in England and the West Indies. (National Park Service)

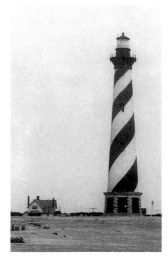

Cape Hatteras Light-house, ca. 1905. This lighthouse, the most famous one on the Outer Banks, is actually the second light in this location and was built between the years 1868 and 1870. When it was completed, it was touted as the "most substantial" lighthouse in the world. Having survived storms and the Civil War, the light is now seriously threatened by beach erosion. (North Carolina Division of Archives and History)

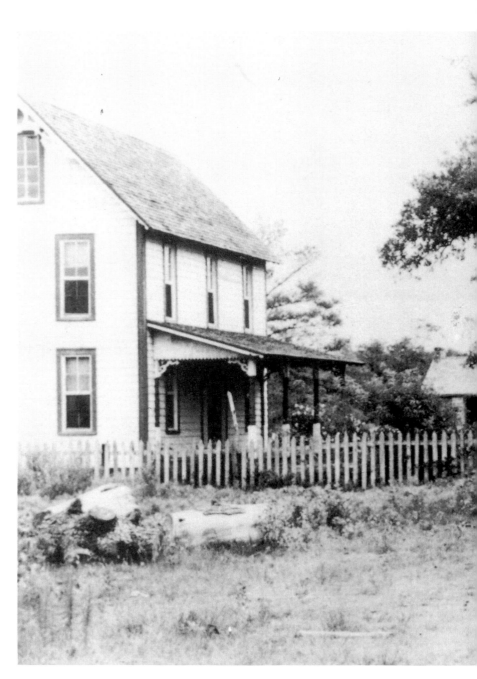

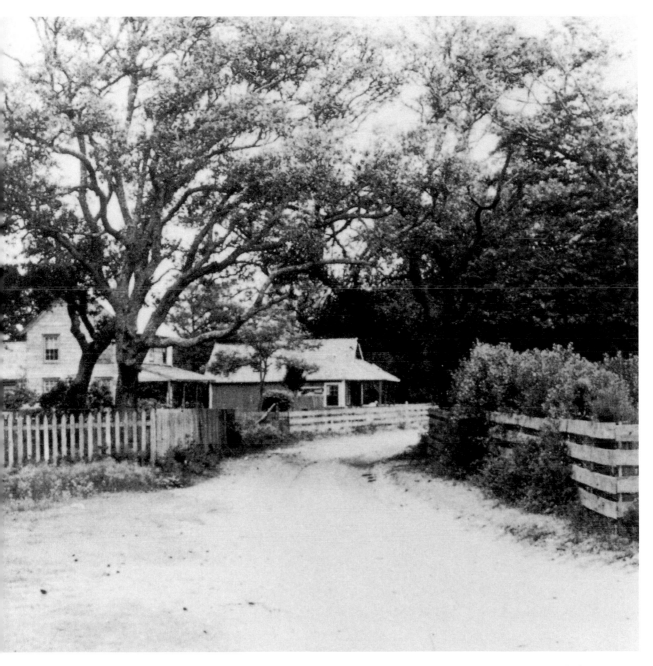

Main street of Frisco, formerly Trent Woods, home of John Rolinson, ca. 1910. Until the twentieth century, all houses on the Outer Banks were built on the sound side of the islands for protection from ocean storms. (Cape Hatteras National Seashore, National Park Service)

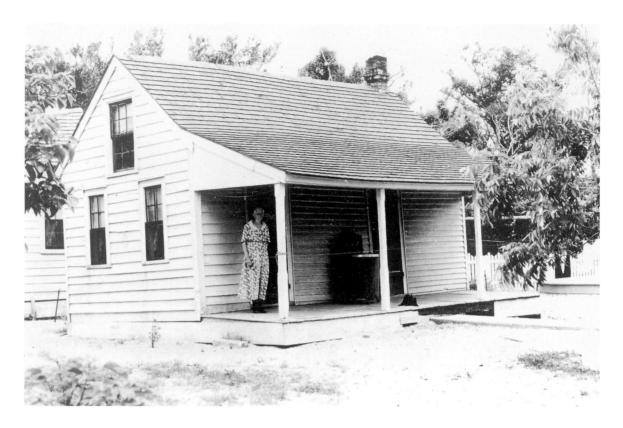

A story-and-a-half Hatteras house that has been painted in the twentieth-century fashion. This domicile has a yard, but many properties on the Banks simply joined the landscape without the interruption of a border. (Cape Lookout National Seashore, National Park Service)

Facing page, top. Hogshead for sweating yaupon, Trent Woods on Hatteras Island, ca. 1904. An elderly man named Mark stands beside a hollow cypress log used to "sweat" yaupon holly leaves to make a home-brewed tea. This tea was considered sacred by the indigenous population, whose members used it in tribal ceremonies. Americans adopted the drink and drank it instead of imported tea when times were hard. (Photograph by H. H. Brimley, courtesy of the North Carolina Division of Archives and History)

Facing page, bottom. Yaupon trough in Trent Woods, 1904. Mark, the same man shown in the previous photograph, stands beside a straining trough through which sweated yaupon liquid was poured into casks for storage. (Photograph by H. H. Brimley, courtesy of the North Carolina Division of Archives and History)

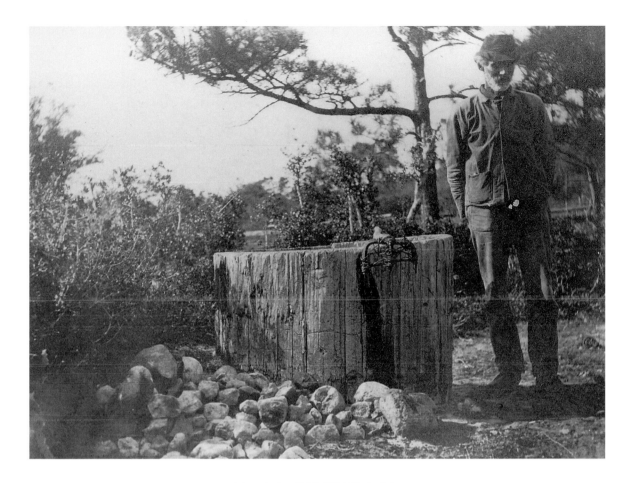

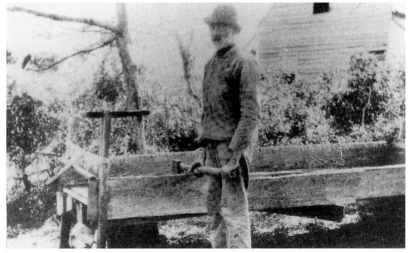

Bankers use a small sailskiff to move their cattle to new grazing grounds. Cattle, sheep, swine, and horses were left to graze free on the Outer Banks. They were rounded up yearly to be dipped against infestation and branded. (Undated photograph, courtesy of the National Park Service)

40

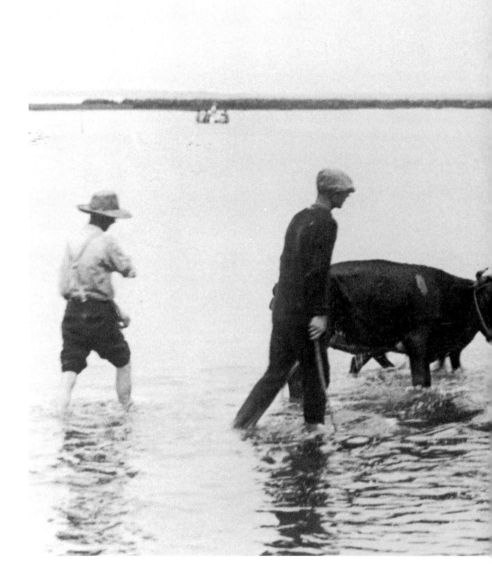

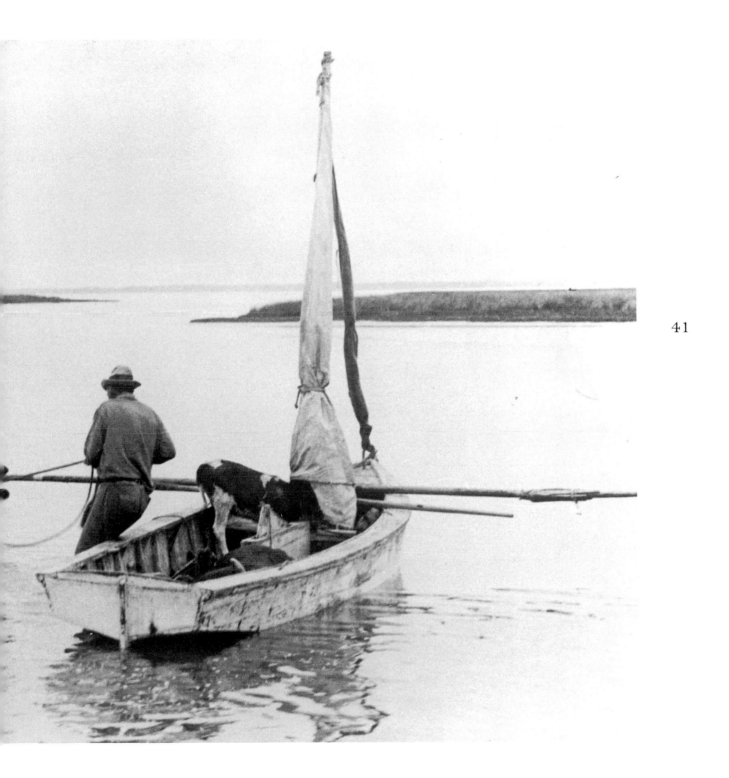

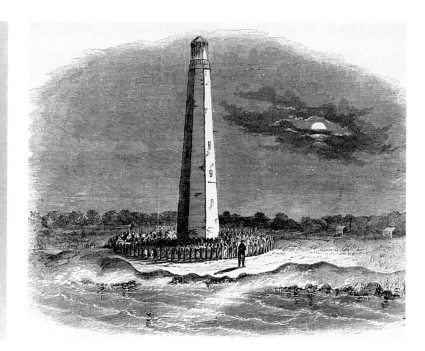

IN MEMERY
of luivisa ON
EAL was born
d december
20 1804 died
JAN 25 1862
A 855 7 ym 5 d

IN sure and eted
fast hope to ree
AND claim her
mansion in the
sky her flesh
laid down the
cross exchangd
for a crown

42

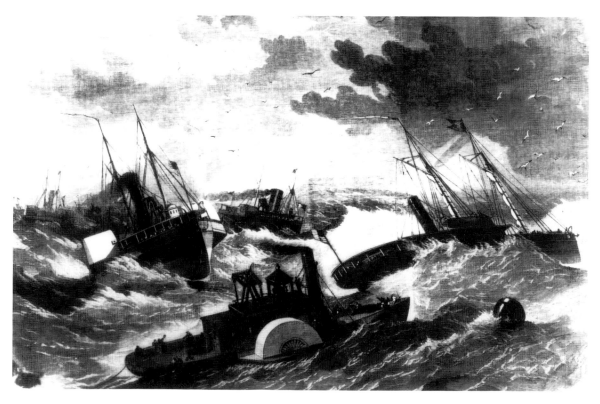

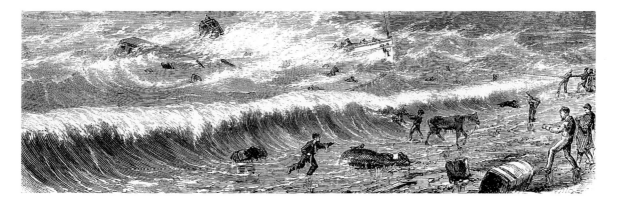

The steamer *Pocahontas* goes down in Hatteras Inlet, throwing men and horses into the breakers. This passage was part of the Union's Burnside Expedition against the Outer Banks, which took place in January 1862. Unpredictable weather played a greater role in the amphibious assault than military strategy did. (From an engraving, courtesy of the North Carolina Collection, University of North Carolina at Chapel Hill)

Facing page, top left. Facsimile of a gravestone on Hatteras Island for Louisa O'Neal (1804–62). Her epitaph uses the language of the Protestant revivals that came to the Outer Banks after 1800. (Pen-and-ink drawing by Edwin Champney, 1862, courtesy of the North Carolina Outer Banks History Center)

Facing page, top right. The Twentieth Indiana encamped around the old Cape Hatteras Light after a harrowing retreat down Chicamacomico Banks from the pursuing Third Georgia. The Twentieth then secured reinforcements and chased the Georgians back up the island. Charles Johnson of the Ninth New York described the escapade in his book *The Long Roll*: "We stopped long enough at the Light House to rest our men and for me to get my fill of grapes, which were splendid. I got a sketch of the Light House, but I did not feel able to travel an extra mile or two to ascend, though I very much wanted to. The only thing I have in my sketch-book beside the Light, is a vine-covered cluster of trees grown in the shape of a little Gothic church." (From an engraving dated October 1861, courtesy of the North Carolina Collection, University of North Carolina at Chapel Hill)

Facing page, bottom. The U.S.S. *Picket*, leading Burnside Expedition ships over the bar at Hatteras Inlet. Used by privateers who knew the waters to raid Northern shipping, the inlet was a stranger to the Union navy and constantly challenged its invasion attempts. (From *The Civil War in America*, courtesy of the North Carolina Collection, University of North Carolina at Chapel Hill)

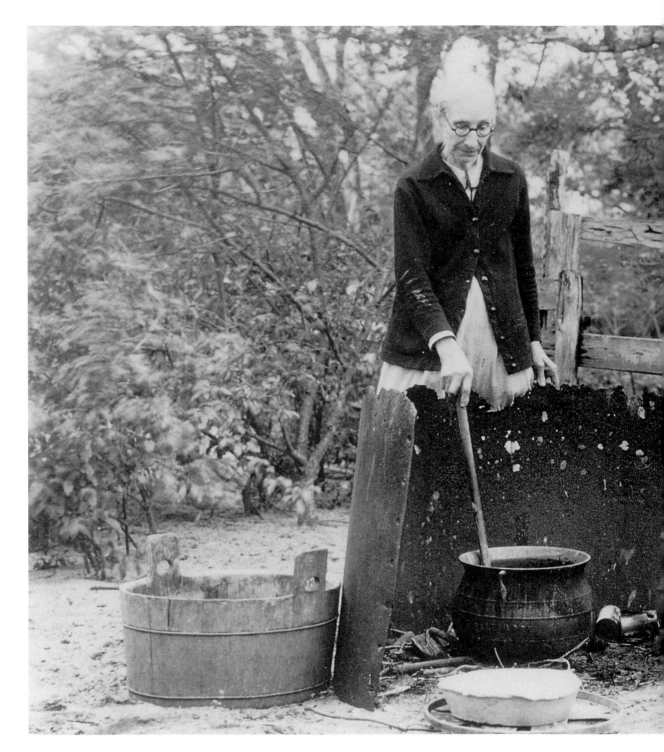

Independent and resilient, Bankers have made do with the natural resources of the island for centuries. This elderly woman on Hatteras Island lived life much as her ancestors did and her children would. (Undated photograph, courtesy of the National Park Service)

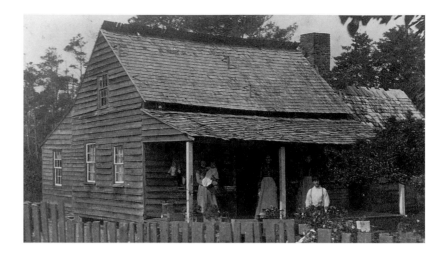

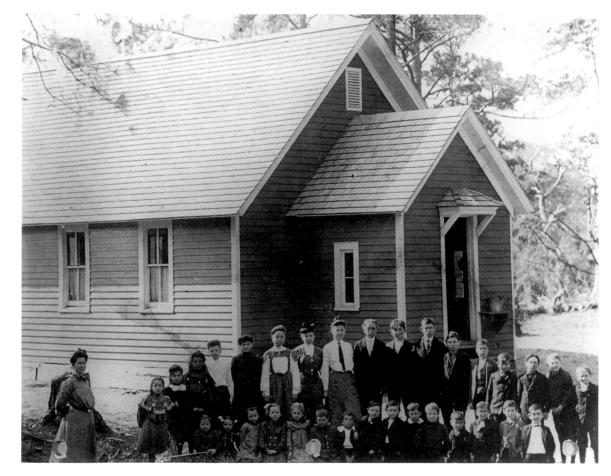

Facing page, top. A typical Outer Banks house, unpainted, unpretentious, with a standard cedar roof, ca. 1905. This one is on Hatteras Island. Fences were sometimes used to keep free-ranging cattle away from the house. (North Carolina Division of Archives and History)

Facing page, bottom. Cape Hatteras School House, ca. 1905. This is possibly the first schoolhouse on Hatteras Island. One teacher taught all grades in the one-room building, usually grades one through eight. Students moved to mainland boarding schools for their high school years. (North Carolina Division of Archives and History)

Below. Horse pennings are a venerable tradition on the Outer Banks. For generations, horses— as well as sheep and hogs—ranged free on the sparse Banks vegetation. They were rounded up yearly for branding and defestation. Today the ponies are part of the scenery, under the care of the National Park Service. (Collier Cobb photo album, ca. 1907, courtesy of the North Carolina Collection, University of North Carolina at Chapel Hill)

47

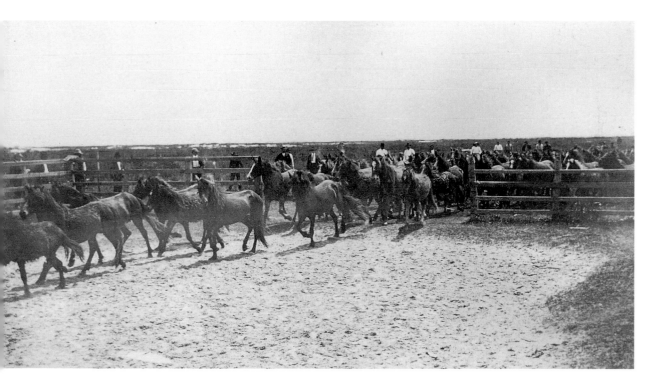

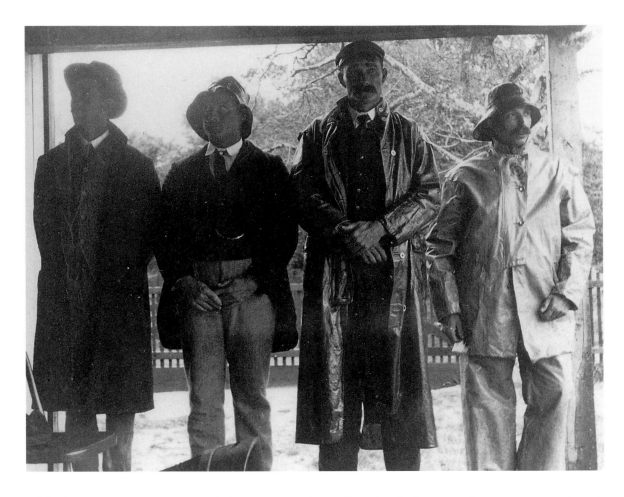

Old salts at Hatteras, ca. 1903. At least two, and possibly all, of these gentlemen were employed by the U.S. Lifesaving Service. Their serious demeanor indicates that they regarded their jobs and their uniforms with pride. (North Carolina Division of Archives and History)

Facing page, top. U.S. Weather Station at Hatteras, ca. 1904. Most government buildings on the Banks were superior in construction to private homes and brought something of an imported style with them. This station survived the deadly San Ciriaco of 1899, but the storm destroyed its recording instruments. (North Carolina Division of Archives and History)

Facing page, bottom. General Billy Mitchell poses with the airplane from which he bombed the battleships *Virginia* and *New Jersey* off Cape Hatteras. The demolition was a demonstration of Mitchell's unconventional theories on aerial warfare. (National Park Service)

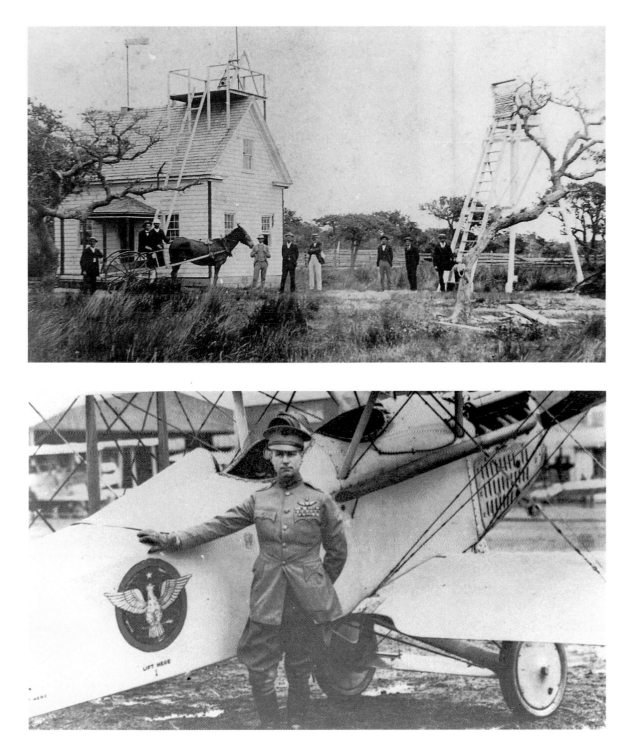

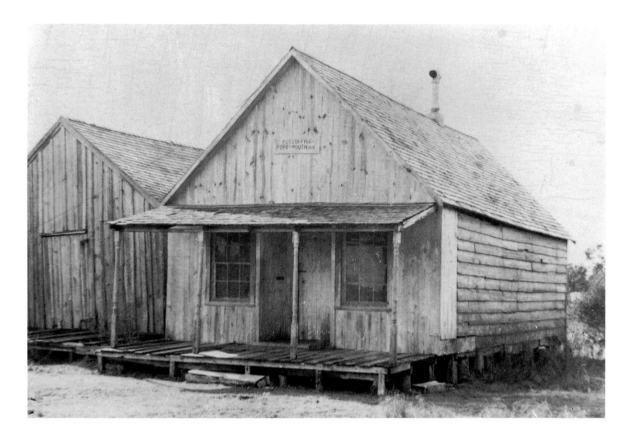

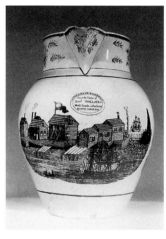

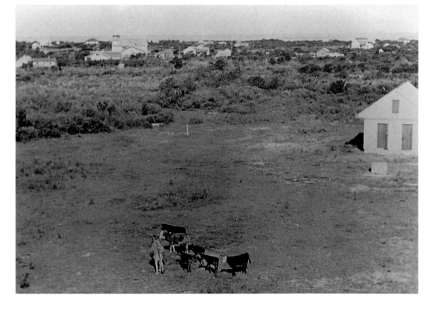

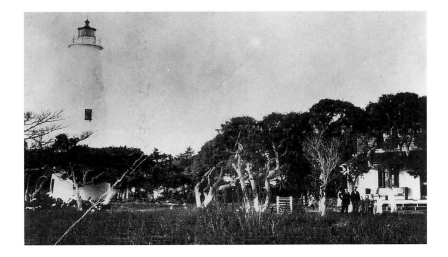

Ocracoke Lighthouse, ca. 1890. Ocracoke was the state's busiest inlet during the eighteenth and nineteenth centuries. The inlet drew ocean-going vessels to the lightering facilities at Ocracoke, Shell Island, and Portsmouth. The collapse of the Shell Island enterprise left Ocracoke Inlet in the dark, and it was not until 1823 that the present tower was put into service. It is the oldest light on the Banks. (North Carolina Division of Archives and History)

Facing page, top. Portsmouth post office—mail source, news source, community meetinghouse. Little more than a shack, the Portsmouth post office has clapboard siding and vertical boarding on its front, sits on wooden pilings, and features a cedar shingle roof and an interior chimney. (Cape Lookout National Seashore, National Park Service)

Facing page, bottom left. Shell Castle Island and Harbor, painted on a Liverpool pitcher once owned by the Blount family, ca. 1790s. In 1789 John Wallace of Portsmouth Island and John Gray Blount of Washington, North Carolina, constructed a lightering complex on a half-mile stretch of oyster beds inside Ocracoke Inlet called Old Rock. They erected warehouses, docks, a gristmill and windmill, a chandlery, and even a lighthouse, and called the place Shell Castle. After some twenty years the complex fell to storms and the shoaling of Wallace Channel. (North Carolina Museum of History, North Carolina Division of Archives and History)

Facing page, bottom right. Cattle range free on sparse vegetation at Portsmouth Village. Even mainlanders would bring their sheep, cattle, and hogs to the island for free foraging. The practice died out in the 1950s, when the residents began to understand the environmental damage caused by unfettered grazing. (North Carolina Outer Banks History Center)

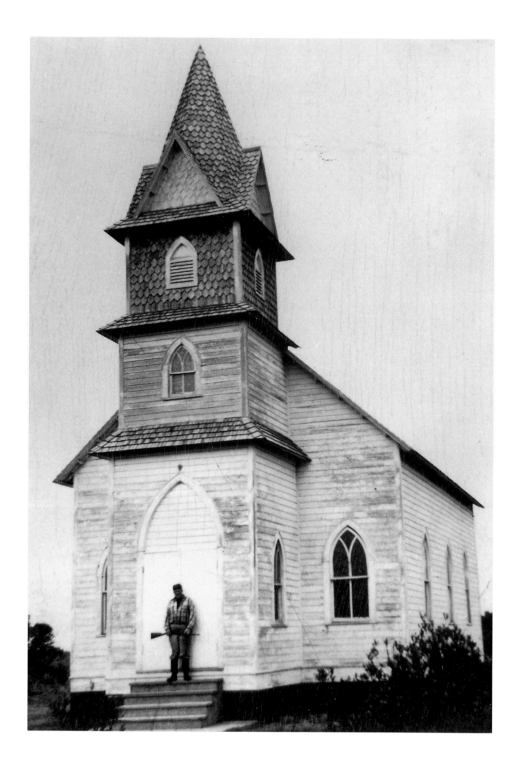

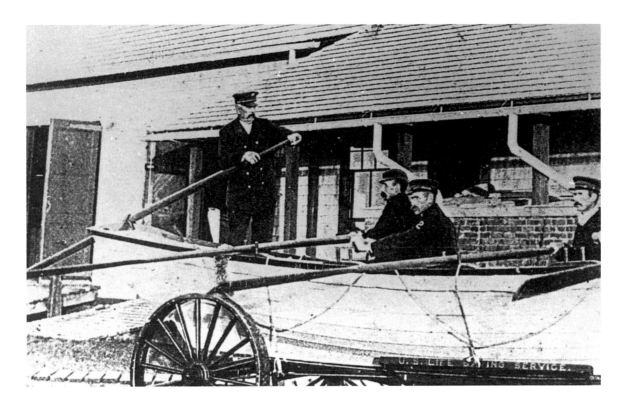

A Portsmouth Island Lifesaving Crew poses in their surfboat in front of the station, ca. 1915, the year the service was merged to form the U.S. Coast Guard. Captain Ike O'Neal commands the steering oar. (Cape Lookout National Seashore, National Park Service)

Facing page. Camp Glenn Methodist Church at Kill Devil Hills, ca. 1950. The church is typical of nineteenth-century buildings on the Outer Banks: unadorned and unembellished, not unlike the parishioners who worshiped there. (Cape Lookout National Seashore, National Park Service)

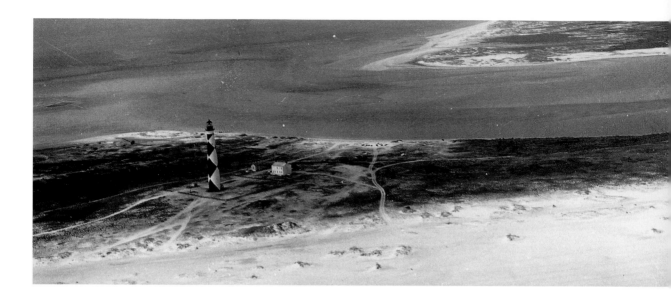

Above. Aerial view of Cape Lookout Lighthouse and the keeper's house, looking west across Barden's Inlet onto Shackleford Banks. Before the Storm of 1899, the two islands were joined and pedestrian traffic was common. (Photograph by Bob Simpson, ca. 1970s, courtesy of the Cape Lookout National Seashore, National Park Service)

Left. The Samuel Buckman, a seven-ton sharpie of forty-five feet, was built at Smyrna in 1899. She is a good example of what became known as a Core Sound Sharpie—a vernacular adaptation of the New Haven Sharpie introduced into the area in 1876 by Connecticut native George Ives. In this undated photograph, the sharpie is manned by a crew of four. (North Carolina Maritime Museum)

Facing page. Camp Lookout Lighthouse, undated. This photograph is of the second Lookout Light. The first tower, lighted about 1812, was too low to be effective and was replaced with this tower in 1859. Its black and white diamond design gave its name to the nineteenth-century community of Diamond City on Shackleford Banks, which lay in the light's shadow. (North Carolina Division of Archives and History)

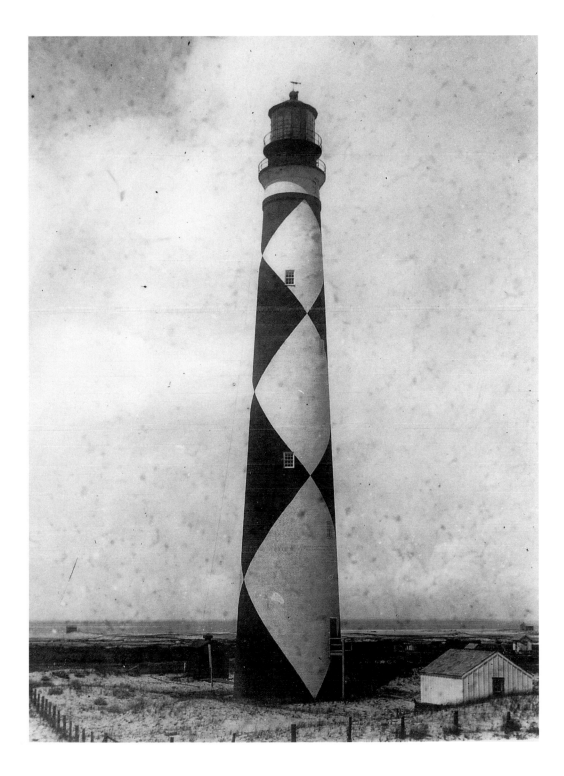

Whaling

Commercial whaling was once a minor industry along the North Carolina coast. During the eighteenth and nineteenth centuries, the taking of whales off Cape Lookout and Shackleford Banks supplemented the meager money economy for hundreds of islanders.

Whaling is not an ancient vocation in America. It took hold in New England in the early eighteenth century and lasted through the nineteenth, except in North Carolina, where it lingered into the first decades of the twentieth century.

The first whalers to appear off the North Carolina coast were from New England. Riding their square-rigged ships, the Yankee whalers engaged in a high seas industry that pursued the leviathan around the globe. They found good hunting in the Cape Hatteras–Cape Lookout area, where their catch was processed and stored aboard ship.

The first documented license issued for whaling on the North Carolina coast was held by Samuel Chadwick of New England. Chadwick and some family members apparently followed the whaling and fishing business to North Carolina's fishing grounds and found them favorable for a profitable future. The family purchased property in Straits, east of Beaufort, and has been in Carteret County to this day. The license was dated 1725 and read in part: "To Samual Chadwick you are hereby permitted with three boats to fish for Whale or Other Royall fish on ye Seay Coast of this Government and whatsoever you shall catch to convert to your own use paying to ye Hon. ye Governor one tenth parte of ye Oyls and bone Made by Vertue of this License."

Whales migrated along the Gulf Stream route, which passed within a few miles of the Outer Banks. New England whalers were

familiar with these migration routes and wanted to be near the source. Their catch was large enough and lucrative enough to provide tax revenue for the proprietary colony in the eighteenth century. During this period, whale oil was even used as a medium of currency.

Unlike their Yankee brethren, who chased the leviathans in months-long voyages, the Bankers specialized in "drift whales," those unfortunates who died en route and were washed to the beach or otherwise beached themselves.

John Bricknell, an eighteenth-century naturalist and physician from Ireland who visited the colony, wrote in his *Natural History of North Carolina*, "the People in these parts are not very much given to industry, but wait upon Providence to throw those dead Monsters on Shoar, which frequently happens to great advantage and profit."

In the nineteenth century, North Carolina whaling came to involve more than simply waiting for the odd whale to wash ashore. At some point whaling men began to organize their efforts, share equipment, and divide their labor. They formed crews to man small pilot boats to chase the whales, and they camped near Cape Lookout for several months in late winter and early spring to wait for the whale migrations.

At least by the late nineteenth century, this shore based whaling involved three crews of six men. They built camps of thatched huts on the Banks and placed lookouts—usually the elderly men who did not participate in the chase—on some high dune. The long wait was monotonous, broken only by the infrequent sightings of whales or dolphins; the culling of the flotsam and jetsam that continually washed ashore; and the always unpredictable and often violent weather that visited the Outer Banks with some regularity.

The whalers' boats were twenty-five-foot lapstrake pilot boats with high bows and sterns. They carried four rowing oars, a steering oar, lines, harpoons, lances, drags, and rifles. Four men rowed, one steered, and one threw or fired the harpoons.

Once the call came from the lookout, the men quickly put their boats into the surf. The whales they chased dwarfed the small pilot boats, making whaling a dangerous occupation. But records indicate that the whalers pursued the job as much for the sport as for the money.

Boats often were swamped or overturned by a flipper or completely smashed by a well-aimed tail. Especially after receiving the harpoon or being wounded by a rifle, a whale was vio-

lent in its panicked thrashing. The whale crews could do little more than hang on and wait for the animal's death to end the wild ride.

Then they had to bring the whale to shore. Carolina crews preferred the right whale because it floated when it died and was thus easier to maneuver to the beach. It also traveled close to shore and tended to be slow and docile. In fact, this species got its name because it was the "right type" for the whalers.

These maritime hunters also took sperm whales and others that were available. An elderly boatbuilder on Harkers Island remembers his grandfather's stories about killing whales off Cape Lookout. At times the crew would capture and wound a calf so that its cries would bring the mother, who would then be killed.

Sperm whales were valued for the oil they carried in their cranial cavity—spermaceti oil. It is of exceptional quality and became popular for its use in candles.

Other whales provided oil from their blubber, which was used for fuel and as a lubricant, and whalebone. The latter is actually not bone but baleen, a cuticlelike material more like the human fingernail, which filters food passing through the whale's mouth. The baleen was used to make corset stays, combs, and even horsewhips.

The killing of a whale was a community project on the Outer Banks. Once the whale was beached, it was important to make quick work of the carcass, else the kill would eventually become an olfactory disaster and the blubber would dry out. Along the beach, workers built a line of wood fires over which cast-iron pots were hung. Sometimes small makeshift brick ovens were erected to hold the pots.

The men would hack the blubber away with spades, cutting it into blocks of fat. A hole was cut through the top of the block, then a pole was inserted through the hole so that men could shoulder the load at each end, much like the way safari bearers carried big game. The blubber was then taken to a mincing trough, cut into strips with a blade similar to a scythe, and thrown into trying pots.

The blubber was boiled to separate its oil, a process called "trying out." The oil was dipped from the boiling pots with ladles and poured into troughs that carried the liquid to large wooden barrels. The fires were then fueled with the blubber strips that had already had their oil ex-

tracted. The filled barrels were capped and rolled away; later they were loaded on a boat for the trip to Beaufort. It might take a week or even two to finish the whale and have the oil ready for market.

One of the many folk descriptions of whaling on the Outer Banks recalls how the community women at Lookout used seashells to scoop whale oil out of impressions in the sand along the beach, hoarding the oil for their lamps, because they could not afford to purchase the very oil they produced. The lamps themselves were often simply conch shells filled with whale oil.

Whalers were paid in share, or "lays," at least during the late nineteenth and early twentieth centuries. One share went to each boat owner; the person in charge of tackle and equipment drew two-thirds of a share; steersman and harpooner drew one-third; each gunner received two shares; other crew members drew one share. Then the boilers and others who worked the trying-out process received shares.

The Bankers, with their strong oral traditions, often named memorable events by the most obvious factor collectively recognized by the community. A storm might be named for the date it occurred, such as the Christmas Storm. Whales were also labeled in this way. One such kill has come down to us as the Children's Whale because it was killed by the island's young people when their elders were not available. Another kill was labeled the Mayflower Whale because it was taken on the May 4, 1872.

The Mayflower hunt was described by Captain John E. Lewis of Morehead City in a letter dated 1926:

He was named "Mayflower" by the men who killed him because he was killed the fourth of May. He was one of the biggest ever killed in these parts, and perhaps the most vicious, since it took fully half a day to kill him.

There were six boats in action, containing six men each; four men rowing, with the captain in the head, directing and the steersman in the stern taking orders and steering the boat. The captain, in the head, always shot the guns and threw the harpoons. . . .

The whale came into the hook (this means the hook or Bight of Cape Lookout) that morning, soon, and all six boats headed for him. Captain Reuben Willis was the first to strike him with the shackle (this means the type of harpoon usually called a "toggle-iron") and then the

big fight began. All the guns were shot and he had to be finally killed with the irons and harpoons.

He fought and slashed about at the six boats for hours, they laying off to one side, and whenever a captain in either boat could pick a chance when his tail was not slashing in his direction, he would rush in and harpoon him.

Whaling proved to be a lucrative occupation along the isolated Outer Banks. During the 1830s and 1840s, more than forty ships plied the waters off Hatteras every year in search of whale oil and whalebone.

Shore whaling continued around Cape Lookout and Shackleford Banks until World War I, when the supply of whales dwindled and the small profit from their oil, undercut by the use of fossil fuels, no longer justified the work.

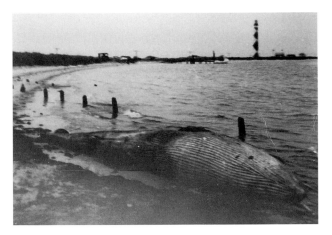

A drift whale beached inside Cape Lookout Bight with the Cape Lookout Lighthouse in the background. Core Banks whalers sometimes got lucky with beached whales and dolphin; these were processed just like a fresh kill. (Undated photograph, courtesy of the Cape Lookout National Seashore, National Park Service)

The first whaling license issued in North Carolina was that of Samuel Chadwick, a New Englander who fished the Hatteras and Lookout whaling grounds. Chadwick bought property on the mainland near Core Sound, and his family prospered. Their descendants are numerous in Carteret County. The license, issued in 1726, reads, "To Samual Chadwick you are hereby permitted with three boats to fish for Whale or Other Royall fish on ye Seay Coast of this Government and whatsoever you shall catch to convert to your own use paying to ye Hon. ye Governor one tenth parte of ye Oyls and bone Made by Vertue of this License. By ye Hon. y Govern. Ord."

Facing page, top. A fishing hut near Cape Lookout, ca. 1885. Throughout the eighteenth and nineteenth centuries, fishermen from Harkers Island and Shackleford Banks built fishing huts on the Outer Banks to scout for whale, dolphin, mullet, and other commercial fish. The huts were constructed of saplings and reeds and provided the fishermen's only shelter during the several months they fished the Banks' waters. Evidence discovered recently suggests that the huts' architectural antecedents may be African. (From George Brown Goode, *The Fisheries and Fishery Industries of the United States, 1884–1887*)

Facing page, bottom. Whaling in North Carolina was a seasonal occupation that engaged residents of Shackleford and Core Banks from the early eighteenth century until the early twentieth century. Termed "on-shore whaling" because the operation was shore-based, the pursuit of whales became a community industry on the southern end of the Outer Banks. The whalers used the beach as a ready-made outdoors factory for processing their catch. One whaler from the Banks reported that he had helped capture and kill fifty-two whales in his life. ("Bulletin of the North Carolina Department of Agriculture," 1894)

Below. Whaling crews in lapstrake double-enders make for a bowhead whale. New England crews worked from tall ships that spent months on the ocean. North Carolina whalers worked in small pilot boats and took their kills within sight of the Outer Banks. (*Harper's New Monthly Magazine*, March 1856)

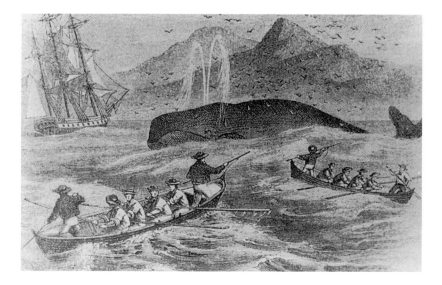

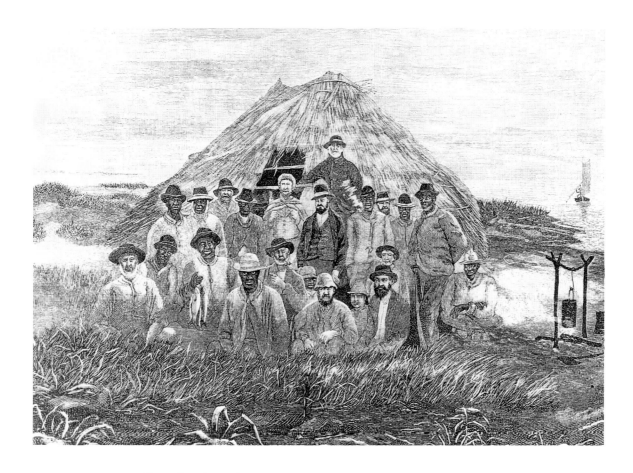

63

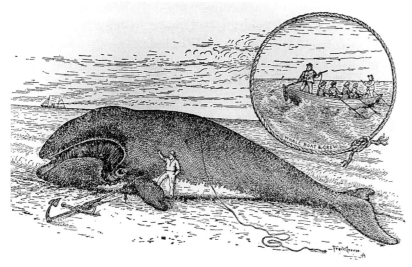

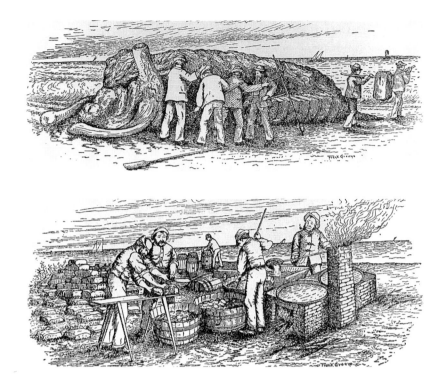

Top. Cutting blubber near Cape Lookout. Whales from the on-shore whaling efforts on the southern Outer Banks were processed on the beaches of Core Banks. With a dozen or more men working in shifts, it might require two weeks to strip blubber from a whale. The whale fat was cut into large blocks that were then skewered with a pole. Two men shouldered the pole safari-style and carried the block of fat to the boiling pots for rendering. *Bottom.* Trying out whale oil, 1894, at Cape Lookout. Boiling oil from whale blubber was called "trying out." The blubber was fed in strips into iron kettles of fifty-gallon capacity. The fat then boiled over fires fueled by wood and by cracklings from previously rendered blubber. The reduced oil was strained through a chute and emptied into barrels for delivery to Beaufort. ("Bulletin of the North Carolina Department of Agriculture," 1894)

Facing page. Josephus Willis, captain of the Red Oar crew that helped capture the Mayflower Whale in 1874. Core Banks' whalers named their catches, just as they named hurricanes and storms. The Mayflower Whale was so named because it was captured on May 4, anniversary of the arrival of the *Mayflower* in the colonies. Willis is pictured here in retirement, ca. 1903, mending nets. (North Carolina Division of Archives and History)

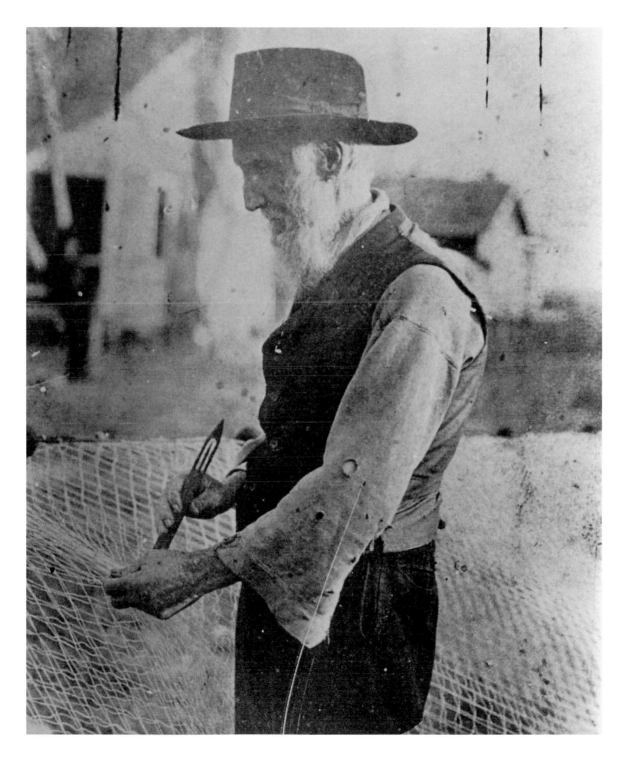

Making a Living from the Sea

Fishing, piloting, and hauling freight on the Atlantic were serious occupations that required alertness and learned skills. The islanders would tell an outlander that they were "born" to these livelihoods or that they were "in the blood." In truth, Banks children were immersed in island occupations at such an early age that life on the water was second nature to them.

Young men well shy of their maturity chased whales in the small pilot boats common to the Banks. Noted boatbuilder Julian Guthrie built his first spritsail skiff when he was twelve years old. He already knew how to clam, how to fish for mullet, how to tong for oysters, where to fish and what to fish for, and how to read the water for shoals. These were not idle pastimes. Children fished, mended nets, repaired boats, set seine nets, raised turtles and geese, and generally worked alongside their elders.

The Civil War disrupted life no less on the Outer Banks than in the Piedmont, and it planted the seeds of change that would mature in the last quarter of the nineteenth century. Invading Northerners brought new perspectives to the Banks. Previous generations of Bankers had absorbed outsiders quietly, but the presence of an army was too much for the small island communities.

Artists and men of letters found something romantic and evocative about the Outer Banks, and they unlimbered their pens and stroked their muses to find the proper words and images to depict the windswept and brooding islands. Edwin Champney, a volunteer with the Fifth Massachusetts Volunteer Regiment, filled a scrapbook with some sixty drawings during his tour of duty on Hatteras Island in 1862. Charles Johnson, who served with Hawkins' Zouaves on the same island, penned a book of memoirs titled *The Long Roll*. These literary and artistic efforts attracted

tourists and adventurers from northern and mid-Atlantic states, many of whom liked the environment so much that they never left.

Other Union soldiers with more mercenary eyes observed the runs of bluefish, the huge schools of menhaden, the large migration of dolphin, and the untold numbers of waterfowl. After the war these men returned armed with northern capital in order to exploit the Banks' natural resources, build commercial fisheries and porpoise and menhaden factories, and establish oyster- and fish-processing plants.

They also returned to hunt and fish. In the second half of the nineteenth century, the Outer Banks were a sportsman's heaven. Hunt and gun clubs flourished. New capital bought vast tracts of marshland and erected substantial and sometimes elaborate hunting lodges. These became the playgrounds of northern industrialists, merchants, and celebrities.

The dramatic increase in commercial fisheries after the Civil War, especially in the soundside communities, made rapid and profound changes in the social fabric of coastal residents. Most coastal folk had practiced a barter economy before the war, swapping goods for services; a keg of fish bought a sack of grain. These people owned their own labor, so they came and went as they pleased. They fished, clammed, and caught turtles; they hunted waterfowl and raised a few cattle and tended a garden. But their independent lifestyle began to change following the war, as entrepreneurs moved into the area.

The late 1860s and 1870s brought the region its first large-scale commercial fish and oyster factories that hired for wages. The Capehart and Belvidere Fisheries of the Albemarle Sound, the oyster factories at New Bern and Beaufort, and the menhaden factories at Beaufort and on the Outer Banks lured hundreds of men and women from their subsistence living into factory systems that, although outdoor enterprises, were no less regimented than indoor industries.

These large commercial operations closed many cottage industries and family-size fishing enterprises. Most men and women were attracted to cash-paying fish-processing factories and surrendered the work traditions of their parents and grandparents.

Seine fishing cast the widest net in commercial fisheries. Its huge nets were hauled by dozens of hands and pulled thousands of pounds of fish in a single sweep. Seine fishers were especially prominent in the Albemarle Sound and its tributaries, where the Capehart Fisheries alone em-

ployed a thousand people during months when the shad were running. The Avoca complex and Sutton Beach and a few others collectively employed more than two thousand people during the fishing season.

Pound nets took their share of the catch as well, and gill nets ranked third, especially in Dare and Carteret Counties. Skim nets were used on the Roanoke and Tar Rivers. Independent fishermen still pursued mullet, perch, striped bass, and sheepshead, tended eel pots, and caught terrapins, but the factories made deeper and deeper inroads on these simple livelihoods.

The menhaden industry found fertile grounds along the North Carolina coast. Several large processing factories were built on the Banks, at Harkers Island, and at Beaufort. Their boats brought thousands of tons of the oily fish back to the mainland for processing. The state became a major exporter of the lowly fish, as the acrid odor from the factories would testify.

These fisheries were the equivalent of the Piedmont's textile factories and a cousin of the coastal plains' naval stores industry. All of these enterprises used regimented labor, paid wages for repetitive jobs, controlled the time of their workers, and created a product that was measured in tons and by the thousands to ship away to other people.

The fishing industry concentrated people into small work areas in a way they had not experienced before. The workers became conscious of fashion and foods and recreation in ways their ancestors never had. They became conscious of time in a new and regulated way, unlike their ancestors, who had measured time by the sun and moon.

Eventually, the sons and daughters of the coast turned from their parents' ways and either accepted the new factory demands on their lives or moved away to city jobs. Either way, the result was that the customs and traditions of fishing and boatbuilding and other coastal home industry began to erode.

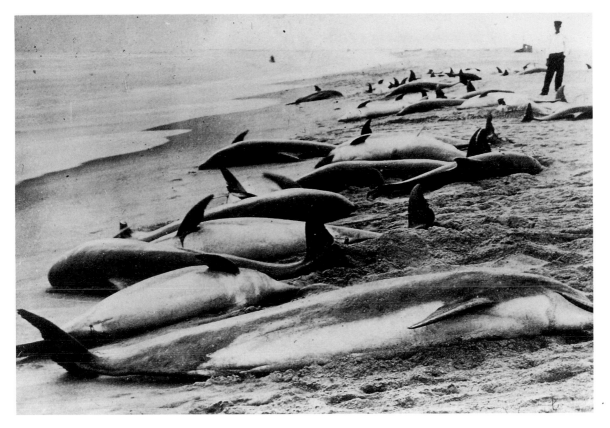

A "porpoise kill" at Hatteras Island, ca. 1900. Bottlenose dolphin, still called "porpoise" by
local residents, were captured and processed on the Outer Banks in the nineteenth century
when whales were in short supply. This industry flourished as early as the 1790s at Portsmouth
Island and was still in operation as late as the 1890s. (North Carolina Collection, University
of North Carolina at Chapel Hill)

"Diving for Loggerhead Turtles, Morehead City, North Carolina."
Turtles, loons, and other animals that are not generally eaten
today were often staples in the diet of Outer Bankers. (Drawing
by H. W. Elliott in George Brown Goode, ed., *The Fisheries and
Fishery Industries of the United States, 1884–1887*)

Facing page. A worthy catch: three Downeasters display the
enormous loggerhead turtle they caught at Cape Lookout Bight,
ca. 1908. Turtles were raised for consumption in the late nine-
teenth century, although the loggerhead was not favored for
eating. Today this threatened species continues to nest on the
Outer Banks. (North Carolina Maritime Museum)

A "seining crew" from the U.S. Bureau of Fisheries and Biological Station at Beaufort, July 30, 1913, showing off its catch of the day: a loggerhead turtle, a hammerhead shark, and a cownosed ray. Beaufort was an important national marine research site after the Civil War. The National Bureau of Fisheries and Johns Hopkins University established research stations in the area during the 1870s and 1880s. Today, the University of North Carolina, North Carolina State University, Duke University, and the National Oceanic and Atmospheric Administration have research offices and labs in Morehead City and Beaufort. (North Carolina Collection, University of North Carolina at Chapel Hill)

Facing page, top. "A Large Haul of Alewives," at Sutton Beach on the Albemarle Sound. In this drawing, a line of men and women pull in a huge catch of herring at one of the many commercial fisheries founded after the Civil War. Subsistence fishing increasingly gave way to commercial fishing, and Bankers' lifestyles changed markedly as a result. *Bottom.* "Haul-Seine Fishing at Sutton Beach, Albemarle Sound, North Carolina." Large commercial fish factories found fertile ground in North Carolina after the Civil War. Some of the largest were in the Albemarle region, such as this operation at Sutton Beach, where workers haul in seine nets, probably to the rhythm of a work chanty. A two-masted schooner rests in the background of this sketch. (Drawings by H. W. Elliott in George Brown Goode, ed., *The Fisheries and Fishery Industries of the United States, 1884–1887*)

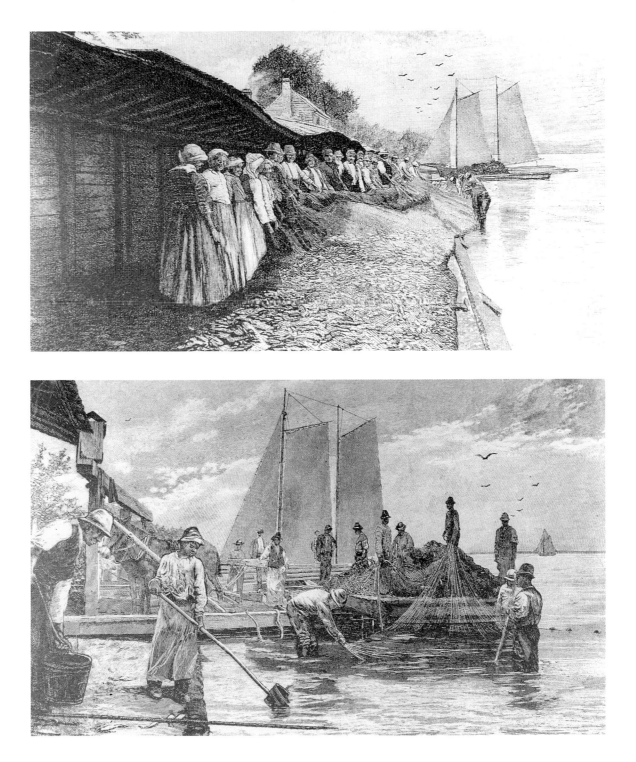

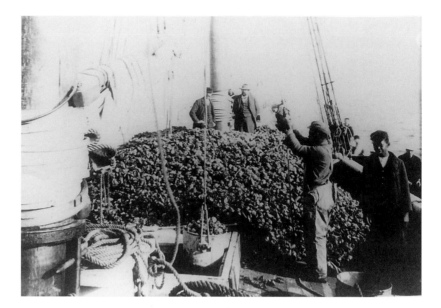

74

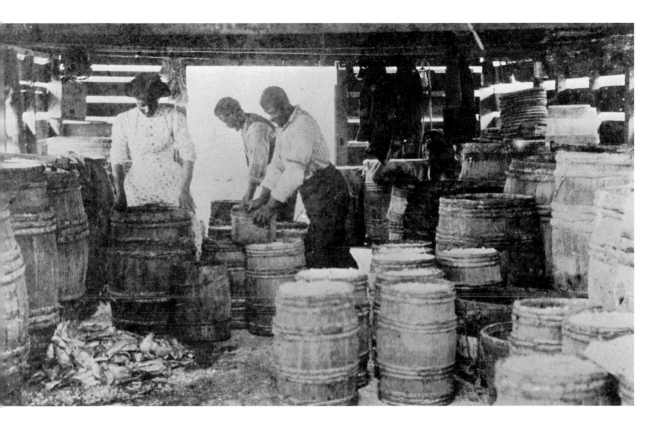

Packing fish for shipping. Commercial fish factories dominated North Carolina fish processing after the Civil War. Companies bought tons of fish and paid workers wages to clean, salt, and ice the catches for export. (North Carolina Maritime Museum)

Facing page, top. A haul of oysters going to market, ca. 1920. Oystering became so lucrative and competitive in the late nineteenth century that an "oyster war" erupted on the Pamlico Sound between native Carolinians and invading watermen from the Chesapeake Bay. Ultimately, the state stepped in and passed regulations limiting the season and size of oyster harvests. (North Carolina Division of Archives and History)

Facing page, bottom. Women canning oysters at the Duncan Oyster Factory at the end of Ann Street, Beaufort, ca. 1900. The oysters were steamed open, and the women removed the meat with knives and put them into cans. They carried their cans to a window to have them weighed, and received small tokens that could be traded for groceries and cash at a company store—a transaction not dissimilar from piecework in textile factories. (North Carolina Maritime Museum)

Windmills

The Outer Banks and coastal North Carolina were devoid of the running water that powered gristmills in the Piedmont and mountain regions of the state. Instead, maritime communities turned to the most obvious natural resource at hand: wind.

Windmills dotted the landscape of coastal North Carolina from the late eighteenth century until the twentieth. Eighteenth-century mills are documented at Nixonton in Pasquotank County (Old Windmill Point); Swansboro, Marshallburg, and Beaufort in Carteret County; and on Portsmouth Island. The short-lived lightering island at Shell Castle inside Ocracoke Inlet had a mill for pumping water. Other mills were built at Ocracoke, Hatteras, Bodie Island, and Roanoke Island.

Union soldiers were surprised at the number of windmills along the Outer Banks when they visited the state in 1861 with the Union invasion force. Charles Johnson, a young Swede who landed at Hatteras with Hawkins' Zouaves, had these impressions of Hatteras Island: "Everything on the Island seems to be devoid of paint —dwellings, barns and windmills, of which latter there are a greater number than I supposed were in existence in the whole country."

Another Union volunteer from Massachusetts, Edwin Champney, sketched the Hatteras mill, along with other images of the island, during his tour of duty in 1861.

Swansboro historian Tucker Littleton made a survey of the state's windmills in the 1970s and documented 155 of the boxy structures from Wash Woods on Currituck Banks to Brunswick County in the south.

North Carolina windmills were of the "post mill" type—frame rectangular sheds built atop a single post some twenty or thirty feet off the ground. The entire structure revolved on the post and

was manipulated by a tail post that reached from the building to the ground some seventy feet away. A wheel attached at the ground end of the tail pole ran in a track. Thus, the mill could be positioned to catch the prevailing winds.

The rotation of the fans turned a huge assembly of wooden gears inside the structure, which in turn moved the stones that crushed the grain.

The speed of the four fans was controlled by sails that covered their surface. The sails were furled to accommodate wind velocity, in much the same way that sails are used on boats. Regulation of the fan revolutions was important to the quality of meal produced. Too much speed on the stones scorched the grain and ruined it.

Mills were used for grinding wheat and corn and for pumping water. The former type were primarily located north of Onslow County and the latter south of Pender County. The mills of New Hanover and Brunswick Counties were often employed in the production of salt.

Post mills were simple and straightforward structures that could be easily built from available materials. If a location proved unprofitable, they were frequently loaded onto wagons and hauled to new sites. The Moravians at Bethabara (now part of Winston-Salem) built and transported a mill to Governor William Tryon's estate at Russellborough in 1767.

Wealthy planters such as Governor Tryon had their own mills for use exclusively on their estates. These were known as "plantation mills." Most mills, however, were "custom mills," operated for the general public, from whom the owner extracted a toll in kind.

Ironically, the greatest threat to coastal windmills was its source of power. Severe storms and hurricanes toppled many mills and lightning destroyed others. These testimonials to North Carolina's maritime heritage eventually became outdated derelicts made useless by the advent of electricity and gasoline engines, and one by one, they were destroyed.

Facing page. Windmill at Beaufort, ca. 1890, with a group of local children posed beneath. This mill had already been abandoned by 1890, perhaps in favor of a more efficient steam mill. (North Carolina Division of Archives and History)

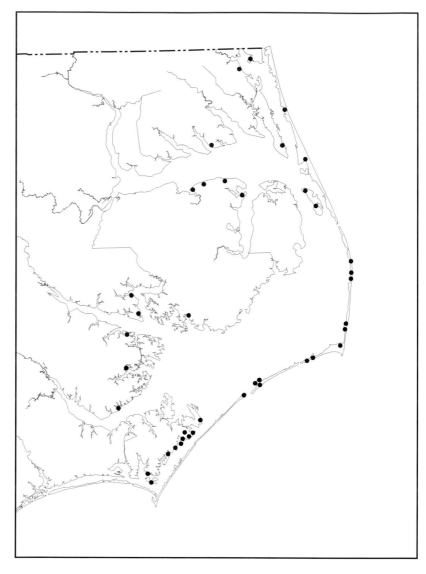

Map 4. Locations of Nineteenth-Century Windmills

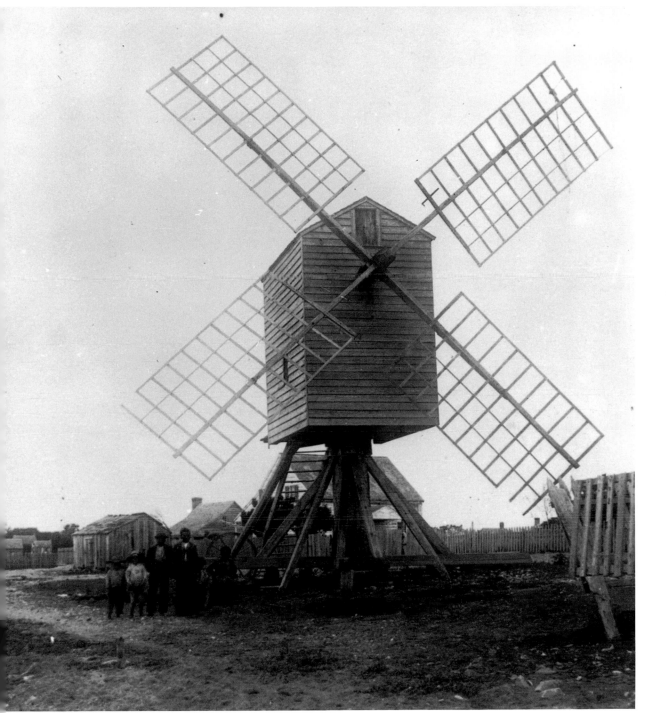

Windmill near Beaufort, with children playing with toy wooden boats in a nearby tidal marsh. Nearer the windmill, a grazing Banks pony ignores the boys as it feeds on marsh grass. (North Carolina Division of Archives and History)

81

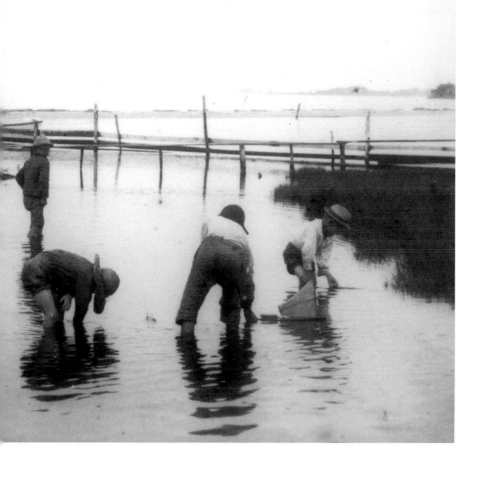

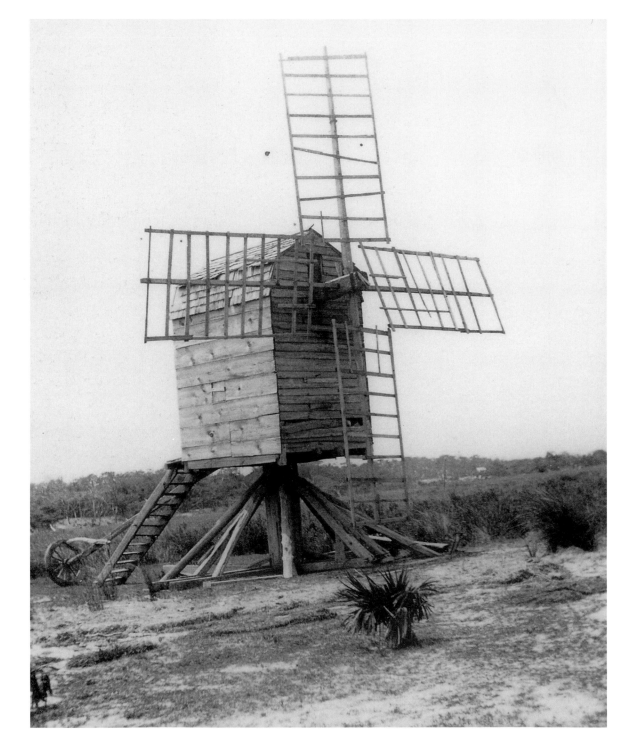

82

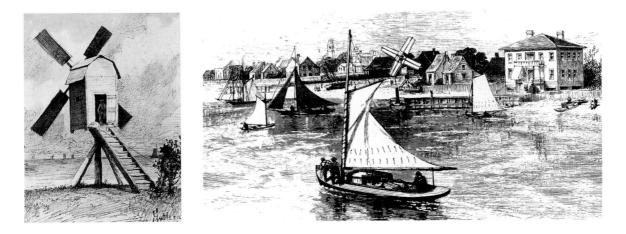

Above left. Hatteras postmill. This postmill was sketched by Edwin Champney, a young Massachusetts volunteer who was stationed at Hatteras in 1862–63. (North Carolina Outer Banks History Center)

Above right. A windmill dominates the Beaufort waterfront in this 1880 sketch, first published in *Frank Leslie's Illustrated Newspaper.* The building at the far right is a marine science laboratory of the Johns Hopkins University. (North Carolina Division of Archives and History)

Facing page. An old postmill at Buxton, near Cape Hatteras, apparently had already been abandoned when this photograph was taken by H. H. Brimley about the turn of the century. The mill was listed in the 1869 *North Carolina Business Directory* and may have been owned by B. C. Jennett. The mill was destroyed by a storm in 1904. (North Carolina Division of Archives and History)

The Civil War

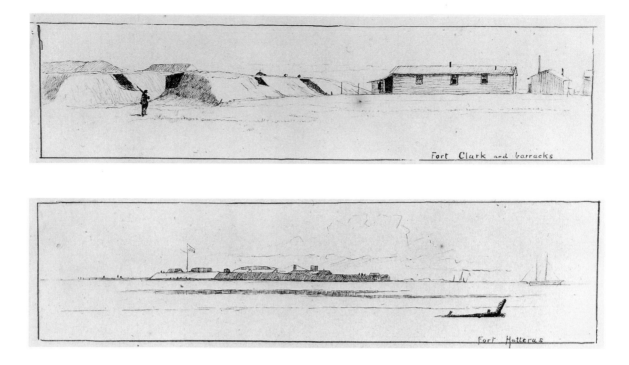

Fort Clark and barracks

Fort Hatteras

Forts Hatteras and Clark stood guard over Hatteras Inlet, an escape route for privateers working against Northern shipping and the key to control of Pamlico Sound. The defense was little more than symbolic, however, and was easily overpowered by a Union flotilla under the command of Commodore Silas Stringham. (Drawings by Edwin Champney, 1862, courtesy of the North Carolina Outer Banks History Center)

Facing page. Bombardment of Forts Hatteras and Clark at Hatteras Inlet on August 27, 1861. The attack at Hatteras, under the command of Commodore Silas Stringham, was the Union's first amphibious assault on the South. Poorly equipped and manned, the forts surrendered after a three-and-a-half-hour barrage. (From a color lithograph by Currier & Ives, courtesy of the North Carolina Collection, University of North Carolina at Chapel Hill)

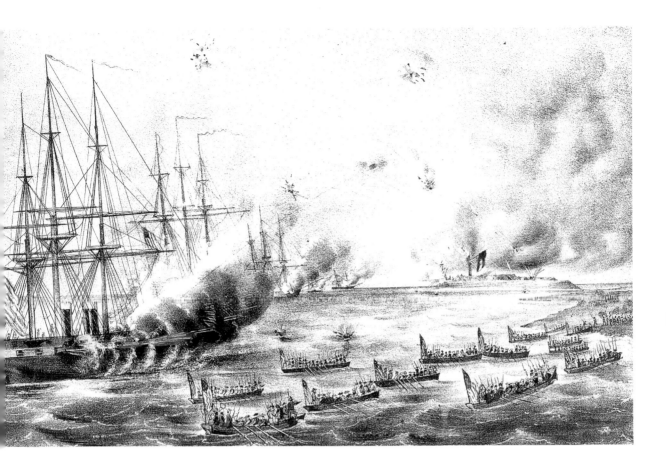

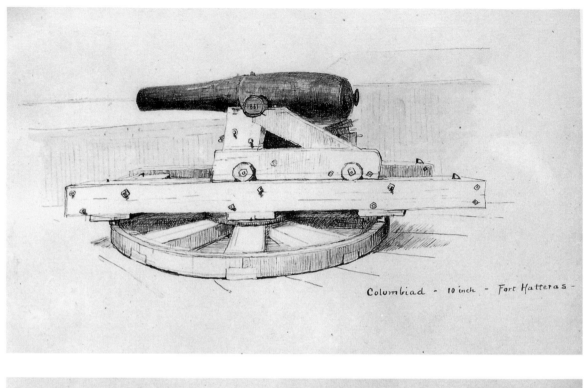

Columbiad - 10 inch - Fort Hatteras -

88

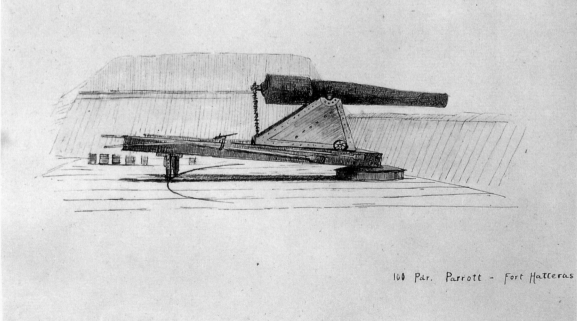

100 Pdr. Parrott - Fort Hatteras

A hundred-year-old Strasbourg cannon, a five-pounder captured at Fort Clark, typified the weak Confederate defenses along the Outer Banks. The shells of the antiquated cannon could scarcely reach the Union ships. An alert Union volunteer from Minnesota noted the irony of the gun's date of manufacture: 1761. The cannon was a century old and likely had seen service in the American Revolution. (Drawing by Edwin Champney, 1862, courtesy of the North Carolina Outer Banks History Center)

Facing page, top. A ten-inch Columbiad captured at Fort Hatteras. It was one of several cannon rushed to the fort after the state withdrew from the Union. Confederate officials consistently underestimated the importance of the Outer Banks to the safety of North Carolina and to the Confederacy and were negligent in designing a proper defense of the barrier islands.

Facing page, bottom. A hundred-pound Parrott captured at Fort Hatteras. The small forts of Clark and Hatteras were completely outgunned by the Union naval forces sent against the island. Much of the fort's fire could not even reach the ships bombarding them. (Drawing by Edwin Champney, 1862, courtesy of the North Carolina Outer Banks History Center)

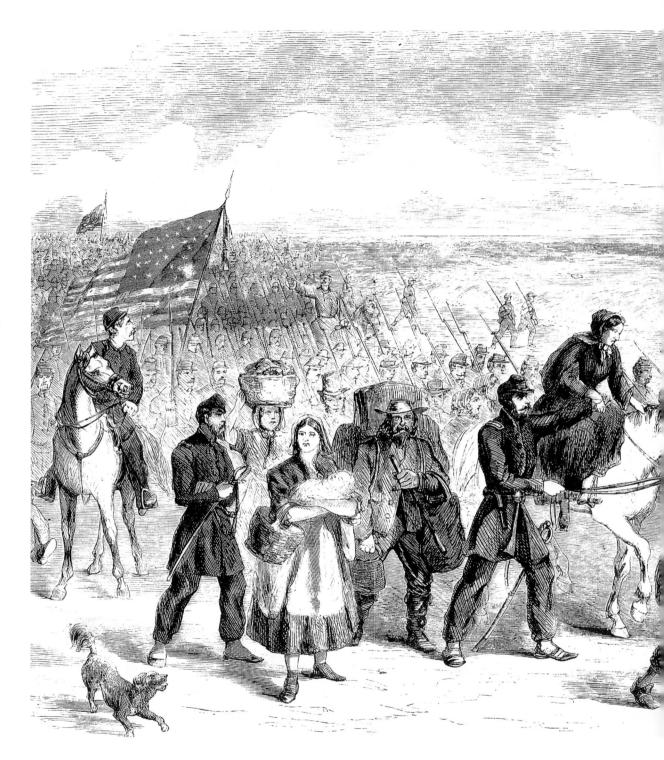

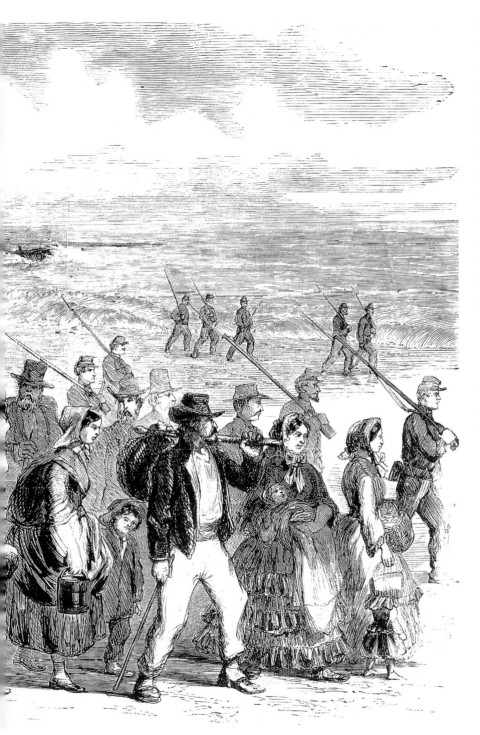

Residents of Chicamacomico Banks join a retreating Twentieth Indiana in its race to Hatteras Lighthouse with North Carolina and Georgia troops in close pursuit. The Federals would find reinforcements at the lighthouse and then chase the Confederates back up the island in a military farce that has been dubbed "The Chicamacomico Races." (From an October 1861 engraving, courtesy of the North Carolina Collection, University of North Carolina at Chapel Hill)

91

The Chicamacomico Races

In keeping with their independent nature and casual acquaintance with the mainland, Outer Bankers—not unlike their isolated counterparts in the North Carolina mountains—were very much out of step when the government at Raleigh opted for secession. The Bankers were so disgruntled over the act of secession that a number of citizens from Hyde County called a convention at Hatteras to proclaim their own government.

The Hatteras Convention drafted and adopted a "Statement of Grievances and a declaration of Independence" that declared their loyalty to the United States and asserted their refusal to recognize the Confederate States of America. In an unparalleled act of defiance, the Hatteras citizens accused the State of North Carolina of treason. The state, the proclamation declared, had acted without representation from the people, and its Ordinance of Secession was therefore null and void.

The Hatteras Convention representatives established a provisional government and appointed a Methodist minister, Marble Nash Taylor, as the provisional governor. They bestowed on him the powers of appointment and whatever authority he required to restore "safety and good order to the State."

The Outer Banks rump government then proceeded to elect Charles Henry Foster as a representative to the national Congress. But the Congress denied Mr. Foster his seat, and the rump government of North Carolina was swallowed up in the march of military events on the barrier islands. Its actions, however, would not be forgotten by the national government after the war.

The Union launched its first amphibious assault against the South at Hatteras Island on August 27, 1861. The attack was a series of foils and fumbles that offers a relatively refreshing alternative to the later Civil War campaigns of human carnage.

Neither side was prepared for the clash of arms on the Outer Banks. The early battles were fought between green troops, most of whom had never fired a weapon in anger. These farmers and shopkeepers were terrified by artillery and were not anxious to look the enemy in the eye. The land skirmishes for Hatteras Island have been labeled, derisively, The Chicamacomico Races.

The Union fleet that attacked Hatteras Island was under the command of Commodore Silas Stringham. The commodore directed a motley fleet of steam frigates, gunboats, tugs, and a sidewheeler. His vessels carried nine hundred cramped New York infantrymen under the command of General Benjamin Butler, a fuming egoist bent on rescuing his reputation from his debacle at Big Bethel two months earlier.

Colonel William F. Martin commanded the Confederate defenses at Fort Hatteras and Fort Clark, which had been hastily constructed during the summer to defend the strategically vital Hatteras Inlet. Fort Hatteras guarded the inlet, while Fort Clark, almost a mile away, provided a cross fire. Some six hundred men of the Seventh North Carolina Artillery occupied the forts.

The Union fleet proceeded with a field shoot against the small forts. Commodore Stringham sent his ships in parallel to the island, firing broadside as they passed, then pulling away to allow the next ship to make its run against the ineffective Confederate fire.

General Benjamin Butler was already counting his laurels when the time came for the amphibious assault, because the Confederates had exhausted their ammunition. As the attack boats were launched, however, nature intervened in the guise of a sudden storm, and Butler could only watch in disbelief as his assault launches were smashed and overturned in the violent surf. Only three hundred men of the Twentieth New York made it to the beach. The others remained on their ships.

Colonel Martin, assessing his precarious position at Fort Clark, made a hasty retreat to Fort Hatteras. On the Union vessels, an alert watch reported what appeared to be a Confederate cavalry charge against the Union troops who had made the beach landing. A battery of fire was loosed into the midst of this "cavalry," which turned out to be a spooked herd of Banker ponies seeking safety.

The New Yorkers then waltzed into Fort Clark and hoisted the stars and stripes. Martin and his troops took up the fight from Fort Hatteras and again drew withering fire from the Union

fleet. The Union artillery barrage was so intense, or so misdirected, that it spilled over into Fort Clark, raining shells on Union troops there and forcing them to abandon the prize they had so recently won.

Fortune again favored the Confederates when they were unexpectedly reinforced by some 230 men from the Portsmouth Island garrison. These men were led by Commodore Samuel Barron, who earlier in the year, as a U.S. naval officer, had commanded the *Wabash*, one of the very warships participating in the battle. President Lincoln had appointed Barron to head the Bureau of the Navy, but Barron had refused the appointment in order to fight with the South.

Barron wanted to recapture Fort Clark and attack the invaders under the cover of darkness while they huddled on the beach, but his officers opposed the venture as too risky. The Confederates thus tossed away a prime opportunity to regain their lost position.

A Union bombardment on Fort Hatteras began the next morning at 7:30 and continued for three and a half hours. Unable to return effective fire, Barron, with the encouragement of his officers, ran up the white flag of surrender and snatched a Confederate defeat from the jaws of victory. For even as he contemplated Ben Butler's unconditional terms of surrender, two Union ships crossed the bar at Hatteras Inlet and grounded within range of Confederate guns. Even so, Barron surrendered his six hundred men.

The fall of Forts Hatteras and Clark was received with much joy and celebration in the North, which had recently been dealt yet another stinging defeat at Bull Run, while North Carolina was stigmatized as the site of the first major defeat of the Confederacy. The Hatteras defenders were shipped to New York, where they were paraded through the streets as trophies of war to boost sagging Northern morale. Admiral David Porter later pronounced the fall of Hatteras "one of the most important events of the war."

Unreasonably, the Confederates willingly abandoned two other forts at Ocracoke and Oregon Inlets, handing the Union control of the entire Outer Banks and effectively ending privateer efforts against Northern shipping. Roanoke Island was now the Confederates' only remaining coastal defense between Norfolk, Virginia, and Wilmington, North Carolina.

Off to the Races

But the battle was not over. General Butler, contrary to orders, left his men at Hatteras and shipped off to Washington to argue with his superiors for holding onto the island. Meanwhile,

his men on the Banks were reinforced by elements of the Twentieth Indiana Volunteers.

On the Confederate side, even as Commodore Barron was surrendering his troops to Butler, the Third Georgia regiment was disembarking from Norfolk bound for the Outer Banks. The opposing forces would meet at Chicamacomico.

General Butler left an anxious and uncertain situation behind at Hatteras. Rumors flew thick and fast about attacks from both sides. One of the rumors was that the Confederates were planning an attack on Union forces from Chicamacomico, so the Union commander sent the recently arrived Twentieth Indiana to intercept the landing.

At Roanoke Island, Confederate commander Colonel A. R. Wright heard that the Union gunboat *Fanny* was en route to Chicamacomico and decided to capture the boat. Colonel Wright teamed up with Commodore W. F. Lynch. The two mounted a Fort Roanoke thirty-two-pounder aboard an Albemarle Sound passenger sidewheeler, the *Curlew*; grabbed some of the untrained Third Georgia soldiers; and steamed off for Chicamacomico.

The *Curlew* found the *Fanny* in Pamlico Sound and, in a fifteen-minute battle, captured the Union gunboat, its crew, forty-three soldiers, and a cargo worth about $150,000.

In their euphoria over the victory, Colonel Wright and Commodore Lynch agreed to force the issue and drafted a plan to land the Third Georgia regiment above the Federals at Chicamacomico and to land a North Carolina regiment to their south to prevent a retreat.

The Indiana troops anticipated the initial Confederate landing and lined up along the beach to catch the landing Georgia troops as they waded to shore. But they quickly had a change of heart as they watched part of the Mosquito Fleet steaming south in an obvious pincer movement. The Twentieth hastily struck camp and beat a ragged retreat toward Fort Hatteras, some thirty-five miles to the south.

It was a warm October day, and the Northern troops—some six hundred of them—slogged their way through deep sand, suffering terribly from thirst. They carried no water. The Confederates came after them in hot pursuit.

With the Georgians close on their rear, the Federals had a most unexpected encounter: they were joined by dozens of the island's villagers, who looked to the Union for protection. One of the soldiers recorded the sight of "mothers carrying their babes, fathers leading along the boys, grandfathers and grandmothers straggling along from homes they had left behind. Relying on our protection, they had been our friends, but in an evil hour we had been compelled to leave them."

Fortunately for the Indiana boys, the planned southern landing by the Confederates went badly. The boats went aground two miles from the designated landing point, and Colonel Wright, apparently losing his nerve, refused to let his men make shore in small surf boats, which they wanted to do. Even a small contingent of Confederates likely would have stopped the exhausted Indiana soldiers, many of whom would have surrendered for a drink of water.

About midnight, the bedraggled Indiana troops made Hatteras Light, where they found comrades and water. The Georgians halted their chase, content with eight Federals killed and forty in tow as prisoners.

The two forces faced off for several hours, until the Georgians learned that the southern landing had gone badly and that they could expect no reinforcements. Deciding that the aborted landing threw the advantage to the Union, the Georgians broke camp and started back to the safety of Chicamacomico.

They were not to tarry. As the dawn broke, a detachment of the Ninth New York—Hawkins' Zouaves—departed Fort Hatteras for the Hatteras Lighthouse to reinforce the tattered Indiana troops. The Georgians soon found themselves in a role reversal of the previous day, looking over their shoulders at the pursuing Federals.

During the Confederate retreat to Chicamacomico, a weather calm allowed the Union gunboat *Monticello* to pull alongside the Georgians and rake them with a heavy fire of shell, grapeshot, and cannister. The scurrying Georgians reached Chicamacomico just ahead of their pursuers and in time to board the awaiting Mosquito Fleet. They made a disheartened voyage back to Roanoke Island, and the battle for Hatteras was over.

Neither side achieved an advantage in the Chicamacomico skirmishes. Both sides bungled several opportunities for victory. And both sides retired from the field believing that they had prevented a major offensive by the enemy.

The eventual capture of Hatteras Island, on the other hand, was a significant defeat for the Confederacy. Southern complacency toward the strategic Outer Banks inlets would be repeated at Fort Fisher (near Wilmington) in the last year of the war, with consequences even more dire.

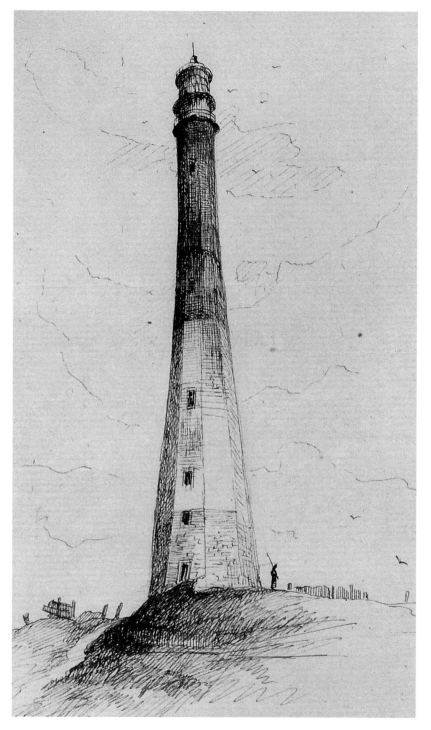

Cape Hatteras Lighthouse, 1862. This drawing shows the original 1802 stone structure and its 1854 addition, which was built with stones of a different color. The drawing suggests a white bottom and a red top. William Tatham described the light in 1806 and complained that "its being composed of two kinds of stones renders its party [*sic*] color an architectural Eye Sore." (Pen-and-ink drawing by Edwin Champney, courtesy of the North Carolina Division of Archives and History)

97

Facing page, top. Capture of the Union gunboat *Fanny* by North Carolina's "Mosquito Fleet" in Pamlico Sound, October 1, 1861. Before the capture of the *Fanny*, Union forces had experienced no losses in their invasion of Hatteras Island. With the *Fanny*, the Confederates took forty-three soldiers and some $150,000 worth of supplies. (From an 1861 engraving, courtesy of the North Carolina Collection, University of North Carolina at Chapel Hill)

Facing page, bottom. The Twentieth Indiana encamped at Hatteras. This group was one of several Union regiments that camped on Hatteras Island. (From an engraving in *Frank Leslie's Illustrated Newspaper*, November 9, 1861, courtesy of the North Carolina Outer Banks History Center)

Below. The Union steamer *Monticello* shells Confederate troops on Chicamacomico Banks on their return from an unsuccessful attempt to cut off the retreat of the Twentieth Indiana toward Hatteras Lighthouse for reinforcements, October 5, 1861. (From an 1861 engraving, courtesy of the North Carolina Collection, University of North Carolina at Chapel Hill)

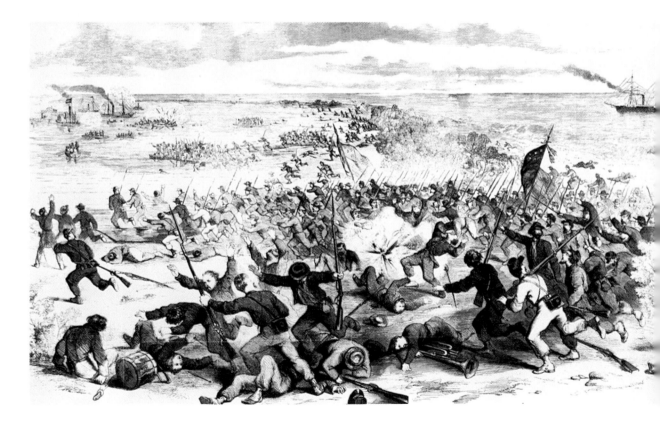

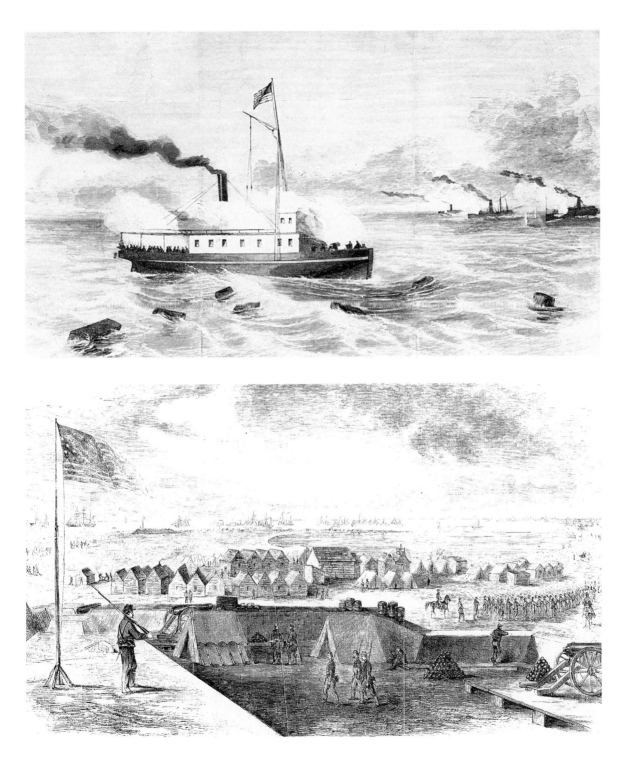

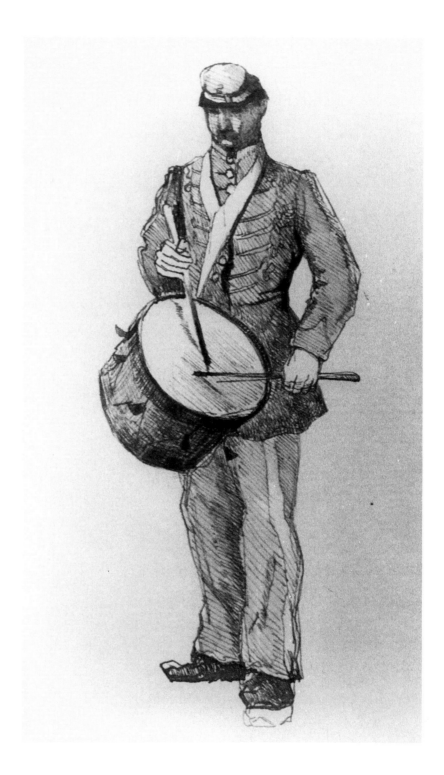

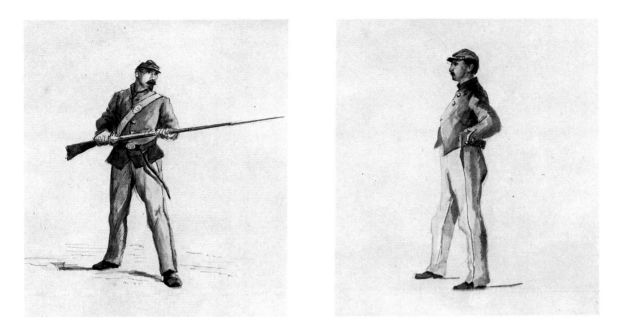

Soldiers of the Fifth Massachusetts Volunteers pose for a young artist, Edwin Graves
Champney, who documented Hatteras Island in some sixty drawings when he went ashore
with the Union invasion forces. Outsiders were shocked by the heat, the barren sweep of
sand, and the persistence of mosquitoes. (North Carolina Outer Banks History Center)

Facing page. A drummer with the Fifth Massachusetts, a regiment encamped at Hatteras Island
(Drawing by Edwin Champney, 1862, courtesy of the North Carolina Outer Banks History
Center)

Unidentified black man, probably a contraband, in civilian clothes and a Union forage hat. Union forces used the term "contraband" for former slaves because it made them legally eligible for confiscation by the invading armies. Wherever the Union secured ground in the South, their camps were flooded with runaway slaves. (Pen-and-ink drawing by Edwin Champney, 1862, courtesy of the North Carolina Outer Banks History Center)

102

Unidentified black participants in the Hatteras occupation. It is not clear whether these individuals were Union sailors or runaway slaves. A chart of Cape Hatteras published in *Harper's Weekly* on September 21, 1861, includes a shack with a sign that reads "Hotel d'Afrique." The site is located just west of Fort Clark. That designation usually identified a slave refugee camp. (Drawing by Edwin Champney, 1862, courtesy of the North Carolina Outer Banks History Center)

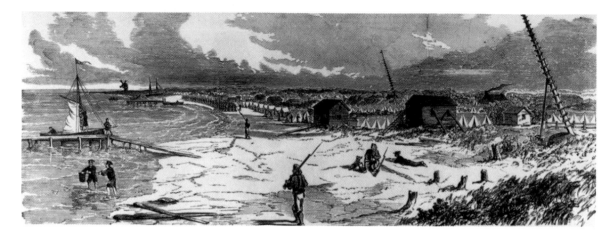

Camp Wool on Hatteras Island. After capturing Forts Hatteras and Clark from the Confederates, the Ninth New York (Hawkins' Zouaves) built its own camp on the sound side of the island about two miles from Fort Hatteras. The Ninth, under the command of Colonel Rush Hawkins, numbered 1,046 men at Hatteras. The regiment went on to achieve a notable reputation for discipline and bravery. Charles Johnson, a young volunteer from Minnesota, was stationed here. He subsequently published a journal titled *The Long Roll*. He recalled, "It was a very romantic march for me. After passing the long open beach above Camp Wool, we entered woods more solid than any on the lower part of the Island, and the night being extremely dark, I could at times scarcely distinguish two file-leaders ahead. But the weariness soon became oppressive, and when the canteen gave out, the men began to drop. I asked my companion for a drink once, for my tongue seemed to be parched; it was refused and I did not ask again, but contented myself with chewing the leaves of the overhanging trees, which were covered with a heavy dew. When we had made thirteen miles, the column halted and we turned in as best we could under the tree." (Engraving in *Harper's Weekly*, 1862)

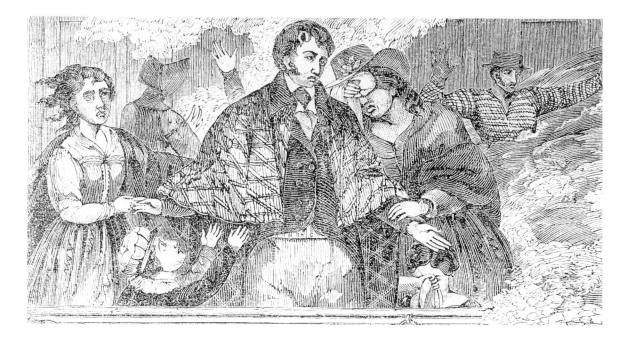

The steamship *Home*, one of some two thousand vessels to founder off the Outer Banks in the past four hundred years, went ashore at Ocracoke in 1837 in a severe hurricane called Racer's Storm. Half of the ship's ninety passengers were lost, including North Carolina native Hardy Bryan Croom and his family. In this illustration the Crooms are shown resigned to the rising waters of a furious Atlantic. (From an engraving in *Tragedy of the Seas,* courtesy of the North Carolina Collection, University of North Carolina at Chapel Hill)

Facing page, top. A "Grand Water Spout" in Albemarle Sound, August 3, 1864. Witnesses to storms along the Outer Banks are unanimous in their descriptions of the coastal storms' ferocity. Hurricanes, nor'easters, cyclones, and waterspouts are part of the history and lore of the islands. (From an 1864 engraving, courtesy of the North Carolina Division of Archives and History)

Facing page, bottom. A storm off Hatteras—a familiar scene to residents of the Outer Banks as early as the seventeenth century. Cape Hatteras was especially dangerous because of its extensive shoals and the destabilizing encounter nearby between the warm Gulf Stream and the cold Labrador Current. It is this area, off Diamond Shoals, that was originally labeled the "Graveyard of the Atlantic." (Engraving from the *Illustrated News,* April 23, 1853, courtesy of the North Carolina Collection, University of North Carolina at Chapel Hill)

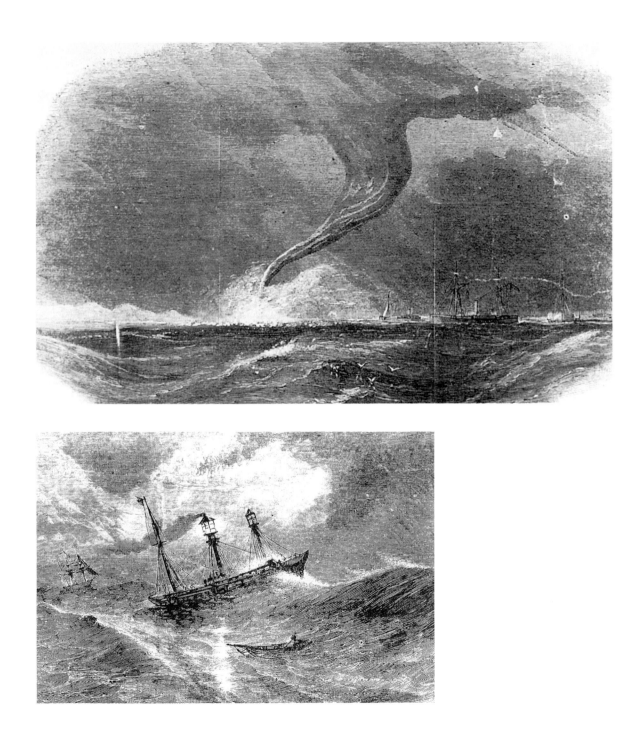

Storms and Shipwrecks

Residents of the Outer Banks are close acquaintances with all manner of storms, including hurricanes, nor'easters, and cyclones, and have been so since before the vicissitudes of these barrier islands' weather were even recorded. Water spouts that swallow ships, cyclones that move houses, sou'easters that open new inlets, and hurricanes of such ferocity that they destroy the instruments recording their fury—these have always been a certainty in the life of the Outer Banks.

The very earliest explorers of the North Carolina coast documented coastal storms in superlative terms. In 1524, Giovanni da Varrazzano, tacking up the North Carolina coast in search of a route to the East, claimed to have survived the most severe gale that "sailing man has ever known."

The Roanoke voyages were plagued with storms, one of which blew Governor Ralph Lane's ship away and forced him to return to England. Another storm in 1590 prevented John White from making a thorough search for his family and his "lost colony" on Roanoke.

Shipwrecks were the common corollary to coastal storms. In the age of sail, weather was both friend and foe of maritime traffic. Until the second half of the nineteenth century, when steam power could out-muscle nature's grip, the only compensating factor to contrary winds was the skill of the man at the helm. Ship's captains and pilots were honored men along the coast, professionals of respect and prominence, because they often held the fate of men and women in their skilled hands. Their courage and integrity were tested constantly.

Storms and shipwrecks form a major part of the history and lore of the coast; perhaps as many as two thousand vessels rest in watery graves along the Outer Banks. Every wreck and every

storm carry their own accounts of human fear and bravery, of individual heroism and collective terror.

Given the ferocity of coastal storms and the absence of lifesaving stations until late in the nineteenth century, it is surprising that so many people were saved from shipwrecks. Rescues were for the most part improvised affairs, executed by innovative crews and passengers or by intrepid residents who happened upon the scene.

When the schooner *Enterprise* from Rhode Island grounded at Chicamacomico in 1822, the quick-thinking crew put a horse overboard to guide passengers to the beach. All of the people aboard were saved. Unfortunately, when a local captain, Edward Scarborough of Chicamacomico, transported the battered survivors to the village of Ocracoke to catch the next ship out, a sudden squall washed the native waterman overboard, and he was drowned. Natives were not immune to nature's tempest.

In 1837, the brigantine *Carroll* struck near Cape Lookout during a snowstorm. In an inspired moment, the crew tied a line around the neck of its mascot dog, Pillow, who swam to shore, where local watermen waited helplessly. All aboard were pulled safely to shore.

The steamship *Home*, a 550-ton passenger vessel out of New York with some hundred people aboard, was less fortunate. The ship was one of the finest and fastest passenger packets at sea. She was no match, however, for one of the century's worst hurricanes, called Racer's Storm.

The *Home* plowed smack into the storm-churned seas off the Outer Banks in 1837. Her pumps could not keep pace with the volume of water washing onto her decks, so the passengers formed bucket brigades. Huge waves kept the paddlewheels out of the water, and her bow dipped dangerously into the troughs.

Finally, when the vessel's fires were extinguished, the captain put her under sail and steered for the beach. She struck just north of Ocracoke at 10 P.M. on October 9, 1837.

Two lifeboats were lost to the high waves before they could be launched. A third capsized in the water with its occupants. There were only two life preservers on the vessel, and two men commandeered them and used them to make shore.

As the ship broke up, a passenger tolled the ship's bell in a plea for help. Of the 103 people who left New York in such high spirits, some ninety, mostly passengers, were lost. As a result of

the *Home* tragedy, Congress enacted legislation requiring life preservers for all passengers on ocean-going vessels.

There are certain years when the Outer Banks are hammered by storms of exceptional force. Knowing that these storms will come again, native Bankers warn the unconcerned against complacency.

The year 1842 was such a time. Storms tore through the Banks in July and August, inundating houses and sinking ships. At least fourteen vessels went aground along the Banks, and several, including the schooner *Lexington*, the brig *Pioneer*, and the ships *Kilgore* and *Congress*, were sunk.

Tales of terror attend the wrecks and storms along the Atlantic's graveyard. The New England bark *Orline St. John* is one such example. She foundered in a gale off Cape Hatteras in 1854. The crew secured themselves in the ship's rigging for a week without food or water. Several, including the captain's wife, died from exposure. The survivors stayed alive by cannibalizing one of the dead crew. They were finally rescued after ten days aboard the wreck.

It is surprising how many watermen, ships' crews, and passengers could not swim. Swimming was not then the leisure activity it became in the twentieth century, and few people had the opportunity or the inclination to learn the rudiments of water safety. Others, particularly crew members who lived on the water, may have deliberately avoided learning the skill, in the hope that their death, if it came on the high seas, would come quickly.

Following the Civil War, ocean-going vessels were increasingly powered by steam, though fishing vessels and freighters continued to ply the Atlantic under sail through the 1920s.

Steamers were less at the mercy of contrary winds and the push of the Gulf Stream, but they carried with them other dangers. Boiler explosions and fires were common aboard steamers, and high seas frequently extinguished boiler fires, rendering the vessels helpless.

In 1870, the steamship *Washington* was destroyed by fire, with a total loss of cargo, and the steamship *Mary Sanford* beached at Cape Hatteras and burned. One hundred forty barrels of turpentine, four hundred barrels of rosin and tar, and six bales of cotton were saved from the latter wreck.

The years 1877 and 1878 brought devastating storms along the Banks, and a tragic loss of life from shipwrecks. In 1877, the 541-ton *Huron*, a man-of-war screw steamer, left Hampton Roads

in a gale with 132 officers and men. Commander George Ryan chose to steam close to shore along the Banks to avoid the contrary push of the Gulf Stream.

The *Huron* struck on a bar off Nags Head in high seas. Her men spent a terror-filled night clinging to spars and railings as the ship broke up and slowly sank. When the pale and cold dawn arrived, fifty men were huddling on the forecastle, while others hung from the rigging and held onto whatever piece of the ship seemed to be holding fast. Through the fog they could see a lantern bobbing along the shore some hundred yards away.

The federal government had begun a systematic program of lifesaving stations along the Atlantic seaboard, and a station had only recently been opened a mere two and a half miles from the helpless *Huron*. However, these new stations were not funded full-time; they operated seasonally, and it was the misfortune of the *Huron* men to have wrecked at the wrong time of year. Moreover, local residents who discovered the wreck were afraid to break into a government facility to get the rescue equipment. So it was not until hours after the discovery of the wreck that someone finally brought some lifesaving equipment to the site.

By then it was too late to help the victims. The ship had broken up and all hands had been swept into the boiling sea. Only thirty-four men made it to shore alive.

The year 1878 also brought unparalleled storms along the Outer Banks. A hurricane with winds estimated at 165 miles per hour whipped across the islands, leaving wreckage and death in its wake. The whaling schooner *Scychelle* was driven ashore at Cape Lookout and totally destroyed. The German barque *Phillip Suppicich* beached near Cape Hatteras, and all those aboard were lost. The schooner *Magnolia* was wrecked in the Albemarle Sound; her captain was lost.

But the greatest loss of the year was that of the *Metropolis*, formerly a Union gunboat named the *Stars and Stripes*. The bark-rigged screw steamer of 879 tons carried 248 people and was bound for the interior of Brazil to lay a railroad.

The *Metropolis* was old and unseaworthy. She was poorly loaded, and her cargo of iron rails shifted from the roll of the seas. Seams opened in her hull, then high waves took out her boiler fires and left the wounded vessel at the mercy of the Atlantic. The captain ordered short sails and steered for the beach. She grounded on Currituck Banks at Poyners Hill.

Lifesavers arrived to pull the victims from the frothing surf, but even with their help, eighty-

five of the men drowned in the angry waters. The *Norfolk Landmark* reported that the beach was strewn with pieces of ship, furniture, and dry goods, "146 people without hats or shoes, and in many instances almost naked, several simply wrapped in blankets, despite efforts of the people to provide clothing."

The twin tragedies of the *Huron* and the *Metropolis* spurred the government to extend its life-saving stations farther south down the Banks.

Along the Outer Banks, the most famous storm of the late nineteenth century was the legendary hurricane San Ciriaco, named after the saint on whose day she struck Puerto Rico in August 1899. The hurricane is still referred to there as the Storm of '99.

The destructive force of San Ciriaco caught even the Bankers by surprise. Homes were flooded and swept from their foundations. Numerous boats and ships were beached or sunk. The island of Shackleford Banks, including the village of Diamond City, was totally inundated, and a mass exodus after the storm left the island barren and uninhabited. It has remained so to this day.

A weather observer at the U.S. Weather Bureau Station at Hatteras, S. L. Dosher, followed the fury of the storm and recorded its destruction. The blow lasted three days, building on August 16 to 140 miles per hour. The barometer fell to twenty-six the next day, as the eye of the storm passed over the island, and the winds shifted to the east and southeast before the storm picked up again and blew itself out on the nineteenth.

The storm was the worst since Racer's Storm in 1837. At the height of the storm, the island was from three to ten feet underwater, and every house was flooded. Residents gathered in groups of forty or fifty in the houses on the highest elevation, squeezing themselves into upstairs rooms while water flooded the lower levels. Cattle, sheep, hogs, and chickens drowned by the hundreds. Ships grounded and broke up. The *Diamond Shoal* lightship left her moorings and went aground at Creed's Hill. The wind-recording instruments at the weather bureau station were blown away. Dosher wrote, "Language is inadequate to express the conditions which prevailed all day on the 17th. The howling wind, the rushing and roaring tide and the awful sea which swept over the beach and thundered like a thousand pieces of artillery made a picture which was at once appalling and terrifying and the like of which Dante's Inferno could scarcely equal."

Ship's crews and passengers were saved up and down the coast by the heroic efforts of the

U.S. Lifesaving teams, whose members braved fierce winds and pounding surfs to pull storm victims to safety. The crew aboard the *Diamond Shoal* was saved by the Creed's Hill team. The crew of the *Florence Randall* was rescued by the Kinnakeet lifesavers.

But the most dramatic rescue of shipwreck victims during the memorable storm was made by surfman Rasmus S. Midgett. The *Priscilla*, a 640-ton barkentine en route to Rio de Janeiro, went ashore at Hatteras Island just south of Gull Shoal Lifesaving Station. The captain of the ship had stood helpless as savage waves snatched his two sons and his wife from his arms and into the roiling seas. Surfman Midgett came upon the scene shortly thereafter. The waves were breaking up the ship, giving Midgett no time to summon help. He plunged into the surf ten times, each time bringing another survivor to safety. For his unparalleled accomplishment, the surfman was awarded the coveted Gold Life Medal of Honor.

With the passing of the age of sail and the improvement of ship safety, major maritime disasters declined. Because of this decrease in the need for lifesavers, in 1915 the USLSS was merged into the U.S. Coast Guard, whose maritime role increasingly became one of prevention.

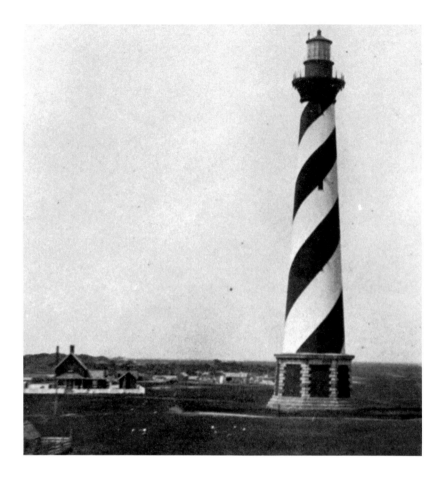

Hatteras Lighthouse, ca. 1903. This lighthouse, the most famous one on the Outer Banks, has flashed its warning signal to mariners approaching the dangerous shoals since 1870.

The first light at Hatteras was authorized by Congress in 1794 and was placed into service some ten years later. It was a sandstone structure that reached one hundred feet. Its beam proved inadequate immediately and drew constant complaints from mariners for fifty years, until Congress appropriated funds to elevate the tower and equip the light with a Fresnel lens, the first on the Banks, in 1854.

The present light—the third—was built between 1868 and 1870. When it was completed, the two-hundred-foot brick structure was dubbed the "most substantial lighthouse in the world." Its black-and-white spirals are recognized by mariners worldwide. It is again in trouble, this time from beach erosion that threatens its 1868 foundation. (Cape Lookout National Seashore, National Park Service)

Top. The lightkeeper's house at Hatteras, 1863. The house is rather grander than most houses on the Outer Banks, as was sometimes true of government-sponsored structures. Even so, the style is typical vernacular with I-house characteristics. Lightkeepers drew a regular salary and free housing for their services, so the position was highly desirable. (Drawing by Edwin Champney, courtesy of the North Carolina Outer Banks History Center)

Bottom. Interior of the lightkeeper's house at Cape Hatteras, 1863. A rare look at the inside of an Outer Banks house in the mid-nineteenth century. A tidy room in the house, sparsely furnished, is typical of the unadorned houses on the Banks. Obviously, this drawing followed the occupation of Hatteras Island: the room is occupied by a couple of dozing Union sentries. (Drawing by Edwin Champney, courtesy of the North Carolina Outer Banks History Center)

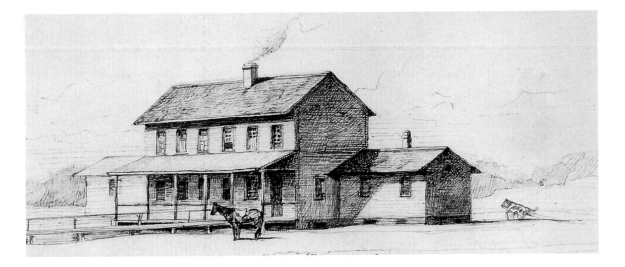

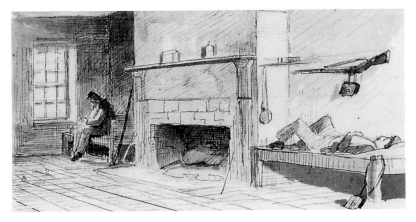

Ocracoke Lighthouse, distinctive due to its white stucco exterior, is the oldest light on the Outer Banks, built in 1823. Ocracoke and Portsmouth Islands replaced Shell Castle Island as the lower Banks lightering ports after the channel to Shell Castle shoaled over. This light guided traffic through Ocracoke Inlet. (Photograph by Lisa Griggs from Martin R. Conway, *The Outer Banks: An Historical Adventure from Kitty Hawk to Ocracoke* [Shepherdstown, W.V.: Carabelle Books, 1984])

116

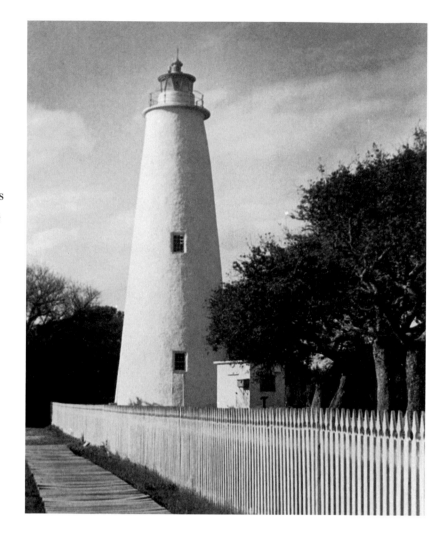

Facing page. Cape Lookout Lighthouse, at the very southern tip of the Outer Banks, was erected in 1812. It was actually two towers, a brick structure of some ninety-three feet inside a wooden shingled tower painted in red-and-white horizontal stripes. Lighthouses were identified by their colors and design and by the sequence of their flashes.

The old towers were replaced in 1859 by a 150-foot brick tower that still stands. The black-and-white diamond designs of the current lighthouse signal mariners that they are approaching Cape Lookout Shoals and Shackleford Banks. The lost nineteenth-century whaling community of Diamond City on Shackleford Banks took its name from the Lookout Light tower. (North Carolina Division of Archives and History)

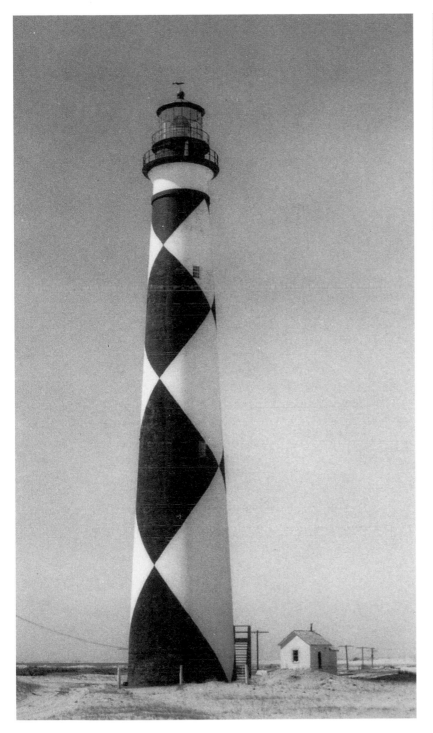

Charlotte Ann Mason, assistant keeper of the Cape Lookout Lighthouse, 1872–75. Women rarely achieved prominent positions on the Outer Banks, and their contributions were not always noted. Charlotte Ann Mason was one of numerous women in late-nineteenth-century America who served as a lighthouse keeper. (Cape Lookout National Seashore, National Park Service)

A schematic drawing of Bodie Island Lighthouse, showing a first-order lens. The tower was constructed in 1872. On the drawing, the island's name is spelled as it is pronounced: "Body's." (From an original drawing, ca. 1870, courtesy of the North Carolina Maritime Museum, Beaufort)

118

Facing page. Bodie Island Lighthouse. This black-and-white horizontal striped lighthouse was built in 1872, after the second Bodie Island Light, completed in 1859, was destroyed by Confederate troops to deny its use to Union forces. The first light was completed in 1852 but was inadequate and was quickly replaced. (Photograph by C. W. Stoughton, 1969, courtesy of the Cape Lookout National Seashore, National Park Service)

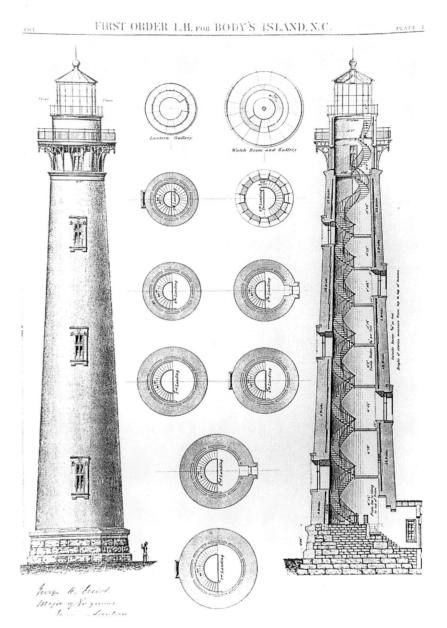

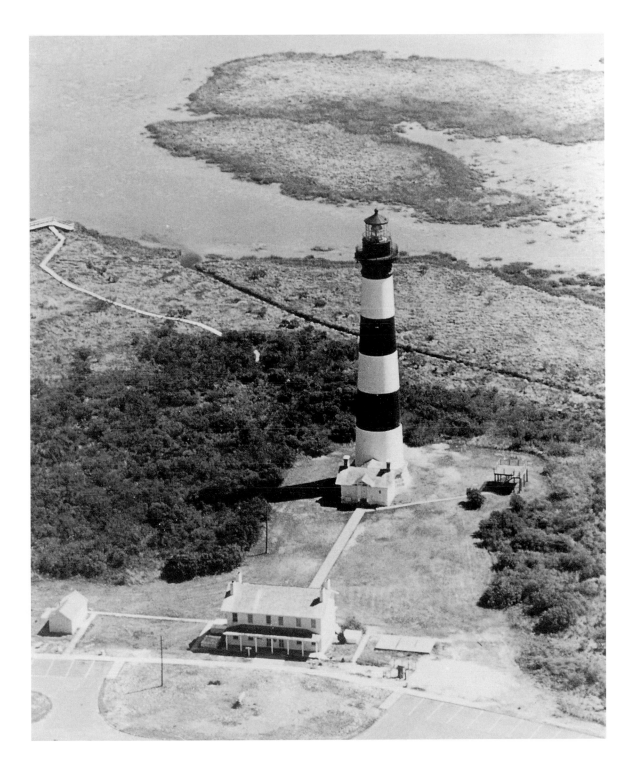

119

Sentinels of the Sea

Lighthouses did not appear on the North Carolina coast until the waning years of the eighteenth century, but their value was so widely recognized that by the middle of the nineteenth century the lights dotted the Outer Banks from Currituck to Cape Lookout. In addition, the state constructed screw-pile lights in the sounds and floated a number of lightships in the sounds and the Atlantic.

The first light built on the Banks was the Shell Castle Light, a pyramid-shaped wooden structure with a shingle exterior that stood only fifty-five feet high. It was located on Shell Castle Island, just inside Ocracoke Inlet, and was built by John Wallace and John Gray Blount to attract maritime traffic to their lightering complex.

The navigational lighting aids of the early nineteenth century were often inadequate, their lights weak and ineffective, and their keepers without training. Most used an Argand fountain lamp with parabolic reflectors and a magnifying lens. The reflecting lenses were difficult to keep clean, and at times the reflective surface was rubbed away. Even after the Argand lamp was refined with a series of lamps and reflectors called the Lewis system, navigational lighting continued to fail mariners when they most needed it.

As late as 1851 the captain of a mail steamer wrote that "The lights at Hatteras, Lookout, Canaveral, and Cape Florida, if not improved, had better be dispensed with, as the navigator is apt to run ashore looking for them." Actually, most of the lights were gradually replaced or elevated and fitted with an improved lighting system.

An efficient lighthouse illumination system had already been developed when the captain made his complaint, but the United States Lighthouse Service was slow to adopt the newfangled technology. The Fresnel lens—named for its inventor, French physicist Augustin-Jean Fresnel—made the conceptual leap in improved

lighting in the 1820s. The lens is a glass dome of prisms and bull's-eyes that concentrate the light at its center into parallel rays that are then intensified with a powerful magnifying glass. This type of light was finally adopted by the United States in the 1850s, and by the Civil War, every lighthouse on the East Coast had a Fresnel lens.

Lighthouses were erected along the Banks at the inlets that cut through the islands and near dangerous shoals, such as Diamond Shoals and Lookout Shoals. Other lights were erected at Ocracoke, Bodie Island, Beacon Island, Bogue Sound, and Currituck.

The cost of building lighthouses and the instability of areas like Cape Hatteras inspired the government to experiment with other navigational aids. Lightships were used extensively in the shoal areas of both the Atlantic and the sounds. The first lightship placed into service in North Carolina was the *Diamond Shoal*, so named for its duty fourteen miles east-southeast of Cape Hatteras at the tip of the island's notorious Diamond Shoals. Launched in 1824, the vessel displaced three hundred tons and carried lights on two separate masts. She was manned by a captain and a crew of four, who likened their duty to solitary confinement.

The *Diamond Shoal* had been in service but a few months when a storm ripped her from her moorings and battered her so roughly that she had to put into Norfolk for extensive repairs. She took two more beatings from storms before finally being tossed onto the beach at Ocracoke in 1827. Seventy years passed before another lightship was moored at Diamond Shoals. Other lightships were positioned at Lookout, at Brant Island Shoals, and at other points in the coastal sounds.

Lightships were supplemented in the sound waters by screw-pile lighthouses, frame houses mounted on pilings some fifteen feet above the water. These simple structures were considerably cheaper to build and maintain than the brick Banks lights and were more suitable to the sound shallows than were lightships.

The first screw-pile light was erected at Roanoke Marshes at the south end of Croatan Sound in 1857. By the end of the century, there were more than half a dozen such lights straddling the sound waters of North Carolina.

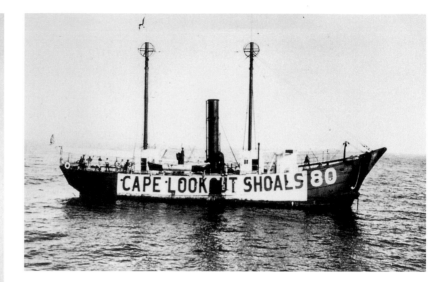

122

Left. Currituck Lighthouse on North Banks, ca. 1890. The light was started in 1872 and completed in 1875. Its natural brick was left unpainted to distinguish it from other lights on the Banks. The light towers over the beautiful Whalehead Club, once an exclusive gun club, now a county museum facility. (North Carolina Maritime Museum, Beaufort)

Top. Cape Lookout Shoals #80, ca. 1904. Lighthouses were not always adequate to the tasks demanded of them. They were occasionally built too short, and their lights were sometimes too weak to signal the intended maritime traffic. Cape Lookout, first used in 1812, suffered from these problems with its first tower, especially in heavy weather. One attempt to extend the reach of light signals was represented by lightships like the *Cape Lookout Shoals #80*. These signal vessels, which carried a light on each of their two masts, were manned by a skeleton crew who complained constantly about the isolation of the duty. (North Carolina Maritime Museum, Beaufort)

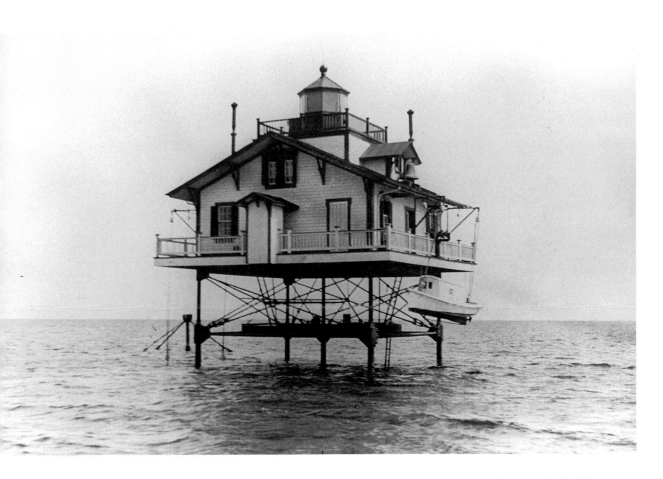

A screw-pile lighthouse in Croatan Sound between Roanoke Island and the mainland. These lighthouses, of which there were at least seven in North Carolina waters, served the same functions as lightships and light towers but were cheaper to build and maintain. The first one was erected at Roanoke Marshes in 1857. This relatively inexpensive navigational aid had replaced lightships in the North Carolina sounds by the end of the nineteenth century. (North Carolina Division of Archives and History)

A third-order Fresnel lens. The Fresnel (pronounced Fre-NEL) lens, developed in the 1820s by French physicist Augustin Fresnel, was a technological leap in navigational lighting. It is a glass dome of prisms and bull's-eyes, and light is concentrated at its center into parallel rays that are intensified with a magnifying glass. The lens was first used in North Carolina at Cape Hatteras Light in 1854. (Cape Lookout National Seashore, National Park Service)

A nineteenth-century surfman in a kapok life belt, as represented by *Harper's Weekly* in 1899, stands ready for duty. Lifesaving and lightkeeping were salaried jobs, a rarity on the Outer Banks, where a near-barter economy lasted until the 1940s. Consequently, the surfman's job, though hazardous, was much desired by men on the Banks. The surfman's unwritten code has been summarized in this verse published in Sonny Williamson's *Unsung Heroes of the Surf*:

The old lifesavers usta' quote
A little ditty, which some salt wrote:
 "You have to go out
 And that's a fact.
 Nothin' says
 You have to come back."

Uncle Sam regards the grim remains of the wreck of the *Huron* off Nags Head. The wreck and its loss of 103 lives in 1877 underscored a public demand for government responsibility for safety in maritime travel and helped to spur a new round of lifesaving station construction along the North Carolina coast. (*Harper's Weekly*, 1877, courtesy of the North Carolina Collection, University of North Carolina at Chapel Hill)

Above. The steamship *Metropolis*, one of numerous ships driven ashore by a winter storm, left her wreckage strewn along the beach at Currituck on January 31, 1878. Of 248 people aboard, 85 were lost to the churning seas. Barely visible in the background are impromptu grave markers for the wreck victims. (From *Frank Leslie's Illustrated Newspaper*, February 1878, courtesy of the North Carolina Division of Archives and History)

Facing page. A victim of the wreck *Metropolis*, one of eighty-five people who went to a watery death off Currituck Beach in 1878. North Carolina's Lifesaving Service received heated criticism in the national press for its failure to save the victims, although the new station operated on a seasonal schedule and was not open at the time of the wreck. (From *Frank Leslie's Illustrated Newspaper*, February 1878, courtesy of the North Carolina Collection, University of North Carolina at Chapel Hill)

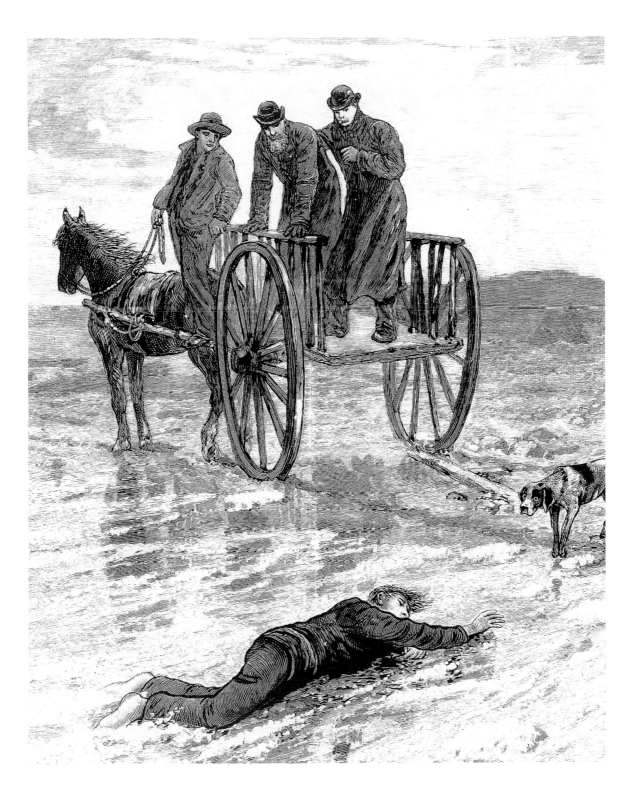

A lone watchman keeps a careful eye out for a distant vessel traveling in heavy seas off Pea Island. The prompt attention of a watchman meant the difference between life and death for wreck victims. One of the most constant distractions for the watch was boredom. (Drawing by R. E. Griffin from the U.S. Coast Guard *Commandant's Bulletin,* June 1980)

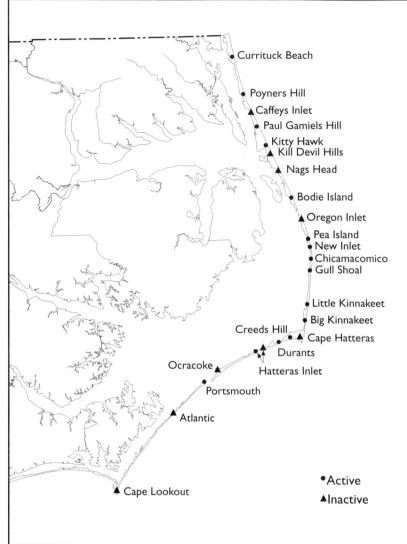

Map 5. Coast Guard Stations

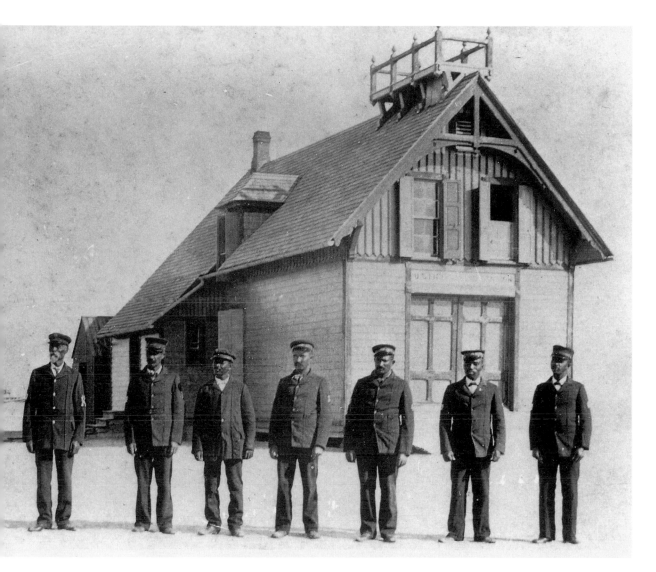

Pea Island Lifesaving Station and crew, ca. 1900. Pea Island has the distinction of hosting the
first all-black U.S. Lifesaving Service and Coast Guard units in the state. The first unit was
formed after the negligence of the original crew resulted in the deaths of at least four shipwreck
victims. Richard Etheridge was appointed keeper at Pea Island on January 24, 1880; he was the
first black keeper in the service. A recommendation for his appointment described him as "one
of the best surfmen on this part of the coast of North Carolina." (Drawing by R. E. Griffin from
the U.S. Coast Guard *Commandant's Bulletin,* June 1980)

Surfman Herbert M. Collins hoists a lifeline in a Pea Island surfboat. "We knew we were colored," recalled one of the unit members, "and, if you know what I mean, felt we had to do better whether anybody said so or not." Surfman Collins remained in the coast guard until his retirement in 1973. (U.S. Coast Guard *Commandant's Bulletin,* August 1980)

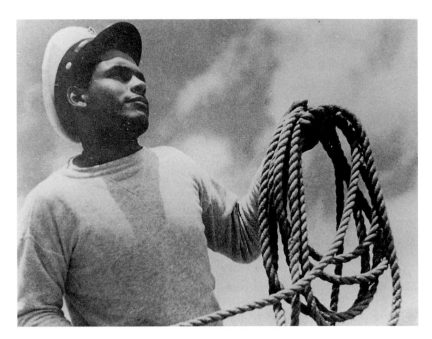

Lonnie C. Gray of the U.S. Coast Guard surfboat unit at Pea Island operates a signal light from the station tower. The surfboat unit was founded in 1915 when the U.S. Lifesaving Service merged with the Revenue Cutter Service to form the U.S. Coast Guard. The unit remained a predominantly black one until it was deactivated in 1947. (U.S. Coast Guard *Commandant's Bulletin,* August 1980)

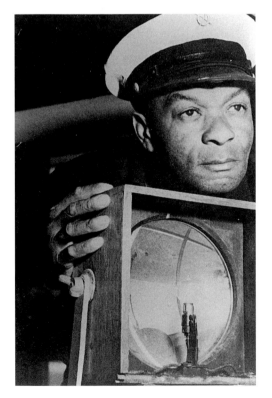

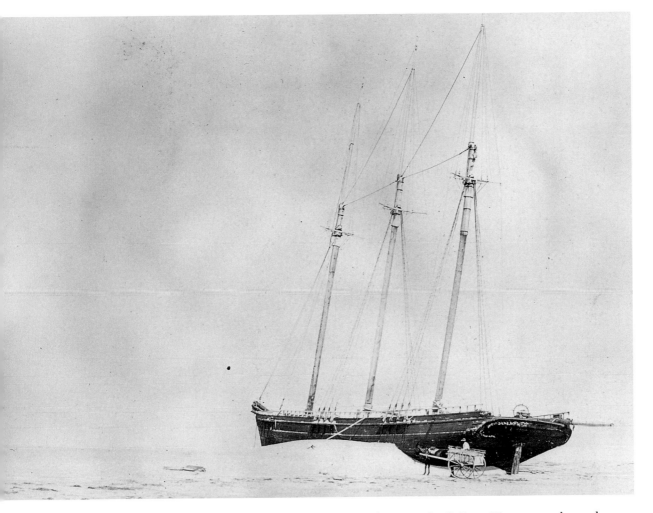

A three-masted schooner lies helpless against a dune just north of Cape Hatteras, where she was run aground by San Ciriaco in August 1899. That notorious summer storm may hold the records for the number of vessels it wrecked along the Outer Banks. (Photograph by W. H. Zoeller, courtesy of the North Carolina Collection, University of North Carolina at Chapel Hill)

Members of the crew from the *Priscilla* pose amidst the wreckage of their vessel, 1899. Surfman Rasmus Midgett of the U.S. Lifesaving Service received the coveted Gold Life Saving Medal of Honor for his singlehanded rescue of ten survivors from the wreck. (Photograph by Charles Morgan, courtesy of the North Carolina Collection, University of North Carolina at Chapel Hill)

Facing page, top. The wreck of the *Priscilla*, August 1899, near Gull Shoal, just south of Chicamacomico. The *Priscilla* was one of some fifty vessels destroyed or grounded by the infamous hurricane San Ciriaco, which also devastated Shackleford Banks. (Photograph by Charles Morgan, courtesy of the North Carolina Collection, University of North Carolina at Chapel Hill)

Facing page, bottom. Cargo from the ship *Priscilla* scattered along Gull Shoal, 1899. The retrieval of such wreckage over the centuries has sometimes contributed to charges of piracy against the Outer Bankers. (North Carolina Collection, University of North Carolina at Chapel Hill)

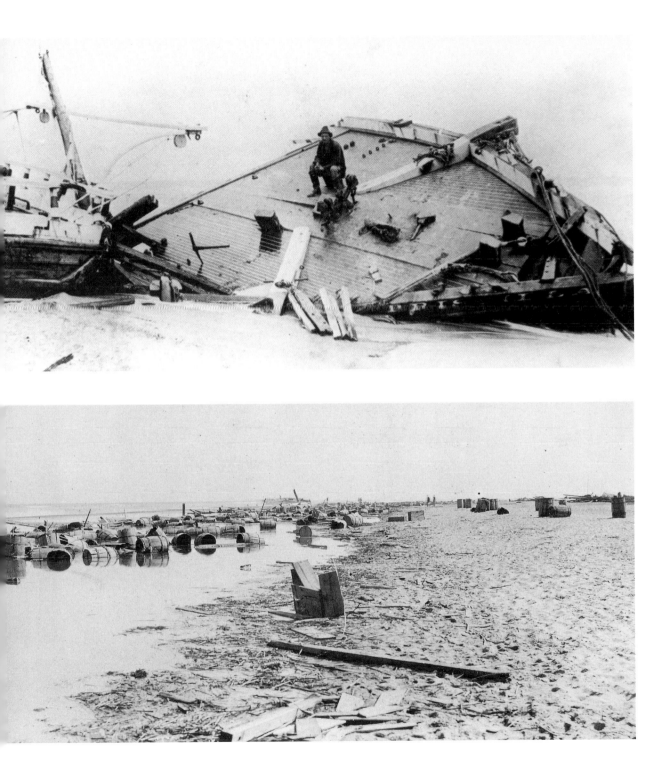

134

Scavengers pick over the remains of the *Priscilla*. The ship's anchor is being hauled along the beach on an improvised sleigh. A public vendue appears to be taking place in the background. (Photograph by Charles Morgan, courtesy of the North Carolina Collection, University of North Carolina at Chapel Hill)

Remnants of shipwrecks, like the remains of large animals, continue to litter the North Carolina coast. The relics are reminders of the area's shoal waters, difficult currents, and frequent storms. (Cape Lookout National Seashore, National Park Service)

An unidentified woman stands alone on her porch on Shackleford Banks in the last year that anyone would inhabit the island. In 1899 the hurricane San Ciriaco overwashed houses and gardens and dredged up cemeteries, forcing an exodus from Shackleford Banks to the mainland. (Cape Lookout National Seashore, National Park Service)

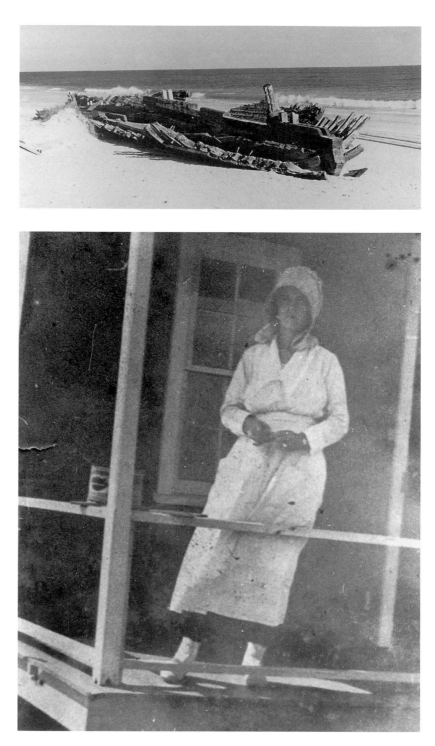

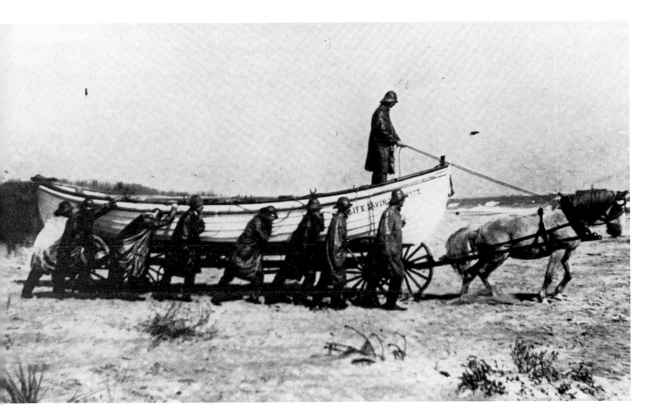

Even with help from the crew, the station horse is having to strain to pull the surfboat across the sandy beach for a drill. (Photograph, ca. 1900, courtesy of the Cape Hatteras National Seashore, National Park Service)

The United States Lifesaving Service

In the early years of their development, during the eighteenth century, the Outer Banks afforded no organized method of dealing with one of the area's most constant and worrisome problems: shipwrecks.

Fortunately, on their own initiative the Bankers did a fair job of saving and caring for hapless maritime refugees. In some cases the Bankers were rewarded for their actions either by wreck survivors, by the ship's owner, or by vendue (public sale) of the ship's cargo.

It is startling how many ships grounded and washed ashore on the Banks during the eighteenth and nineteenth centuries and how many times the Bankers risked their lives to save wreck victims and their cargo. Historical records are rife with melancholy statements of ship disasters off the Banks, such as the following cryptic newspaper notice that appeared in 1812: "The schooner *Independence*, of Burlington (New Jersey) from St. Domingo, with sugar and coffee, was cast away about fifteen days ago, at Kenekeet [*sic*], near Hatteras—Cargo nearly all lost; of the crew, consisting of eight, only one man was saved."

In 1801 the North Carolina General Assembly finally legislated a loose system of wreck districts for the Outer Banks that authorized wreck commissioners to handle maritime disasters. Wreck masters were responsible for gathering a posse to rescue ships in distress, accounting for the wreck and its cargo, and assuring that the ship's owners reimbursed the rescue party.

It was a haphazard system at best, leaving initiative with the various coastal communities, and it depended on local residents to have the integrity to do the right thing. If the cargo from a wreck went unclaimed for a year, a vendue was arranged by the wreck master.

A rash of maritime disasters near the midpoint of the nine-

teenth century convinced a reluctant Congress to appropriate funds for government-sponsored lifesaving stations. In 1852, federal money paid for surfboats to be stationed at Wilmington, Ocracoke, and Bodie Island in the custody of the customs collector.

It was not until 1871, following another series of shipwrecks, that a Revenue Marine Bureau was funded within the U.S. Treasury Department and given responsibility for maritime rescues. The new legislation authorized seven lifesaving stations on the Outer Banks, to be built in 1873 and 1874 at Jones's Hill, Caffrey's Inlet, Kitty Hawk, Nags Head, Bodie Island, Chicamacomico, and Little Kinnakeet.

The presence of lifesaving stations on the Outer Banks was a step in the right direction, but the stations were understaffed for years. It required the wreck of the *Huron* off Nags Head in 1877, with the loss of 103 lives, to create a public outcry for increased government resources for maritime disasters.

Two months later, the steamer *Metropolis* grounded at Currituck, and eighty-five people drowned. That same year, Congress conferred full bureau status on the U.S. Lifesaving Service (USLSS), and the agency came into its own. Like the Revenue Marine Bureau, the USLSS lay within the Treasury Department.

Still, the government rescue operations extended only halfway down the North Carolina coast, leaving Core Banks, Shackleford Banks, Bogue Banks, Topsail Island, and the Cape Fear regions without an official means of responding to shipwrecks. This geographical limitation may have been influenced by the Union sympathies of the upper half of the Outer Banks during the Civil War.

The politics of Reconstruction may have dealt another hand in the evolution of the USLSS on the Outer Banks. The story of the Pea Island Station, for example, is an anomaly in the service's annals and should be recounted in some detail.

The Pea Island station was built in 1878 and was staffed with an all-white crew. Soon after its opening for active duty, one of its watches failed to spot a grounded vessel. This lapse cost the lives of four men. An investigation of the tragedy by USLSS officials forced the resignation of the station keeper and of the surfman who had neglected his duties. The investigating official further recommended Richard Etheridge, a local black, for the position of keeper, and on January 24, 1880, Etheridge became the first black station keeper in the USLSS.

The appointment of a black keeper raised the ire of the local population, especially when Etheridge hired an all-black crew. On May 29 the station burned to the ground. An investigation cited arson as the cause, but no one was ever charged with the crime. Captain Etheridge supervised the construction of a new station and continued with his duties, drilling his crew beyond the requirements of the service. "We knew we were colored," recalled one of the unit's later members, "and, if you know what I mean, felt we had to do better whether anybody said so or not."

The Pea Island crew performed competently for years. In 1881 they assisted with the rescue of survivors from the grounded schooner *Thomas J. Lancaster*. They received accolades from the master of the schooner *Charles C. Lister, Jr.*, for their "timely heroic service," without which "we should likely all have been lost."

The crew made another dramatic rescue in 1896, when the *E. S. Newman* went aground on Pea Island in a hurricane. On board were the captain, his wife and child, and a crew of six. Etheridge and his men hauled their heavy equipment—sand anchor, faking box, 150-pound lyle gun—through hurricane winds over three miles of sea-washed beach. The equipment sank deep into the sand; it required supreme effort on the crew's part just to reach the wreck site.

A pounding surf and violent winds rendered a rescue most improbable. The lyle gun could not be used in the punishing winds. Crashing waves made it impossible to launch a lifeboat. So Etheridge tied lines to his two strongest surfmen and sent them wading through the roiling sea to the vessel. When the men reached the ship, one of them lashed the captain's child onto his back, and they struggled through the breakers back to shore. Taking turns, the lifesavers returned to the schooner again and again until every person was rescued.

Etheridge ran a taut and professional lifesaving unit at Pea Island for twenty years, until his death in 1900. His position passed to other black captains, and the Pea Island unit retained its special status when the USLSS merged with the Revenue Cutter Service in 1915. The unit was deactivated in 1947.

Yet another shipwreck tragedy was required to convince Congress of the wisdom of extending lifesaving operations south of Kinnakeet to the southern reaches of the Carolina coast. The dreadful breakup of the *Crissie Wright* in 1886 off Shackleford Banks, during which horrified citizens watched passengers and crew freeze to death in the ship's rigging, inspired lifesaving sta-

tions at Hatteras, Ocracoke, Portsmouth, Lookout, and so on down the coast to Wilmington and Southport. Ultimately, twenty-nine stations were built along the Carolina coast.

On January 15, 1915, the U.S. Lifesaving Service merged with the Revenue Cutter Service to form the United States Coast Guard. The coast guard absorbed the Lighthouse Service in 1939; its duties had come to include both prevention and rescue, customs violations, prohibition enforcement, and all other national maritime regulation. In many instances, the coast guard simply occupied the structures of its predecessors and went on with business as usual. Numerous family names that appear on the rosters of the U.S. Lifesaving Service in the 1870s also make up the duty rosters of the present-day coast guard along the Outer Banks.

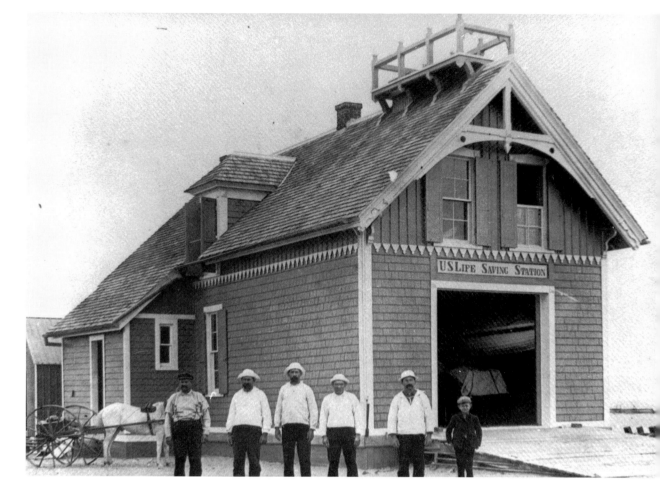

Little Kinnakeet Lifesaving Station and crew, ca. 1895. Little Kinnakeet's was one of the original seven stations built in 1873–74. The station horse is harnessed to an equipment cart. Note the observation deck on the roof of the building. The young man in the photograph is probably the station mascot. (National Archives)

Facing page, top. Creed's Hill Lifesaving Station on Hatteras Island. The Victorian-style cottage was likely copied from a New England model. (Undated photograph, courtesy of the North Carolina Division of Archives and History)

Facing page, bottom. Portsmouth Lifesaving Station and crew, ca. 1915. The station was built in 1894, its architecture modeled after a station built at Brant Rock, Massachusetts. It is presently used by the National Park Service. (Cape Lookout National Seashore, National Park Service)

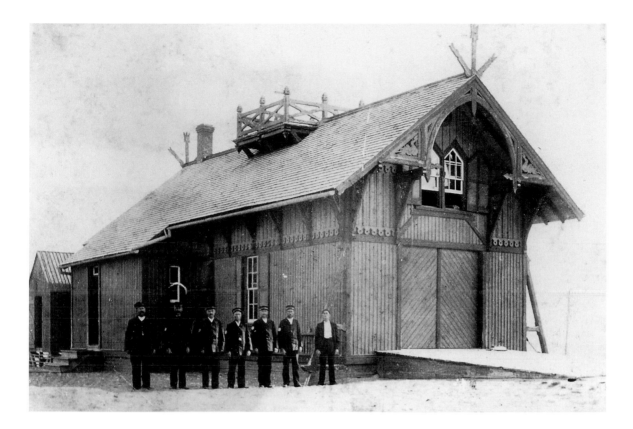

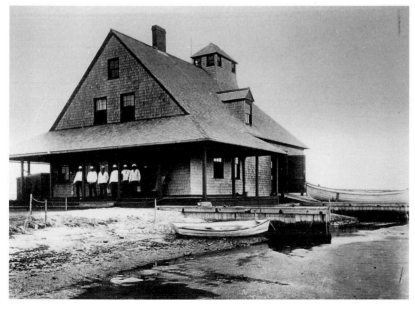

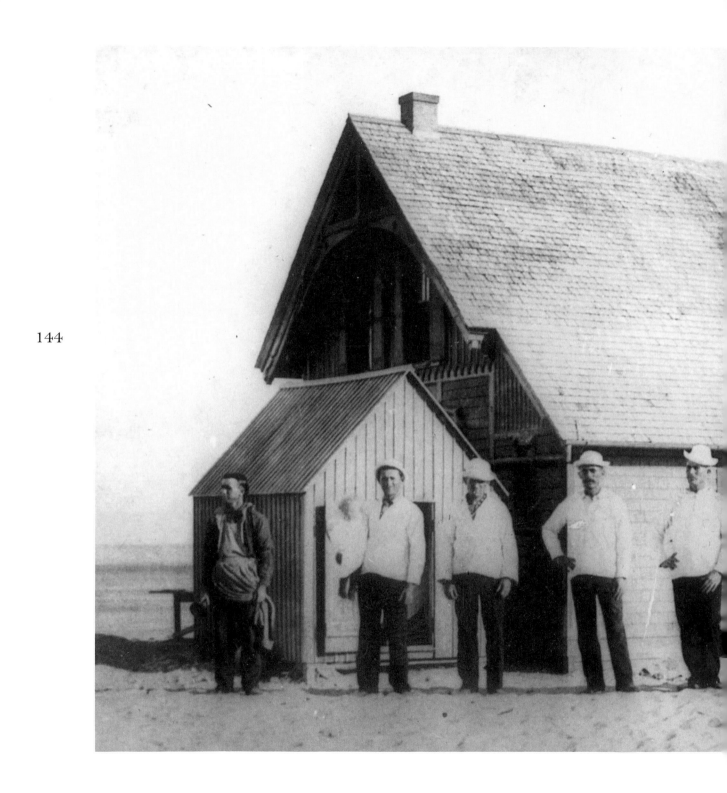

144

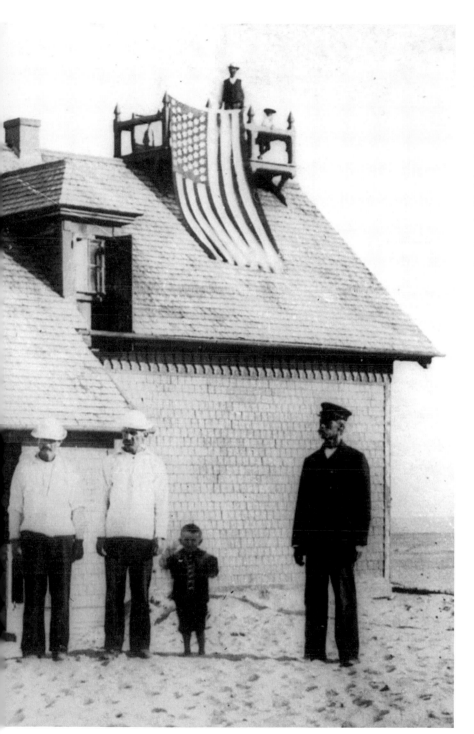

Big Kinnakeet Station and crew, ca. 1900. This photograph may have been taken on a holiday when families were permitted to visit, as evidenced by the children present and the enormous flag draped from the observation deck. (North Carolina Division of Archives and History)

New Inlet Lifesaving Crew, ca. 1903. The members of this integrated lifesaving crew pose outside their station, proudly displaying the USLSS insignia on their jackets. (North Carolina Division of Archives and History)

146

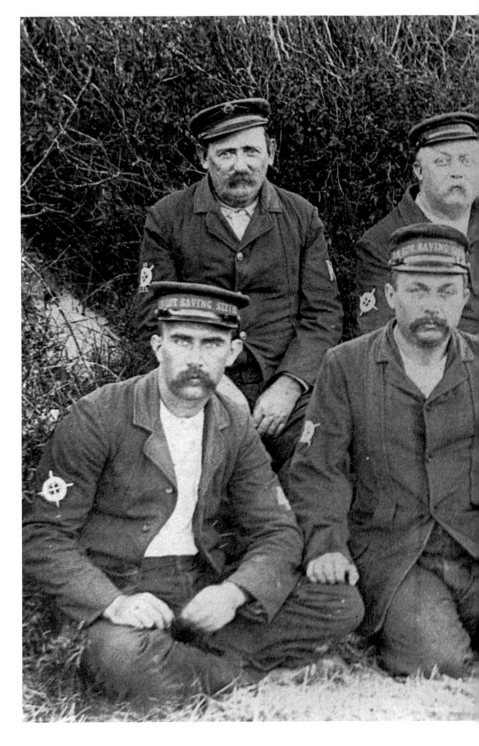

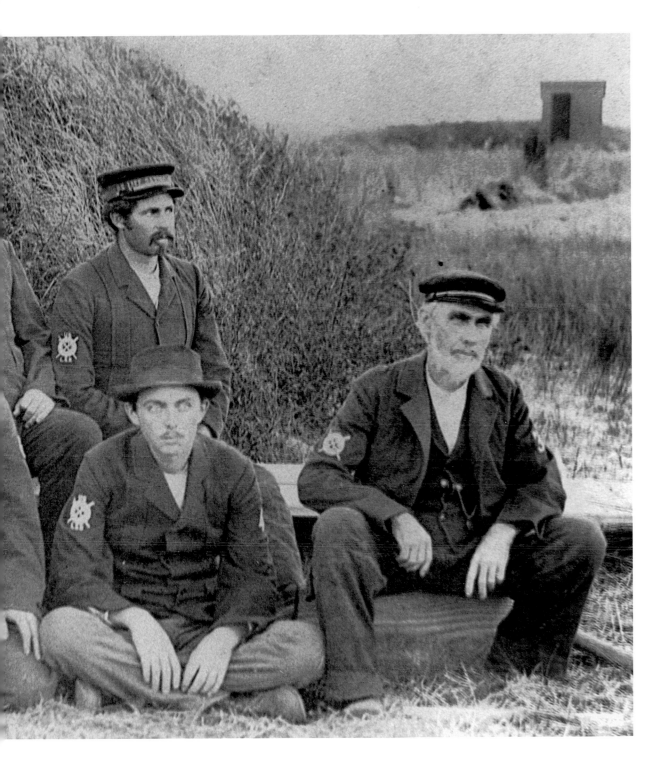

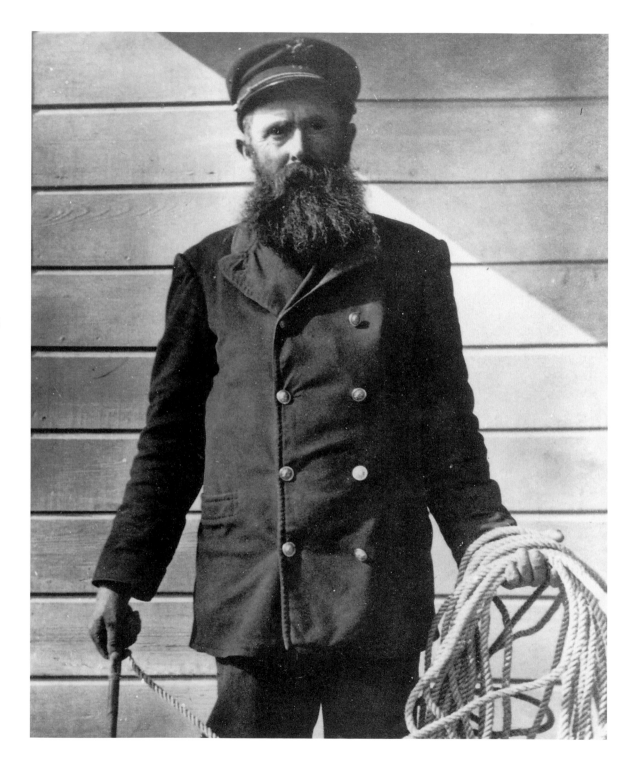

148

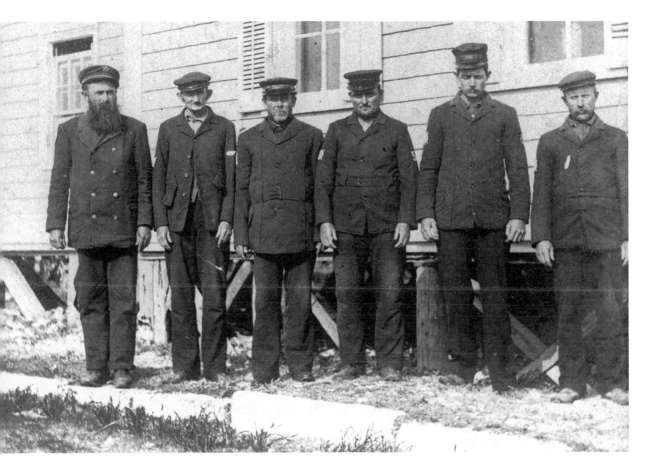

Captain Pat Ethridge and crew at Cape Hatteras Lifesaving Station, ca. 1903 (Photograph by H. H. Brimley, courtesy of the North Carolina Division of Archives and History)

Facing page. Captain Pat Ethridge of the Cape Hatteras USLSS poses with a lifeline. Looking very much the proverbial old salt, Ethridge, like most other lifesaving captains, generated considerable local legend and lore. (Undated photograph, courtesy of the North Carolina Division of Archives and History)

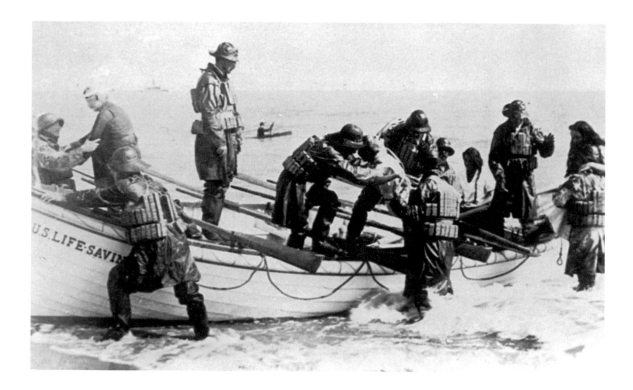

Lifesavers pull victims from a surfboat onto an unidentified stretch of beach. Scenes like this one occurred regularly up and down the North Carolina coast, usually passing without public notice or comment. It required a major maritime disaster to get the attention of the press and the public. (Undated photograph, courtesy of the National Archives)

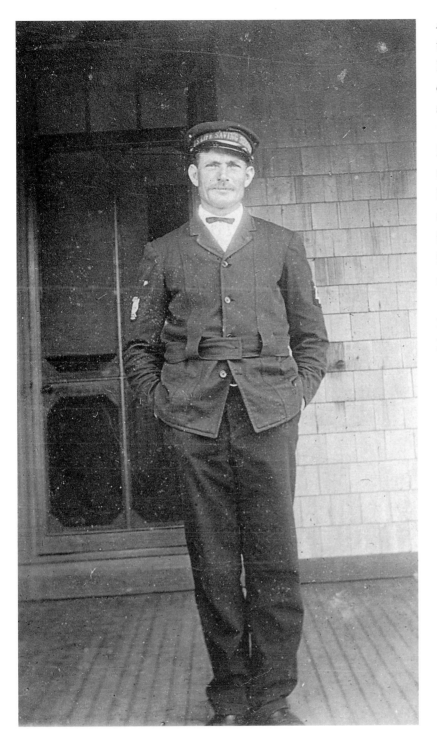

A dignified member of the crew at Portsmouth Island Lifesaving Station, ca. 1910. The Portsmouth station was opened in 1894 on the old Marine Hospital grounds the same year the hospital burned. The population of the island had dropped from over five hundred in the 1850s to less than two hundred by the 1890s. (Cape Lookout National Seashore, National Park Service)

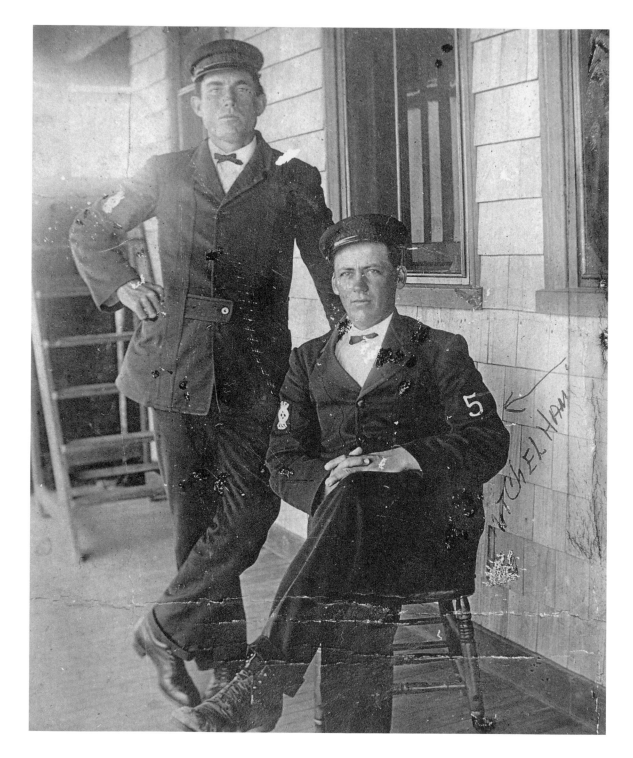

The *Helen H. Benedict*, a three-masted schooner out of New Haven, grounded at Nags Head in 1914. Sailing freighters such as this one plied the seas well into the 1930s. (Photograph by D. Victor Meekins, courtesy of the Victor Meekins Collection, North Carolina Outer Banks History Center)

Facing page. Portsmouth USLSS crew members Monroe Gilgo and Mitchell Hamilton pose on the front porch of the station in their winter dress uniforms, ca. 1910. Both family names are common on the Outer Banks. The Lifesaving Service drew heavily from the Outer Banks communities. (Cape Lookout National Seashore, National Park Service)

Sharpies and Other Boats

Top. A "kunner" or split-log canoe. These European-style canoes were fashioned by splitting a hollowed log down the center and adding timbers between the two halves to add stability and capacity. Fortified with ribs and sometimes with decking, the boats were hardy and cheap to build. They were put under sail and plied the ocean waters with ease. This particular kunner was used by the Bonner family in Bath, North Carolina, for several generations. (Postcard by T. R. Draper, courtesy of the Bath Historic Site, North Carolina Division of Archives and History)

Bottom. This drawing of the Hatteras lightkeeper's boat is likely the only extant image of a North Carolina perriauger. The early perriauger was built much like the split-log canoe but was larger and might have decking. It typically carried two masts. (Drawing by Edwin Champney, 1862, courtesy of the North Carolina Outer Banks History Center)

Numbers	Packages or Articles in Bulk		Contents or Quantities	Value at the Port of Exportation
8,500	W.O. Staves	at 20		170
32,500	P. Pine Boards	at 14		455
20.000	Cypress Shingles	at 23		330
20	barrels Flour	at 10 50/100		210
65	D⁰ Tar	at 1 75/100		113.75
84	bushels Peas	at 1		84.
6	Barrels P. Bread	at 8		48
21	half d⁰ d⁰	at 4		84
6	barrels Onions	at 4		24
				1518.75

157

Cargo manifest of the schooner *Rosario*, bound to Jamaica from Beaufort in March 1818. The ship was typical in size and type to those that dominated North Carolina's maritime trade: schooners and sloops of one hundred to two hundred tons trading coastwise and with the West Indies. This particular ship carried 120,000 cypress shingles; 32,500 pine boards; 8,500 white oak staves; 65 barrels of tar; and various food staples. The naval stores industry fueled the state's maritime trade for many years. (From an original manifest in the North Carolina Maritime Museum)

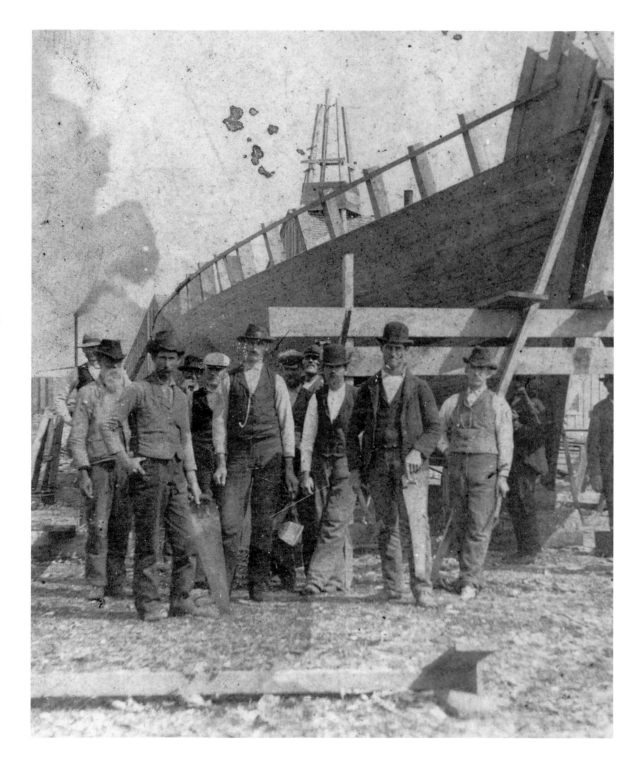

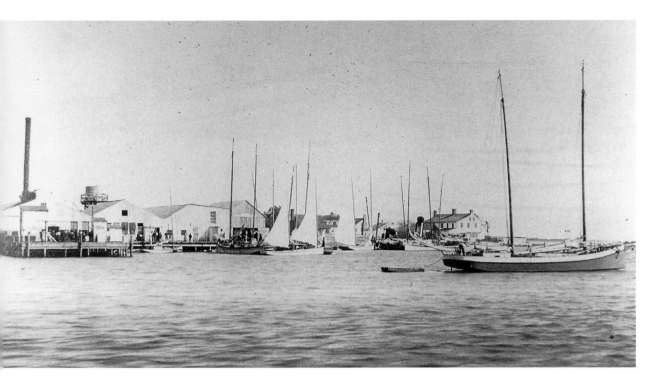

Whitehurst and Rice Boatworks at the west end of Ann Street in Beaufort built many of the smaller sloops and schooners used in the state's coastwise trade. (Photograph, ca. 1900, courtesy of the North Carolina Maritime Museum)

Facing page. The sailing yacht *Roma*, under construction at Beaufort in 1897. Carteret County harbored dozens of small family enterprises that built vernacular boats. More than one thousand such boats were built in North Carolina between 1865 and 1930. Families continue to build boats in their backyards in Downeast communities. (North Carolina Division of Archives and History)

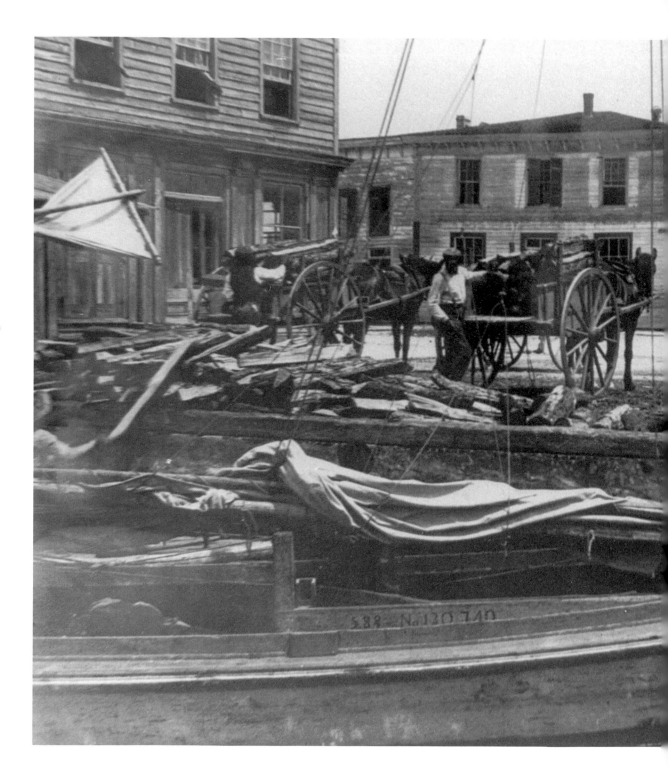

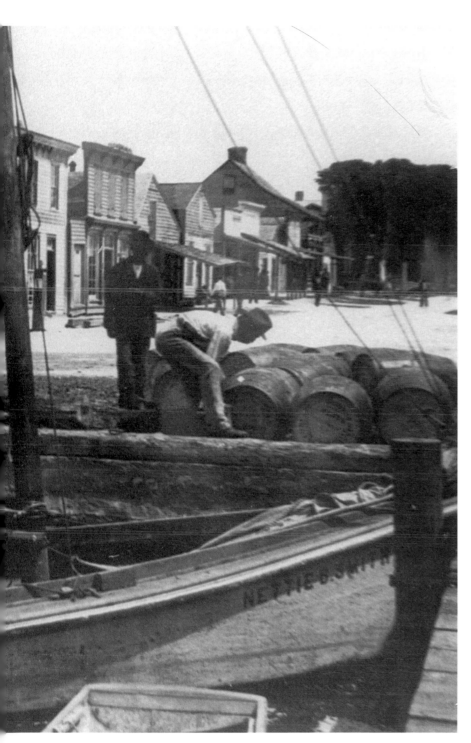

Beaufort waterfront, with the *Nettie B. Smith* tied to the docks in the foreground. The sloop was owned by store owner Alex Graham, who hauled lumber and dry goods. She was converted to gasoline prior to 1912. (North Carolina Maritime Museum)

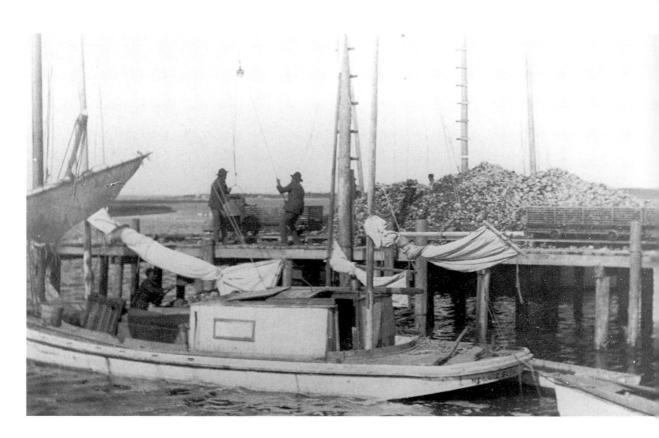

The *Nellie Bly*, a five-ton oyster sloop built at Morehead City, unloads a catch of oysters at a Carolina wharf. Built in 1891, the forty-one-foot vessel was still under sail in 1912. Fishermen and freight haulers who worked boats like the *Nellie Bly* were a hardy and independent breed even by Bankers' standards. (North Carolina Maritime Museum)

Facing page, top. The *Julia Bell*, ca. 1900. This five-ton schooner was well known around Carteret County. She may have been the sharpie that was built in 1876 in Beaufort and defeated Mr. George Ives's New Haven sharpie. The uncertainty about her identity is caused by the appearance of three *Julia Bell*s in the county between 1876 and 1912. (North Carolina Maritime Museum)

Facing page, bottom. The *Ella S. Henderson* was a skipjack oyster sloop built at Belhaven in 1902. The forty-seven-foot, five-ton vessel resembled the skipjacks of the Chesapeake Bay, their native region. But a few were built on the shores of the Pamlico and worked the local waters. (North Carolina Maritime Museum)

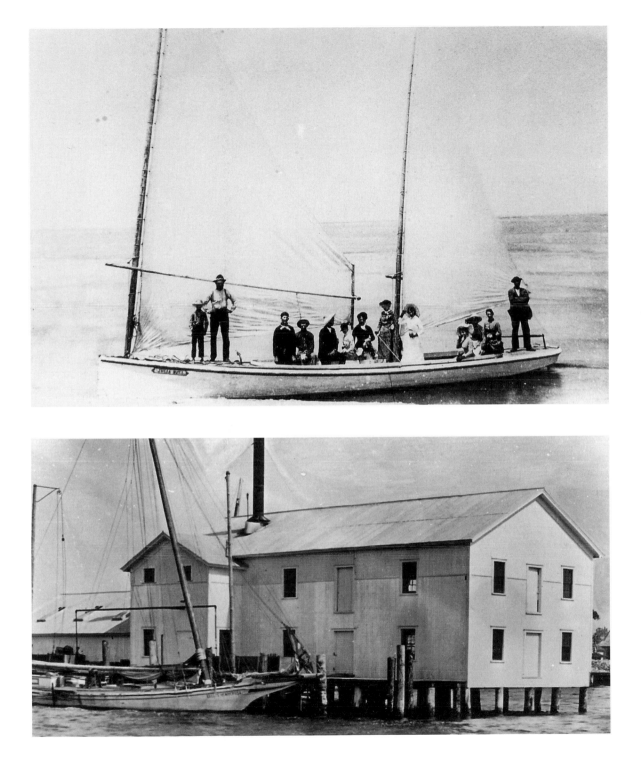

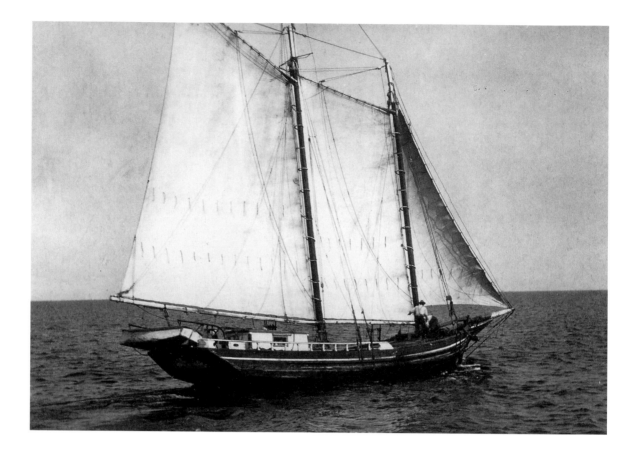

The *Maggie Davis,* a sharpie built at Hatteras in 1899. The nine-ton, fifty-three-foot schooner was owned by Dr. Josh Davis of Hatteras, later of North River. She was converted to gasoline by 1915 and was used as a menhaden boat until she went aground in Bogue Sound in a storm. (Undated photograph, courtesy of the North Carolina Maritime Museum)

Facing page. top. The *Alfonso,* a schooner-rigged sharpie, had several careers. The twenty-one-ton vessel, built at Williston in 1911 for $300, hauled freight and oysters and worked for a time as a menhaden boat. She is tied here at a dock in Beaufort with a load of freight. (Photograph, ca. 1898, courtesy of the North Carolina Maritime Museum)

Facing page, bottom. Sharpie schooners at anchor in Beaufort harbor with rolls of fishing nets drying in the lefthand background, 1910. These simple two-masted vessels were introduced to North Carolina waters in 1876 by Connecticut transplant George Ives when his New Haven sharpie, *Lucia,* defeated a local freight schooner in a race off Shackleford Banks. (East Carolina Manuscript Collection, East Carolina University)

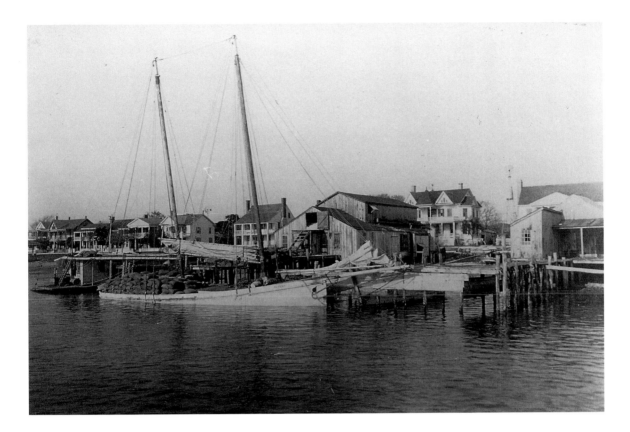

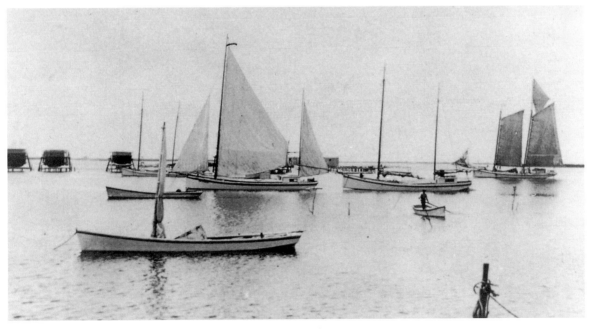

Sharpies, Spritsails, and Shadboats

Boats were the accepted mode of transportation on the North Carolina coast in the eighteenth and nineteenth centuries. Horses and oxen were also used, but they were far outnumbered by vessels built for water travel.

Every family owned a canoe, a shove skiff, or a shallop, small open boats that were home-built from available material. They were used to transport freight, to visit neighbors, to attend church, and to take families to weddings and funerals.

The boats along the coast were often flat-bottomed and shallow-draft to accommodate the shoal waters of the sounds and rivers. Furthermore, the construction of flat-bottomed boats did not require much technical skill. Most anyone could build one.

Janet Schaw, an English visitor to North Carolina in 1775, described a funeral scene in coastal North Carolina where more than a hundred people arrived in canoes to pay their respects to the deceased.

Canoes were the simplest vessels to ply North Carolina's waters. Some residents imitated the Indian style of canoe by hollowing and shaping a tree. Such canoes were easy to build and served the needs of basic transportation.

Other canoes were larger and adapted a European style. A tree was hollowed and split down the center. A third log was laid parallel between the halves and joined to the others with pegs. This method increased the canoe's beam considerably. The term "split-log boats" referred to these large canoes made from three or more logs joined together with pegs and sometimes fitted with frames or ribs to pull the units together. Commonly rigged with a sail, such canoes were also used to move freight from one town to another, or occasionally from one colony to another. Some were even covered with decking.

H. H. Brimley witnessed these homemade workboats in service in 1884 at Currituck. They could carry five or six head of cattle or horses and commonly traversed the sounds. Some were rigged with a spritsail and a jib.

The perriauger was another common type of boat used in North Carolina. There is no definitive description of the perriauger, but this simple workboat is mentioned frequently in correspondence of the 1700s. The perriauger was larger than a canoe and smaller than a sloop. The larger ones shared construction techniques with the split-log canoe, including parallel logs fitted with framing and decking. Others were built with planks and typically carried two sails.

John Lawson remarked on the ubiquitous perriauger in his *Voyage to Carolina*. He described the vessel as large enough to carry a hundred barrels of freight. It plied rivers and the sounds and even sailed the ocean. "Some have gone out of our Inlets," wrote Lawson, "on the Ocean to *Virginia*, laden with Pork, and other Produce of the Country."

Until the Civil War, the larger sailing vessels used for commerce in North Carolina waters were sloops and schooners. Sloops ranged from five to sixty tons. Schooners were larger, carrying one hundred to two hundred tons.

Smaller sloops and schooners were used for lightering the larger ocean-going ships that called at North Carolina ports along the Outer Banks. As they lay offshore, the larger ships were off-loaded onto smaller vessels, which then sailed the goods into Portsmouth and Ocracoke or into the river towns of Washington, New Bern, and Edenton.

These freight sloops and schooners—modest vessels of fifty to two hundred tons—also traded coastwise to Norfolk and Baltimore and Philadelphia. Many carried trade to the Caribbean, calling at St. Kitts, Jamaica, and St. Thomas. Ship manifests of the period list planks, scantling, staves, and shingles as their main Caribbean-bound cargo.

In general, though, sloops and schooners primarily carried naval stores, the collective name for the tar, pitch, rosin, and turpentine produced from the longleaf pine. North Carolina was a major exporter of these goods until the 1920s.

While numerous North Carolinians built many boats for home use and even built sloops and schooners for commerce, the larger ocean-going vessels were mostly left to the shipyards at Norfolk and Philadelphia and other deepwater ports to the north and south. Only Wilmington had a significant shipbuilding industry.

Between 1710 and 1739, of a total of 229 vessels recorded trading in North Carolina, only 38 were built in the colony. Of the 38 home-built vessels, 33 were small sloops and schooners. The industry increased during the Revolutionary War. Of 78 ships registered through Port Roanoke in 1788, 44 of them were built in-state.

Boatbuilding actually increased after the Civil War in North Carolina's coastal communities. Local builders continued to construct vernacular boats, but they introduced new types designed to handle the larger demands of commercial fisheries and processing factories. Between 1865 and 1930, these men built more than a thousand sloops, sharpies, and schooners of between five and one hundred tons burden. A few were even larger.

Some outside influences on the vernacular boatbuilding tradition were more direct. For example, boatbuilding and boat types in North Carolina changed forever in 1876, when a transplanted New Englander, George Ives, challenged a local fisherman, Daniel Bell, to a race. Few cultural departures in history are so clearly defined in place and time.

Ives moved from Connecticut to Beaufort after the Civil War to open a wholesale fish and oyster business. The local log boats were not built for dredging oysters or for hauling large loads of fish, so Mr. Ives had two New Haven sharpies built in Connecticut. He brought this pair of sharpies, the *Lucia* and the *Ella*, to Beaufort by schooner and began to use them for fishing, oyster dredging, and even as a passenger ferry and party boat.

The sharpie is a flat-bottomed, shallow-draft vessel of moderate size, comparable to a sloop or schooner. Initially it was rigged with traditional leg-o'-mutton spritsails, but that rigging was modified over the years. A fast sailer, the sharpie could also carry heavy loads in shallow waters —a winning combination for the shallow sounds and rivers of North Carolina.

It was not uncommon for watermen to test their boats against each other in races and other types of competition. So it was not out of the ordinary for George Ives, an interloper in the Reconstruction South, to find himself in a duel with local son Daniel Bell, a Morehead City waterman.

Ives's sharpie *Lucia* was put up against Bell's traditional vessel *Sunny Side*, a twenty-eight-foot open boat. The race began at Harkers Island, followed along Shackleford Banks, and ended at Beaufort Inlet.

Shackleford Banks must have been lined with partisans cheering their favorite boat. The is-

land was then home to more than a hundred residents, and the race would have lasted from two to three hours, depending on the wind.

At the finish it was the New England sharpie that sailed into Beaufort Inlet the undisputed champion, with the old North Carolina open boat and perhaps some old customs and traditions riding in its wake.

Bell was a good loser. The following year he had his own sharpie built along the lines of the New Haven boat and promptly challenged Ives to a revenge match. The race took place on the Neuse River near New Bern, the *Lucia* against a southern-built version of her called the *Julia Bell*. This time the New England sharpie lost to the North Carolina vessel. Bell was somewhat vindicated, and boatbuilding in North Carolina was forever changed.

Soon after these races took place, a visitor to Carteret County echoed Janet Schaw's observations. In 1880 as in 1775, everyone went by boat: "The only mode of transportation in some portions of this county is by water. The judge, the lawyers and the jurors attend Court by water; the sheriff takes his prisoners to jail by water, and often goes by water to collect his taxes or to serve his writs; the people frequently attend church by water; the young gallant often goes by water to get his marriage license; and to secure the minister to perform the marriage ceremony, he sometimes goes by water."

The new boat of choice in North Carolina, at least in Carteret County, was the long and lean sharpie. Over the years to come, the old perriaugers and log canoes were mostly left beached on forgotten islands and shorelines to rot and return to the earth. With the low freeboard that allowed it to carry heavy loads in shallow water, the sharpie was North Carolina's new workboat.

When individuals construct their own dwelling, the building can take on nuances never intended by the original designer, peculiarities that reflect the personality of the builder and the requirements of local geography. The same is true in boatbuilding, and accordingly, the transplanted sharpie began to take on vernacular characteristics until it became something called a Core Sound Sharpie.

Core Sound Sharpies were rugged little workboats, usually gaff-rigged, easier and cheaper to build than the round-bottomed sloops or schooners they sometimes replaced. They hauled freight, dredged oysters, carried passengers, and doubled as party boats.

By the turn of the century, they were seen up and down the Atlantic coast and in ports of the Caribbean. They generally ranged from five to ten tons, though one 1899 Beaufort-built sharpie measured twenty tons. A large number of boats were built in 1898 and 1899, presumably because several severe storms destroyed numerous ships in those years.

Around home, along the bays and rivers fronting the North Carolina sounds, the simple flat-bottomed skiff continued to dominate the short voyage. Built with local woods, the skiff was easy to build and required few skills. It had been used in the coastal area of the state throughout the nineteenth century. The earliest version was either poled (this type was called a "shove skiff") or rowed with oars. When the skiff acquired sails, it was usually sprit-rigged. By the 1920s most of the sailing skiffs had been converted to gasoline power, but there are still a few Downeasters who will occasionally knock one together in the backyard.

Yet another type of vernacular workboat found in North Carolina waters was the deadrise or V-bottomed boat. The hull's deadrise or "V" helped it cut through and roll with waves, much like a round-bottomed vessel, but it was cheaper and easier to build than a round-bottomed boat.

The round-bottomed boat was a more complicated piece of work than a flat-bottomed boat or a deadrise. The construction of round-bottomed boats required considerable skill, so most of them were built by experienced boatbuilders. The most successful such boat in post–Civil War North Carolina was a workboat that originated on Roanoke Island as a response to the expanding market for fish.

The commercial fisheries that appeared along the coast after the war could handle all the fish the local fishermen could catch. The demands of the fish market increased dramatically, and competition among fishermen was keen. The problem was that pre–Civil War workboats were not adequate to the task. What fishermen needed was a larger boat that could handle a greater load without greatly increasing its draft.

George Washington Creef found the right formula in the 1870s, when he fashioned a fishing boat with a round bottom, a wide midsection, and a tapered bow. The wide beam allowed for large fish hauls, and the round bottom and tapered bow made for smoother sailing in rough seas. The boat was also relatively fast. The "shadboat," as it came to be called, was a handsome,

well-designed vessel with graceful lines. Creef framed his first ones with natural juniper. They were rigged with a sprit mainsail, a jib, and a topsail.

The shadboat was so comfortable and perfectly suited for North Carolina waters and work that it was quickly imitated by boatbuilders up and down the coast, but especially in the northern part of the state. Naturally, other builders imparted their own peculiar nuances to the basic design; there are numerous variations on Mr. Creef's original boat.

The Creef Boatworks at North End and Wanchese on Roanoke Island was active for several generations. The shadboat was being built there even in the 1930s. The complicated round bottom gradually gave way to a less expensive deadrise, even at the shop of the designer, but it continued to be a much-used workboat in North Carolina.

North Carolina did not develop a large shipbuilding industry, as other Atlantic coastal states did. The lack of such an industry was due in no small part both to the formidable barrier islands called the Outer Banks and their threats to deepwater traffic and to the shallow sounds that separated the islands from the mainland.

Coastal communities along the state's seaboard adapted by building smaller vessels that could negotiate the shallow waters and narrow inlets. North Carolina craft traded coastwise and with the Caribbean islands but seldom made cross-ocean voyages.

The lack of deepwater ports discouraged the development of large seaport towns and preserved the Outer Banks as a series of small, self-sufficient communities that relied on fishing, piloting, and lifesaving for their economic livelihoods.

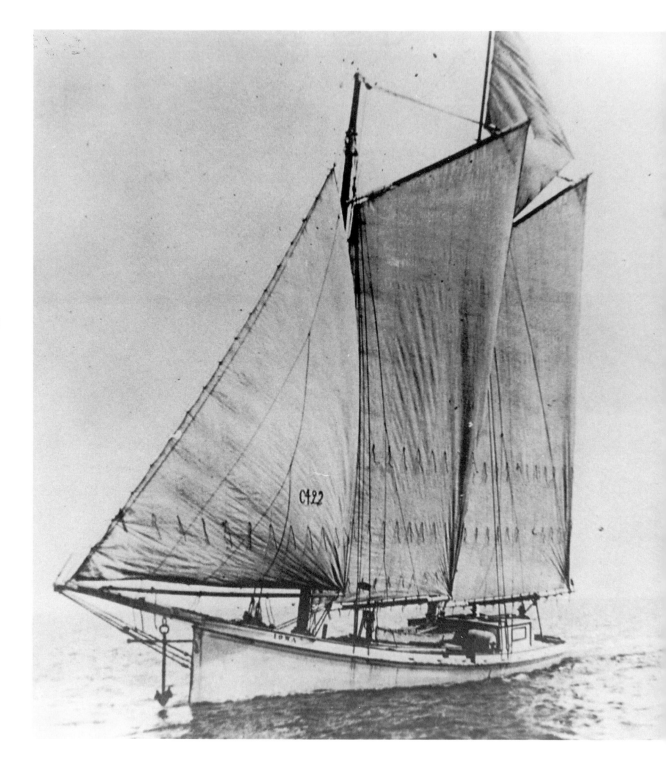

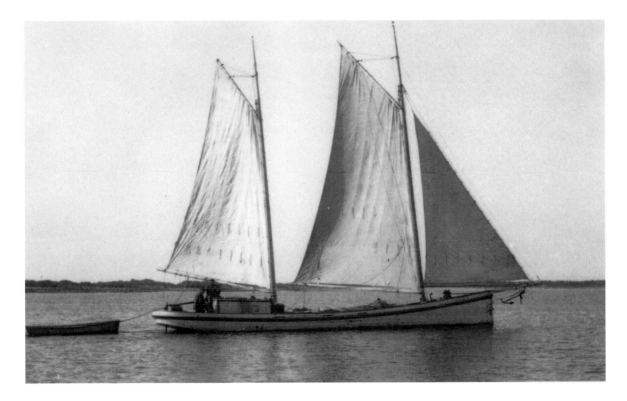

The *Bessie D.* This seven-ton sharpie was built at Smyrna in 1891. She was used to harvest oysters and is shown here under sail off Marshallberg, North Carolina. The vessel was forty-four feet long, with an eleven-and-a-half-foot beam. Under sail in 1912, she was abandoned in 1924—the fate most North Carolina ships shared when gasoline engines became available. (North Carolina Maritime Museum)

Facing page. The *Iowa,* ca. 1900. This nineteen-ton sharpie was built by Van Buren Salter in 1898 at Wards Creek near the community of Bettie for Michael Hill of Atlantic. She was owned by the Hill family until 1941, when she was sold to George Clark of Washington, who converted her to gasoline. (North Carolina Maritime Museum)

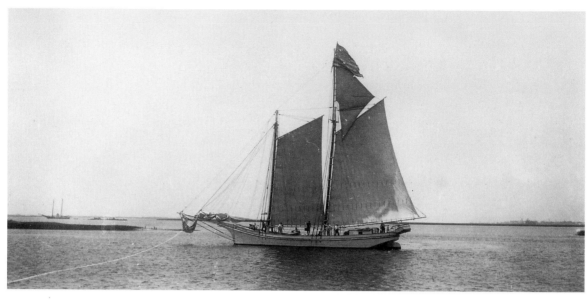

174

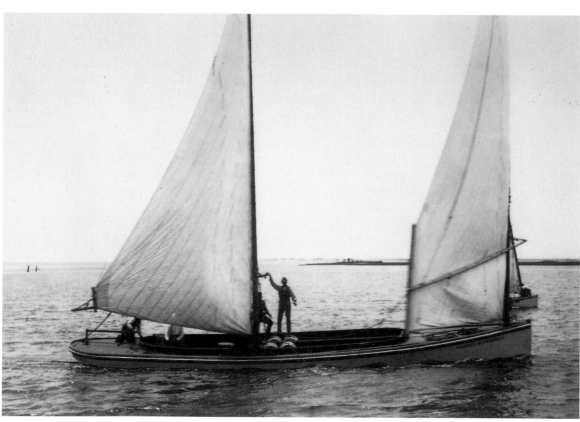

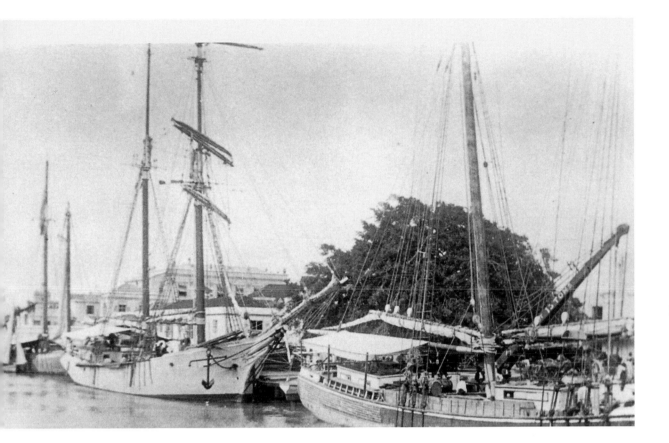

The *Downeaster, Clotilde,* and the *Cora,* all trading schooners from Washington, North Carolina, hug the wharves at Barbados, a frequent trading destination for North Carolina ships. (Photograph, ca. 1900, courtesy of the North Carolina Maritime Museum)

Facing page, top. The *Prince,* a well-known sharpie built in Beaufort in 1899, shows off her schooner rig inside Beaufort harbor, ca. 1900. At sixty-three feet, she is the largest sharpie on record. She carried twenty tons with a four-and-a-half-foot draft and was likely built at Whitehurst and Rice Boatworks at the end of Ann Street in Beaufort. (North Carolina Maritime Museum)

Facing page, bottom. The *Samuel Buckman,* a seven-ton sharpie of forty-five feet, was built at Smyrna in 1899. She is a good example of what was called a Core Sound sharpie, a vernacular adaptation of the New Haven sharpie introduced into the area by George Ives. In this undated photograph, the sharpie is manned by a crew of four. (North Carolina Maritime Museum)

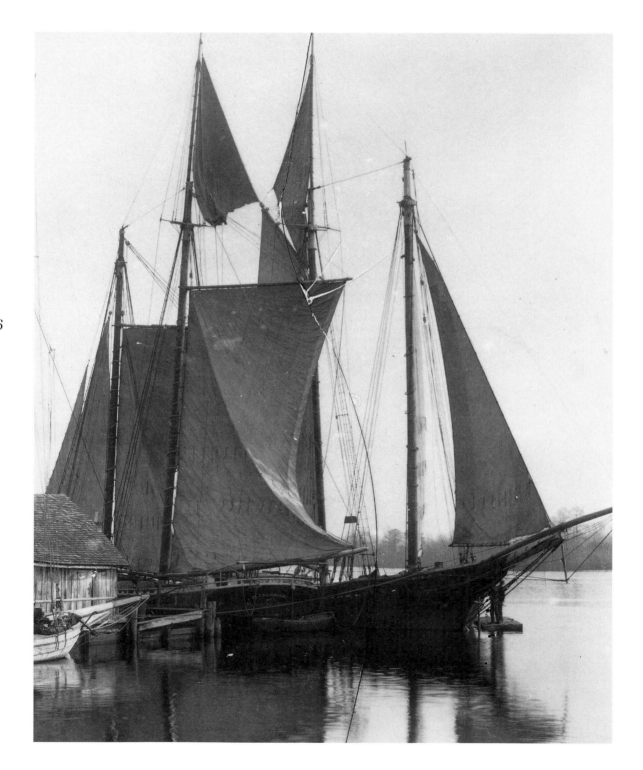

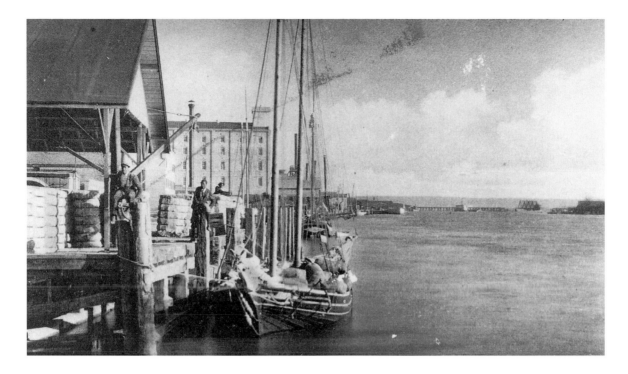

A freight schooner takes on cargo at the wharves in Washington, North Carolina, in 1910. These versatile schooners could be handled by a two- or three-man crew and could negotiate the shallow sounds and rivers of North Carolina. (East Carolina Manuscript Collection, East Carolina University)

Facing page. The *Regulator*, a forty-two-ton round-bottomed schooner built at Williston in 1882 by William Willis. The sixty-three-foot vessel was owned by Captain Tom Gillikin of Marshallberg, who hauled freight between Norfolk and Charleston. At the time of this undated photograph she was still under sail, but she was converted to gasoline shortly thereafter. (North Carolina Maritime Museum)

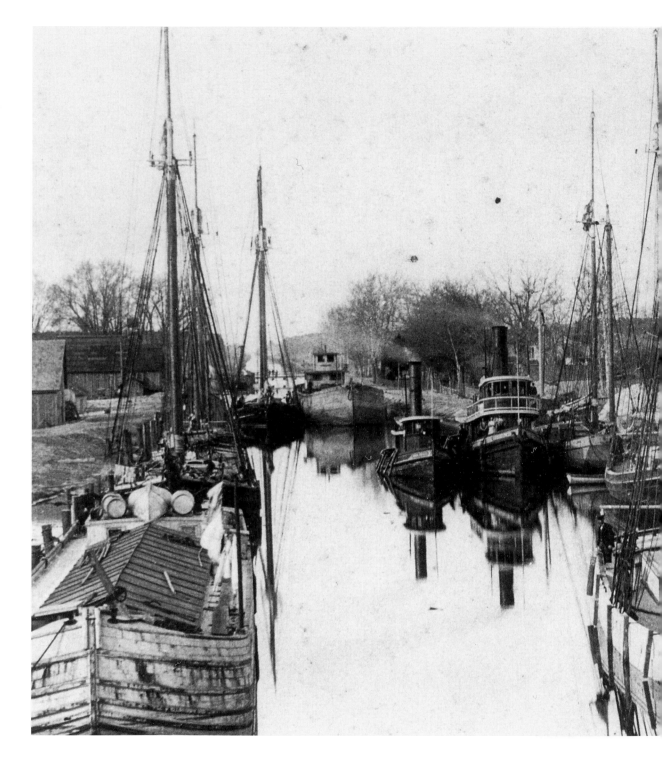

Commercial sail and steam vessels wait their turns for passage through the Dismal Swamp Canal at South Mills, north of Elizabeth City. The canal was often the quickest route from Norfolk to the Albemarle and Pamlico Sounds and was used by ships wanting to avoid the Outer Banks and the Gulf Stream. (North Carolina Maritime Museum)

179

This spritsail skiff makes good time across the sound. The small sailing skiffs were common on North Carolina waters from the 1870s until the 1920s, when most were converted to gasoline power. The lines of this boat suggests that she was built on Roanoke Island or in the northeastern corner of the state. (Undated photograph, courtesy of the North Carolina Maritime Museum)

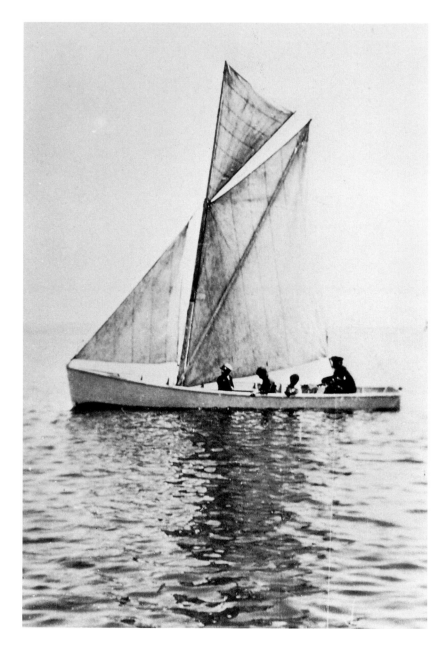

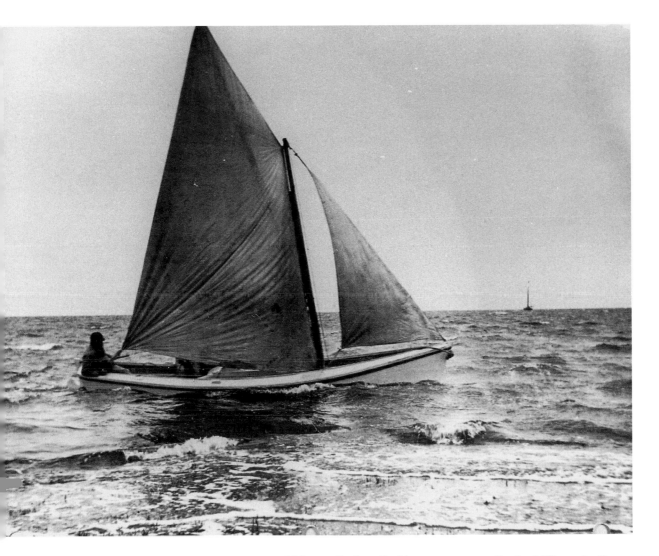

A flat-bottomed skiff like this one could be easily handled by one person. Such skiffs typically carried a sprit mainsail and a small jib and a sprit topsail. The versatile boats were used for fishing, hauling freight, traveling to church, and carrying party groups. (North Carolina Maritime Museum)

George Washington Creef (1829–1917) was a legendary boatbuilder who lived and worked on Roanoke Island. In the 1870s Creef combined design elements of the old dugouts and log boats with a plank-on-frame construction to create a new type of fishing boat. Commonly called a "shadboat," the round-bottomed vessel was wide at its center and could thus carry large quantities of fish, but it was also a swift sailer. The Creef shadboat is the only identified *new* vernacular boat type ever built in the state. Its design was subsequently imitated by boatbuilders up and down the coast of North Carolina. In 1987, the state's General Assembly passed an act designating the shadboat the official State Boat of North Carolina. (North Carolina Maritime Museum)

182

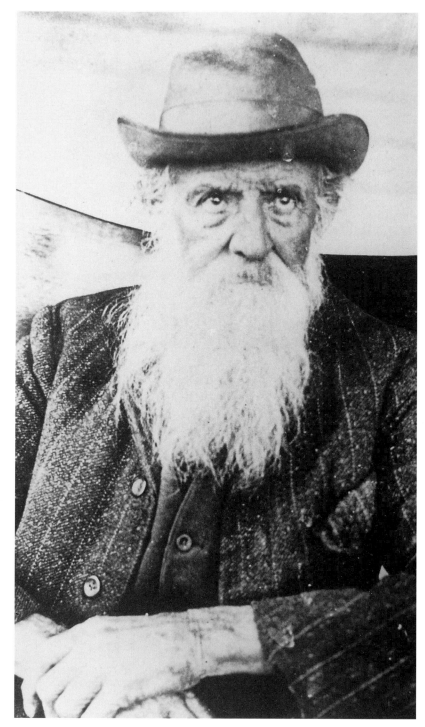

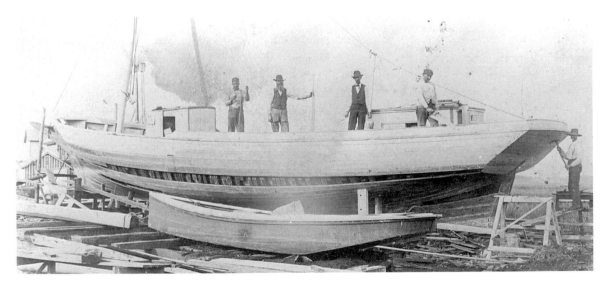

Top. George Washington Creef at work on a shadboat at the Creef Boatworks at Wanchese on Roanoke Island, ca. 1890s (North Carolina Maritime Museum)

Bottom. The Creef Boatworks at Manteo, ca. 1898. George Washington Creef, Jr., stands on the ways at Creef Boatworks with a crew at work on a North Carolina schooner. The Creef Boatworks passed through several generations of the family. (Photograph by H. A. Creef, courtesy of the North Carolina Maritime Museum)

Facing page, top. Devine Guthrie, legendary boatbuilder and resident of Shackleford Banks, with one of his lapstrake whale boats, ca. 1895. These twenty-five-foot pilot boats were used by on-shore whalers to pursue their quarry off Core and Shackleford Banks. The boats were manned by six whalers: four rowers, a helmsman, and a harpooner. Guthrie was the progenitor of numerous Guthries, whose descendants continue to inhabit Carteret County. (North Carolina Division of Archives and History)

Facing page, bottom. The Dough Boatworks at North End on Roanoke Island, ca. 1915. Builders Lee Dough and Horris Dough are joined by the younger Wynne T. Dough and an unidentified youngster on a bicycle with metal wheels. (Victor Meekins Collection, North Carolina Outer Banks History Center)

Below. Fishermen in a typical Roanoke shadboat pose before their vessel. The wide-beam, shallow-draft fishing boat was a fitting marriage of boat type to the shallow sounds of North Carolina and was used widely along the coast. (Photograph by W. H. Zoeller, ca. 1898, courtesy of the North Carolina Collection, University of North Carolina at Chapel Hill)

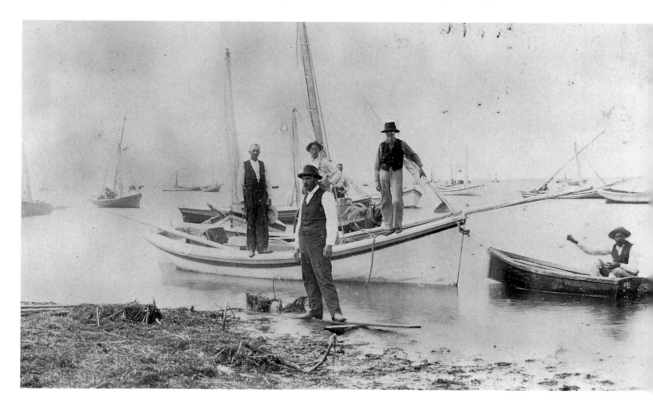

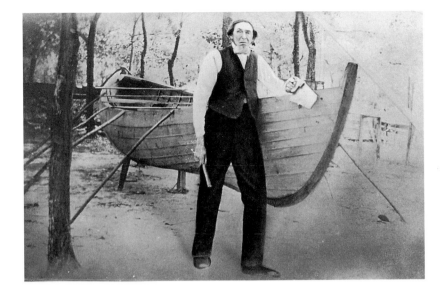

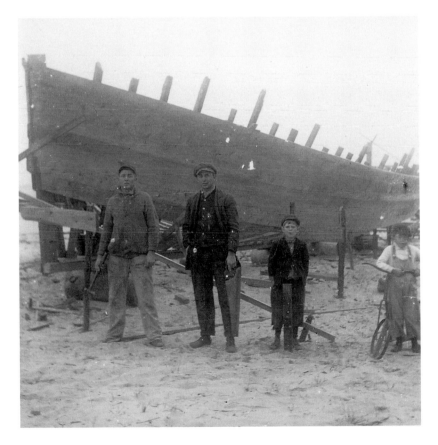

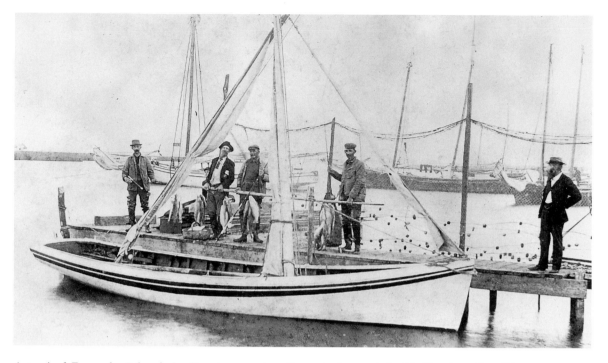

A typical Roanoke Island shadboat preparing for a day's work in Shallowbag Bay, Manteo, ca. 1900. The small fishing boat could carry a large haul and several crew. (Photograph by W. H. Zoeller, courtesy of the North Carolina Collection, University of North Carolina at Chapel Hill)

All in all, the people who inhabited the Outer Banks were different from the people who occupied mainland North Carolina. Unlike citizens from the agricultural mainland, Bankers looked to the sea and sounds for their sustenance and livelihood. Their occupations were solitary or were pursued in small, usually family-related groups.

They disliked central authority, except when it was far removed and stayed out of their business. They disliked routine and confinement, except that dictated by nature. There are many Bankers alive today who left the islands only to perform military service or attend college. They returned to the unfettered and independent life on the Banks to live forever.

In their aggressive independence and sometimes quaint personal differences, Bankers resemble not so much their geographically closer cousins of the coastal plains and the Piedmont as the mountain Carolinians of the Blue Ridge and the Smokies.

While the subject matter of the lore and legends of the Banks is different from that of its mountain counterparts, it has the same drama and sense of aloneness that mountain lore has. It speaks of storms and shipwrecks and lifesavers making lonely rescues in terrifying gales, of humans against the elements. It tells of pirates and privateering, of larger-than-life heroes and villains who break all the rules and either win everything or lose everything. Banker lore recalls mysterious Indians and shipwreck survivors from exotic lands, haunted ships and monster whales, buried treasures and royal lineage.

Like their mountain counterparts, Bankers retain a distinctive brogue, a "hoigh-toide" accent that outsiders insist on characterizing as "Elizabethan." The brogue not only sets

Conclusion

Ever since our schoolboy days we had heard of Beaufort harbor . . . where the people lived on fish, and used oyster shells as cups, with which to drink water out of old pine stumps. . . . The men of that region— as had been reported and believed in the interior by many—were scaly, had broad tails and thorny fins growing from their backs, the result of living on fish and diving after crabs.
—*Greensboro Patriot*, 1858

Otway Burns (1775–1850), a native of Onslow County, was America's most successful privateer in the War of 1812. Burns captured more than a million dollars' worth of British shipping and cargo with his vessel, the *Snap Dragon*. After the war, Burns found a calling in politics and served as Carteret County's representative in both houses of the state's legislature. He was defeated for office after voting in favor of more equitable representation for the western part of the state. He retired from Beaufort to Portsmouth Island when he was appointed keeper of the Brant Shoal Lighthouse by President Andrew Jackson. (Portrait from an original by Roger Kramer, courtesy of the North Carolina Division of Archives and History)

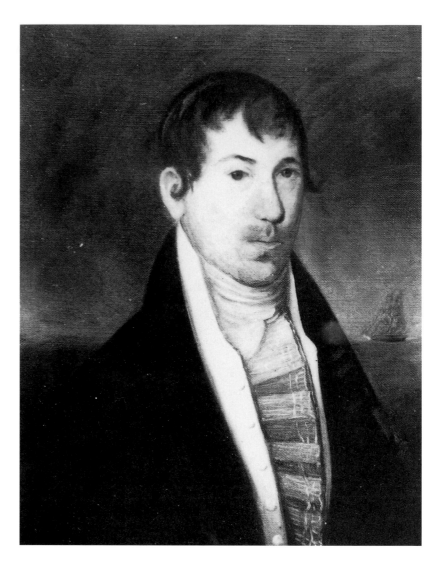

Bankers apart from outsiders, it gives the community its own sense of self-identification.

Just as mountain folks have held onto old herbal remedies and even created an export business out of the rare ginseng plant, Bankers were still using herbs for medicinals when the rest of the state had already gone to patent medicines and

The grave of Otway Burns in the Old Burying Grounds at Beaufort, decorated with a cannon from his privateer, the *Snap Dragon*. (From the Collier Cobb photo album, ca. 1898, courtesy of the North Carolina Collection, University of North Carolina at Chapel Hill)

store-bought remedies. Even as late as World War II, the Bankers found outside markets for seaweed and yaupon.

Both regions had barter economies well into the twentieth century and used their available natural resources in lieu of store-bought goods. Mountaineers used animal skins for clothing and bed coverings, for door hinges and water skins. Bankers used dolphin and shark skins for household hardware such as hinges, conch shells for lamps fueled with whale oil, and seaweed for mattress stuffing.

Both mountaineers and Bankers resisted secession, and Union sentiment in these regions persisted throughout the war. Both areas tended to be physically and mentally remote from state authority at Raleigh, and they often had stronger family and economic ties with Virginia and South Carolina than with their own state.

The Bankers also held to the national or northern hierarchy of Methodism when the

church split over slavery. The Banks were not suitable for plantation farming, and slavery never took root. When the church split over slavery the people of Shackleford Banks retained their northern affiliation through the war and through the last half of the nineteenth century.

When San Ciriaco blew their homes and lives away in 1899, some of the people of Shackleford Banks moved to an area called the Promised Land in Morehead City. They took their northern-affiliated church with them into a town not ten miles removed but leagues apart in feelings. It was the Methodist Blue Ridge Conference of the North Carolina mountains that came to the support of the displaced Shackleford congregation at the other end of the state.

In a tighter turn of the screw of irony, the Shackleford congregation at Morehead City scavenged the lumber to build their new church from a lumber schooner recently wrecked on nearby Bogue Banks. Many believed this coincidence to be providential.

In the center of Yancey County, sitting 2,800 feet above the sea, four hundred miles from the coast, is the small mountain town of Burnsville. The town is named to honor Otway Burns, eminent privateer from Swansboro and resident of Beaufort, who spent his last years on the island of Portsmouth as keeper of a lighthouse. Burns lost his local support and his seat in the Senate when he voted to give the western counties greater representation in the state's General Assembly.

In short, the Bankers were frequently more atuned to mountain culture and needs than to their much closer neighbors of the Piedmont and coastal plains. The geographical separation from the mainland is only part of the answer. The two cultures shared a mindset shaped and nurtured for centuries by a harsh environment that rendered all life uncertain and temporary.

On the other hand, Bankers do not think of themselves as isolated from or on the fringes of the modern world. They are very aware of their unique cultural heritage and are not averse to promoting its more obvious aspects before outlanders. As the modern world continues to intrude on the Outer Banks and their unfettered life rhythms, to the tune of a million visitors a year, that heritage may be the only common bond left to the islanders.

Alford, Michael B. "Traditional Work Boats of North Carolina." Beaufort, N.C.: North Carolina Maritime Museum, 1990.

Angley, Wilson, comp. "North Carolina Shipwreck References from Newspapers of the Late Eighteenth, Nineteenth, and Early Twentieth Centuries." Raleigh: North Carolina Division of Archives and History, 1991.

Ballance, Alton. *Ocracokers*. Chapel Hill: University of North Carolina Press, 1989.

Dunbar, Gary S. *Historical Geography of the North Carolina Outer Banks*. Baton Rouge: Louisiana State University Press, 1958.

Emmons, Ebenezer. *Report of the North-Carolina Geological Survey: Agriculture of the Eastern Counties*. Raleigh: Henry D. Turner, 1858.

Frye, John. *The Men All Singing: The Story of Menhaden Fishing*. Virginia Beach, Va.: The Donning Company, 1978.

Goode, George Brown, ed. *The Fisheries and Fishery Industries of the United States*. Washington, D.C.: Commission of Fish and Fisheries, 1884–87.

Hancock, Joel G. *Strengthened by the Storm: The Coming of the Mormons to Harkers Island, North Carolina, 1897–1909*. Morehead City, N.C.: Campbell & Campbell, 1988.

Havens, Jonathan. *The Pamlico Section of North Carolina*. New Bern: N. S. Richardson & Son, 1886.

Holland, F. Ross, Jr. *A Survey History of Cape Lookout National Seashore*. Washington, D.C.: National Park Service, 1968.

Johnson, Charles. *The Long Roll*. East Aurora, N.Y.: The Roycrofters, 1911. Reprint, Shepherdstown, W.Va.: Carabelle Books, 1986.

Lawson, John. *A New Voyage to Carolina*. Ed. by Hugh T. Lefler. Chapel Hill: University of North Carolina Press, 1967.

MacNeill, Ben Dixon. *The Hatterasman*. Winston-Salem, N.C.: John F. Blair, 1958.

Merrens, Harry Roy. *Colonial North Carolina in the Eighteenth Century: A Study in Historical Geography*. Chapel Hill: University of North Carolina Press, 1964.

Bibliography

North Carolina State Board of Agriculture. *North Carolina and Its Resources*. Winston, N.C.: M. J. & J. C. Steward, 1896.

O'Brien, T. Michael. "Black Heroes of Pea Island." *Commandant's Bulletin* [U.S. Coast Guard], parts 1–3, June–August 1980.

Odum, Eugene P., ed. *A North Carolina Naturalist, H. H. Brimley: Selections from His Writings*. Chapel Hill: University of North Carolina Press, 1949.

Quinn, David B., and Alison M. Quinn. *The First Colonists*. Raleigh: North Carolina Department of Cultural Resources, 1982.

Quinn, William P. *Shipwrecks along the Atlantic Coast*. Orleans, Mass.: Parnassus Imprints, 1988.

Ruffin, Edmund. *Agricultural, Geological, and Descriptive Sketches of Lower North Carolina and the Similar Adjacent Lands*. Raleigh: Institution for the Deaf & Dumb, & the Blind, 1861.

Shears, David. *Ocracoke: Its History and People*. Washington, D.C.: Starfish Press, 1989.

Sprunt, James. *Tales of the Cape Fear Blockade*. Wilmington, N.C.: J. E. Hicks, 1960.

Stick, David. *Graveyard of the Atlantic: Shipwrecks of the North Carolina Coast*. Chapel Hill: University of North Carolina Press, 1952.

———. *The Outer Banks of North Carolina*. Chapel Hill: University of North Carolina Press, 1958.

Walsh, Harry M. *The Outlaw Gunner*. Centreville, Md.: Tidewater Publishers, 1971.

Williamson, Sonny. *Sailing with Grandpa*. Marshallberg, N.C.: Grandma Publications, 1987.

———. *Unsung Heroes of the Surf: The Lifesaving Services of Carteret County*. Marshallberg, N.C.: Grandma Publications, 1992.

Winslow, Lt. Francis. "Report on the Waters of North Carolina, with Reference to Their Possibilities for Oyster Culture; Together with the Results Obtained by the Surveys Directed by the Resolution of the General Assembly, Ratified March 11, 1885." Raleigh: P. M. Hale, State Printers and Binder, 1886.

ML

3/03